Philadelphia
MANSIONS

Philadelphia
MANSIONS

STORIES AND CHARACTERS
BEHIND THE WALLS

THOM NICKELS

THE
History
PRESS

Published by The History Press
Charleston, SC
www.historypress.net

First published 2018

ISBN 9781625859518

Library of Congress Control Number: 2017960344

Notice: The information in this book is true and complete to the best of our knowledge. It is offered without guarantee on the part of the author or The History Press. The author and The History Press disclaim all liability in connection with the use of this book.

For Carla Zambelli Mudry and Noel Miles.

CONTENTS

PREFACE

*Y*ears ago, I lived for a while at 20 Hancock Street on Boston's Beacon Hill. The house was a four-story unostentatious brownstone built in 1805 by Ebenezer Farley. It was purchased by the father of famous abolitionist Senator Charles Sumner in 1830. Sumner advocated the complete elimination of slavery at a time when most politicians hedged or compromised on the subject. Educated at Harvard, he joined the abolitionist Free-Soil Party in 1848, from which he was elected to the Senate in 1851. His reputation as an orator was legendary. He once gave a five-hour speech on the floor of the Senate on the immorality of extending slavery into the new United States territory of Kansas, and in so doing, he lashed out at Senator Andrew Butler of South Carolina. The speech enraged Representative Preston Brooks, also from South Carolina, who then assaulted Sumner with a heavy cane. The brutal attack, which took place on May 22, 1856, caused Sumner to return to Boston, where he spent several months recuperating at 20 Hancock Street.

The *Richmond Whig*, as well as a number of other southern newspapers, applauded the attack, stating, "A glorious deed! A most glorious deed! Mr. Brooks, of South Carolina, administered to Senator Sumner, a notorious abolitionist from Massachusetts, an effectual and classic caning. We are rejoiced. The only regret we feel is that Mr. Brooks did not employ a slave whip instead of a stick. We trust the ball may be kept in motion. Seward [another abolitionist senator] should catch it next."

Sumner went on to champion civil rights for free slaves during the Reconstruction era. He was a close friend of Frederick Douglass and knew Abraham Lincoln intimately but often disagreed with the latter—Sumner was a fiery radical and Lincoln much more conservative and circumspect.

This famous house at 20 Hancock Street was not yet a National Historic Landmark when I lived there. That would happen in 1973, very shortly after I moved out. The 1973 nomination form for NHL status reads as follows:

> *The Sumner House is a Federal style four-story townhouse in which Charles Sumner lived for nearly thirty years of his life. While not in the best of repairs, owing to limited finances of the present owner (Mrs. Helen C. Smith), the floor plans, mantelpieces and woodwork of the Sumner House are intact.*
>
> *The central and original block has a standard side hall plan. The hall enters into a front parlor and rear sitting room, beyond which is a kitchen. The upper floors have a similar arrangement of rooms.*

Sumner grew up in the house and lived there until 1867 when not away on business in Washington. Five Sumner family members died in the house, beginning with Charles's father (with whom he did not get along), three of his sisters and finally his mother, who earned her living as a seamstress. As a young man in his early twenties, Charles was confined to his bedroom because of a serious illness that almost took his life. The house was sold after his mother's death in 1867.

Sumner biographer Elias Nason wrote, "[The house] was well located in one of the higher and better parts of Boston, not far from the State House. No effort had been made to change it to correspond to a larger life. It continued the same comfortable and substantial home that had sheltered him in his boyhood. There peace and happiness, the usual accompaniments of good sense and good habits, prevailed." Nason wrote that before Senator Sumner's mother's death, "from no particular illness…Charles was summoned at last by telegraph and reached her bed several days before her death and remained with her to the end, the only one of her once large family present to pay this debt."

When I agreed to rent the room at 20 Hancock, I had no idea who Charles Sumner was. My first impression of the house was that it had remained perfectly intact from the nineteenth century. The dark parlor was filled with old furniture and rugs. There was an old mahogany desk off to the side that I later discovered was where the famous senator wrote his speeches. From

the front door, you could see a series of doorways leading into a number of rooms, one of which was the kitchen. A sense of mystery penetrated these rooms. The landlady's general demeanor added to the feeling that this was no ordinary abode. Friendly but distant, the landlady's overall manner was that of someone who belonged to a religious cult. She appeared old to me at the time, although when you are twenty-one, everyone over thirty has an ancient cast. At the time, I had the sense that she did not leave the house much. She and her daughter, a young adolescent girl, occupied the first floor.

When I first went to see about the room, I noticed the daughter peering at me behind a door. I remember leaving the house feeling that something wasn't quite right about it. The room I agreed to rent was on the second-floor front, which meant that I had a view of the Massachusetts Statehouse farther up Hancock Street. (Senator Sumner would walk to this building every day from 20 Hancock.) Since the room was furnished, I noted with curiosity the washstand in one corner with built-in tiles to prevent splashing. There was also a four-poster bed, an antique wardrobe closet that looked as though it was from the Sumner family and an out-of-commission fireplace topped with a vase holding artificial flowers. The room was a page out of the past. I knew of no other boarders in the house—at least I don't remember any other tenants coming or going. The bathroom in the hallway, with its antique sink and tub and long chains used to open the window and flush the toilet, had a large window with a view of the oldest part of Boston. I remember shaving in the morning and looking out the window at an old water tower and thinking, "I am no longer in the twentieth century." I had truly stepped into something strange.

During my time at 20 Hancock, the landlady's daughter would occasionally stare at me without ever saying hello. Sometimes I'd come home from work and see her retreat quickly into a room. There was no TV in my room, but I did have a radio. At night, I never heard a sound from the first floor. Mother and daughter were abnormally quiet. My room, however, seemed to grow on me. I would lie in bed at night, stare at the ceiling and begin thinking about my own family's history, and as I did this night after night, a new and different world seemed to be opening up. It wasn't long before I began to see and hear things in that room, some of them unsettling and frightening.

Before you start thinking that the writer of this essay needs to be committed, I should mention that by a stroke of good fortune or self-discipline, I managed to escape the drug mania of the late 1960s and early '70s. This was the time when artists and others who took LSD were jumping out of high-rise windows thinking that they could fly. My Harvard professor

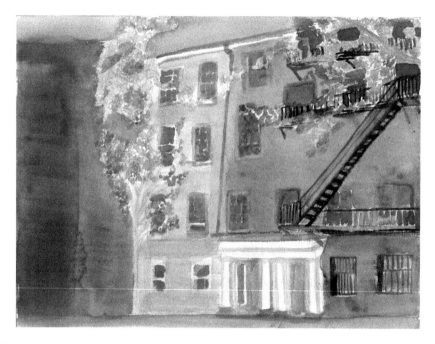

Senator Charles Sumner Home on Hancock Street, Beacon Hill, Boston. *Illustration by Chuck Schultz.*

friends, dancing to the beat of the counterculture, did their best to push LSD, but I somehow managed to refuse the invitation. The strange goings-on in the Sumner house, therefore, did not stem from an artificial substance or dream. I was clear-minded and "sober" when the apparently haunted or "besieged" room opened up its hidden world to me.

While lying in bed one night, I thought I saw one of the artificial flowers on the mantelpiece leaning in the opposite direction from the rest, like William Blake's poem "The Sick Rose":

> *O Rose thou art sick.*
> *The invisible worm,*
> *That flies in the night*
> *In the howling storm:*
>
> *Has found out thy bed*
> *Of crimson joy:*
> *And his dark secret love*
> *Does thy life destroy.*

Immediately after noticing the flower, I observed how the other flowers, working together as a collective, leaned toward the hurt, bent flower as if on a rescue mission and then drew it back toward the group with the force of what I perceived to be "love." The strange room in the even stranger house seemed to be demonstrating to me the healing power of love, but how was this possible?

In this room, where possibly Senator Sumner's father, mother and all of his sisters died, I was experiencing something beyond the pale. It was as if the walls themselves were giving up part of their "lived" human history; the "consciousness" of long-forgotten events that happened here were, in a sense, breaking through and coming at me like random psychic darts. Some things cannot be explained. Whenever I visit Boston, I make it a point to visit 20 Hancock Street on Beacon Hill.

In writing about important Philadelphia houses and mansions and the people who lived in them, it is perhaps fitting that one begins in Boston, a city some fifty years older than its neighboring metropolis to the southwest. Important questions to keep in mind are as follows: What can these old houses tell us? What, if anything, can we feel when we enter these structures? Do some old houses stand mute, while others, like Charles Sumner's house, exude a historic mist that can be "read" or experienced paranormally given the right conditions? Historic houses don't exist in a vacuum. They cannot be appreciated apart from the built environment that surrounds them and the human history lived within their walls. These two factors add a dimension beyond architecture. They create the truly multidimensional house.

ACKNOWLEDGEMENTS

Special thanks to Marita Krivda Poxon, Jim Tate, William Scudder, Carla Zambelli Mudry and Philadelphia artists Noel Miles and Chuck Schultz.

Chuck Schultz is an artist working in Philadelphia. He is a Fine Arts graduate of the Delaware College of Art and Design and the Pennsylvania Academy of the Fine Arts.

INTRODUCTION

*L*et's consider the built environment around many of Philadelphia's historic mansions. The Philadelphia Quakers may have been right about many things, but they were wrong about entertainment. Quakerism, for all its fine attributes in the fields of peace and justice, tended to downplay entertainment and the arts. As a result, Philadelphia was a Johnny-come-lately to the world of musical entertainment. This is why people of long ago called it a droll, conservative town that was half alive on a Friday and virtually nonexistent on Sunday. That changed to some degree in 1839 when the city began to make plans to build a grand opera house. Years passed before that vision became a reality.

In 1854, architects Napoleon LeBrun and Gustave Runge won an architectural competition to design what would later become the oldest opera house in America: the Academy of Music on South Broad Street. In 1855, the year of the building's ground breaking, Broad and Locust Streets was a residential area and thought to be far enough away from traffic noise to build an opera house. Budgetary restrictions, however, forced the architects to concentrate on the interior of the building.

The Academy's exterior, despite failed plans to redo it in marble, remained as simple as what was then termed a "market house." Its exterior does, in fact, resemble a Quaker meetinghouse, but that all changes when you go inside. The Academy's lavish neo-Baroque interior made it one of the most spectacular buildings in the city.

The fourteen huge Corinthian columns supporting the balconies in a recessed upward-tiered fashion, as well as Karl Heinrich Schmalze's murals

illuminated by the central crystal chandelier, caused Le Brun and Runge to note that "acoustic and optical effects have been very carefully studied and particular attention given to the comfort and accommodation of the audience." The crystal chandelier alone is fifty feet in circumference and weighs five thousand pounds. It was electrified in 1900.

"The architects placed a dry well under the main floor, known as 'the Parquet,' to balance the dome on the roof which, the experts tell us, contributes to the spectacular sound….Also, during its construction, the Academy was allowed to stand roofless for one year to be seasoned," wrote Philadelphia author John Francis Marion. One can only imagine what a roofless Academy of Music was like, especially with snow, rain, sleet and random "spot check" bombs from flying pigeons.

The Academy stage has hosted world-famous musicians like Marian Anderson, Maria Callas, Aaron Copland, Gustav Mahler, Richard Strauss and Joan Sutherland. Poet Walt Whitman used to take the ferry in from Camden and attend operas there. That's why whenever I attend an opera at the Academy, I think of Whitman sitting somewhere in the vast hall and then going out onto Broad Street to walk up to City Hall (which he admired) and take a streetcar to the ferry at Penn's Landing.

"The Academy of Music, with its gilt, festoons, griffons, shells and other carvings, is older than the Convent Garden Opera House or the Paris or Vienna operas and has its own particular aura, its own special glamour," Marion noted. This is despite the fact that the audience seats are small and the leg room minimal. By today's standards, it is really a concert hall built for little people.

As a child, my great-aunt Dora introduced me to the Academy of Music. Together we would go into town from Bala Cynwyd on the Paoli Local. We'd have lunch at Stouffer's in Penn Center, walk to Rittenhouse Square and feed the pigeons, visit "the Eagle" at Wanamaker's and then stop in at St. John the Evangelist Church on Thirteenth Street to light a candle. Going to the Academy with Aunt Dora was my first introduction to classical music. I especially liked Ravel's *Bolero*, Beethoven's Ninth and Grofé's *Grand Canyon Suite*. Aunt Dora used to tell me that an education in classical music was a necessary part of a good education, or "good breeding."

One building that Aunt Dora never showed me was the Julian F. Abele–designed Philadelphia Free Library. Able, a black architect, didn't get a lot of credit for his work despite the fact that the building is one of the most iconic structures in the city.

The building was first proposed by William Pepper and head librarian John Thomson in 1894. In 1897, Philadelphians authorized a city loan of $1 million through a referendum for a new structure on a new site. (The library was previously housed in a room the size of a closet in City Hall, in the Old Concert Hall building at 1217–21 Chestnut Street and then at Thirteenth and Locust Streets.) In 1910, the present site at Nineteenth and Vine Streets was selected.

Horace Trumbauer (1868–1938), an architect from the city's Frankford section, was one of the nation's foremost architects during the Gilded Age. Trumbauer designed the Whitmarsh Hall Mansion for Edward T. Stotesbury and the Elms for Edward J. Berwind in Newport, Rhode Island. As the chosen architect for the Free Library project, Trumbauer hired Julian F. Abele, one of the first university-trained black architects, as his assistant. Abele, a graduate of the University of Pennsylvania and the Pennsylvania Academy of the Fine Arts, based his rendering on French architect Ange-Jacques Gabriel's twin façades for the Ministère de la Marine, as well as the Hotel de la Crillon on the Place de la Concorde in Paris. Abele held eighteenth-century French classical architecture in high esteem.

Unfortunately, the "slash and cut" reformist mayor Rudolph Blankenburg questioned additional funding for "the extravagant Benjamin Franklin Parkway" then under construction. Without a parkway, there could be no main library, so the city's cultural leaders were summoned to usurp the nearsighted, cheap mayor. The campaign hit another snag: city lawyers warned of coming court battles, so the project was put on ice. John Thomson told benefactor Andrew Carnegie, who donated $1.5 million for thirty branch libraries, that "we are in very great trouble in Philadelphia as to our main library." It was a cry for help.

In the meantime, fire and brimstone preacher Billy Sunday built a makeshift tabernacle on the site. The hallelujahs came to an end, however, when yet another city referendum decided that the city would fund the stalled project. The project hit another snag when groundbreaking ceremonies were delayed yet again. The new building would not open until 1927.

Trumbauer's ideas for the new library included freestanding vertical book stacks, a nineteenth-century innovation designed to house large numbers of volumes. As for the design of the building, Abele once said that the "lines are all Mr. Trumbauer's, but the shadows are all mine."

Fiske Kimball, director of the Philadelphia Museum of Art at the time, called Abele "certainly one of the most sensitive designers anywhere in America."

HIGH VICTORIAN PICTURESQUE 2

In the 1970s, Philadelphia's architectural treasure, City Hall, suffered from abuse and neglect. Not only did the portals leading into the courtyard smell of urine, but most of the bathrooms in the building were tagged with graffiti and strewn with trash. At the time, it was not uncommon to find homeless people asleep or changing clothes in one of the bathroom stalls. The shocking state of affairs didn't seem to bother most in city government. Even "law and order" Mayor Frank L. Rizzo seemed oblivious to the problem. It wasn't until the administration of Ed Rendell that a massive City Hall cleanup campaign was launched.

During that period, City Hall was in such a state of disrepair that architect Louis Kahn called the building "the most disreputable and disrespected building in Philadelphia" (a comment that no doubt referred to the building's shabby condition), while earlier critics in the 1920s insisted that the structure was inherently ugly anyway. These criticisms, for the most part, were based on that era's anti-Victorian bias; it wasn't until 1983 that people stopped calling for City Hall's demolition. (In fact, demolition was first suggested a mere twenty years after the building's completion in 1901.)

Demolishing the largest municipal building in the United States, which had more than seven hundred rooms, 88 million bricks and a 548-foot tower (the world's tallest masonry structure minus a steel frame), not to mention more than 250 pieces of intricate sculptures by Alexander Milne Calder and a twenty-seven-ton cast-iron statue of William Penn atop its tower, was not an option when one considered where the rubble was to be deposited. Such a venture would also cost a fortune. "Too big to maintain and too expensive to tear down," was a catchphrase during those years.

In 1921, calls for City Hall's demolition occurred because the pristine white High Victorian Picturesque (or French Renaissance) building had begun to turn coal black from nearby trains and buildings. It didn't help that the building was also called "an impediment to traffic." City Hall, which took thirty years to build, was pretty much out of style by the time the finishing touches were applied. What had started as a bold architectural experiment with world stage potential was overshadowed by the completion of the Washington Monument and the Eiffel Tower in Paris. Both projects stole the limelight from the building that the AIA called "perhaps the greatest single effort of late 19th Century American architecture" and that poet Walt Whitman (observing its construction from his home in Camden) termed "a majestic and lovely show there in the moonlight…silent, weird, beautiful."

Construction on City Hall began in 1871 after a year of planning. John McArthur Jr. was selected to design the building. It is said that the Palais des Tuileries and the Louvre in Paris influenced the design of the building. In 1873, Alexander Milne Calder began the sculpture work; construction on the tower also began at this time. The construction of City Hall had many starts and stops, as funding was a common problem. When McArthur died in 1890, John Ord was appointed the new architect. He resigned three years later over a wage dispute and was replaced by W. Bleddyn Powell.

In 1921, the Philadelphia Police Department recommended lights on the tower to monitor traffic flows. This experiment pleased some when it was initiated several years later, but many on the road could not see the lights. In 1924, a thirty-inch, 350-million-candlepower spotlight from General Electric was put into the north side of the tower, below the clock. The purpose of the floodlight was to catch thieves who might be running on North or South Broad Streets.

The building was designed with four separate wings that formed an open courtyard. The large exquisite gold-colored compass on the floor of the courtyard (as common a meeting place as "the Eagle" at Wanamaker's or Macy's) was mysteriously replaced with a far less spectacular-looking city compass sometime in the 1980s. The original compass was truly majestic and framed like an enormous gold star. The building is supported not by steel but by stone and bricks reinforced by the same.

"A restoration of the building's lavish stairway and exteriors, perhaps the nation's largest ever art conservation effort, is slowly transforming its dingy main floors into bright granite and marble," the *New York Times* reported in 2010. The *Times* also reported crumbling marble and "chunks of ironwork and body parts of statues that would occasionally come crashing to the ground."

In the late 1970s, I had the opportunity to take an unofficial tour of City Hall's basement, something that could not be done today given the emphasis on security. In the 1970s, however, there were no security checks, and if you knew a City Hall employee, you could team up and take an impromptu walk-through. What struck me then was all the stored furniture, the old desks, planks of wood, old picture frames and other stored old artifacts that seemed to go on forever. It was as if each mayoral administration had thrown its leftover chairs, papers and desks into the basement, turning it into a kind of holding bin.

Of course, the high point in any City Hall tour is a trip to the tower observation deck. When I'd take these official tours with Aunt Dora as a

child, I would marvel at the small five-person elevator that took you close to Billy Penn's hat. The observation deck, while hardly as grand at the deck atop the Empire State Building, is still something to see. Small and intimate, most people enjoy the fact that a limited number of viewers can fit on the deck at once.

One building that Aunt Dora never mentioned was Philadelphia's Divine Lorraine Hotel at Broad and Fairmount Streets in North Philadelphia. Designed in the French Renaissance Revival style by architect Willis Gaylord Hale (1848–1907) in 1892–94, the Lorraine began life as an opulent apartment building in the epicenter of what was then one of Philadelphia's most exclusive areas, North Philadelphia, which in those days included the nouveau-riche mansions of William Elkins and the Wideners.

Life was glorious for the grande dame of North Broad Street and would continue to be satisfying even after its purchase in 1900 by the Metropolitan Hotel Company, which turned it into apartments.

Time sometimes has a way of turning the finest piece of alabaster into sandstone, but the Lorraine was still in top form when it was purchased in 1948 by Father Divine, who transformed it into the city's first racially integrated quality hotel.

Father Divine was a benevolent Harlem preacher and civil rights and social welfare activist whose purchase of the building meant more than a name change. His International Peace Mission had its headquarters in the building and found employment for many black Philadelphians. Father Divine once wrote, "A good painter, when he paints a house, rubs paint in all the pores of the wood and then, when the rains and the storms of winter come, that paint will protect it and prohibit the wood even from so much as decaying. Greater is He that is within, He that is painting you, than the beautifier of complexion."

After Father Divine's death in 1965, the Peace Mission owned and operated the hotel until 1999, the year that brought the finest preserved late nineteenth-century apartment house in the city into another albeit less positive era.

For half a decade, the building was vacant and unattended, visited only by pigeons, rats and an occasional vagrant in search of shelter despite its having been awarded the official Pennsylvania State Historical Marker in 1994.

Some spoke of demolishing the landmark at the time, while others, like a New York real estate entrepreneur who purchased the building in 2000, wanted to refurbish it. Prospects seemed good for the structure, especially in 2002 when the building was added to the National Register of Historic

Places. Real estate's unpredictable roulette wheel, however, brought about another abrupt jolt: the building's resale and the unveiling of plans to build condominiums and retail space.

With the new sale in the bag, the building's future seemed certain, and the American Institute of Architects Landmark Building Award in 2005 seemed to confirm that fact.

When yet another developer bought the Lorraine for $10 million with plans to add five fifteen-story condo towers behind the hotel, the future seemed ensured. "Thus do we build castles in the air when flushed with wine and conquest," Samuel Butler warned us, and so it's been for the grande dame of North Broad. The former hotel is now a renovated apartment complex.

The legendary Church of the Advocate, designed by architect George M. Burns (1838–1922), stands as a monumental example of ecclesiological design in the United States. Its French Gothic forms include stained glass, flying buttresses and ornamental gargoyles.

The interior vistas of the church are immense and almost symphonic. "Painting, sculpture and architecture that ought to compete and disagree somehow harmonize into something larger," wrote critic Peter Rockwell. "In the Church of the Advocate, paintings that by their color, form and meaning are an art of protest function together with carvings by master carvers who never thought of themselves as artists."

The nave, with a thirty-foot-high stone statue of the angel Gabriel, is especially dramatic. Gabriel used to perch outside the church, but time and the elements forced the statue's removal to a more secure position inside the church near the medallion-studded rose window. The rose window is shrouded behind a vast net that was put up decades ago to collect falling plaster from the capitals near the ceiling.

The church, which is listed in the National Register of Historic Places and which was designated as a landmark by the Philadelphia Historical Commission in 1980, began to deteriorate in the 1960s. Originally built as a Presbyterian church in honor of George W. South, a wealthy Philadelphia merchant, it was thought too ornate for Presbyterian worship services and was offered to the Episcopal diocese.

Another of Aunt Dora's favorite haunts was Frederick Graff's Fairmount Water Works, especially as seen from the West River Drive. During one such visit with her, I remember watching a boy my own age lower a bucket on a rope into the muddy waters of the Schuylkill River. Along the balconies high above the water, other boys also lowered buckets. Less successful than pole

fishing, bucket fishing could take hours and getting a catch was often left to chance, although during the afternoon in question, I saw one boy catch a large catfish, pulling up the rope as if it were an anchor. I saw the fish jump above the rim of the bucket yet never manage to escape. In a matter of minutes, the huge bewhiskered brown catfish was dead.

If the handsome Neoclassical columns that grace architect Graff's Fairmount Water Works could talk, they'd tell a hell-raising tale.

They would paint a picture of a cramped, dirty and fetid city where the 1793 yellow fever epidemic had forced the government to move the capital from Philadelphia to Washington. The once great "Athens of America," as Philadelphia was then called, was awash in disease and contagion, thanks mainly to a nasty mosquito imported from the Caribbean. It didn't help that the city's water supply at that time consisted of cisterns, springs and wells. Benjamin Latrobe designed the waterworks as a response to the epidemic that wiped out almost 60 percent of the city's population.

The first waterworks were located in Center Square (the site of City Hall). Although better than cisterns and wells, Latrobe's steam-powered pumps kept failing. He moved them to a reservoir on top of Fairmount in 1812, but this also proved inadequate. In the same year, Graff designed a dam and mill house at the Fairmount location. At this time, the system changed from steam to water power. The new complex made Philadelphia's water system the most advanced in the world.

The waterworks' striking resemblance to Roman temples caught the eyes of Charles Dickens and Mark Twain, as well as many regular Americans, who made it the most popular eighteenth-century tourist attraction after Niagara Falls. The aesthetic appeal of the twelve-acre Graff-designed park surrounding the waterworks—which included a garden with "storybook" paths and esplanade—encouraged further additions to the complex, such as the 1859 mill house built with a wide patio top and a series of boathouses known today as Boat House Row.

A CITY TRANSFORMED

Jane Jacobs, author of the 1961 classic urban planning bible *The Death and Life of Great American Cities*, wrote that modernist planning policies had destroyed inner-city communities. Jacobs criticized Edmund Bacon (she called him "a big poobah"), the seminal city planner responsible for

the creation of Penn Center and the revitalization of Society Hill. Jacobs disliked the Penn Center plan because of its extensive underground components. She thought the plan left an empty and sterile aboveground promenade, despite the fact that the Center's emphasis on underground pedestrian activity was not entirely Bacon's fault. Somewhere along the line, New York real estate broker Robert Dowling was brought in to alter Bacon's design. Dowling's changes displeased Bacon, but they were implemented anyway. (Dowling's plan called for roofing over Bacon's underground shopping plaza.)

Unfortunately, Jacobs also had something to say about Bacon's other lifetime achievement: the revitalization of Society Hill. She objected to what Paul Goldberger of the *New Yorker* called Bacon's "bulldozer approach to urban renewal." Goldberger, in fact, wrote of a walk that Jacobs and Bacon took around Society Hill. During that walk, Jacobs wanted to know where all the people were in the "renewed" sections of the neighborhood. According to Goldberger, Bacon replied, "They don't appreciate these things."

Jacobs notwithstanding, Philadelphia prior to the work of Edmund Bacon and architect Vincent Kling was a city that inspired little civic pride. The Washington Square and Society Hill neighborhoods, for instance, were nearly in ruins, with abandoned or dilapidated buildings. (Jacobs wrote about "derelict" Washington Square in *Death and Life*.) In the 1940s and '50s, Washington Square was populated by vagabonds, public drunks and the homeless. Bacon's plan called for leveling some nineteenth-century houses and making the surrounding Society Hill area comfortable for the urban middle class, a transformation that, in turn, would revitalize the Square.

Pre-Bacon Philadelphia was a Sunday blue law town with a ten-block stone viaduct extending to the Schuylkill River. Known as the "Chinese Wall," this medieval-looking fortress was connected to the Pennsylvania Railroad's Frank Furness–designed Broad Street Station. When the wall and Broad Street station were demolished in 1952–53 to make way for Penn Center, Philadelphia was on the map again. *Time* magazine even cited the project as an excellent example of successful urban renewal. The change was long overdue, as Philadelphia was still recovering from one of its greatest failures: the collapse of the 1926 International Sesquicentennial, a World's Fair commemorating the 150th anniversary of the Declaration of Independence of the United States.

The Sesquicentennial was a city-within-a-city, covering massive parts of South Philadelphia. Judging from the brochures of the period, it held the possibility of being a fantastic success.

A luminous Liberty Bell, some eighty feet high, greeted visitors to the fair, and countless palaces—from the Taj Mahal–looking Persian Building on Edgewater Lake to the Cuban Building, the India Building and a Palace of Agriculture with tall towers that would fit quite nicely in the middle of a city like Vienna—provided a striking contrast to the "other" city uptown.

The fair even displayed a full-scale re-creation of High Street, now Market Street, in 1776 and a dramatic seventy-foot-high Frank Vittor–designed statue dedicated to the steel industry. Sadly, at the close of the Sesquicentennial, all of these structures were demolished, with the exception of the Russian Pavilion, which survives today as a summer picnic venue for random outdoor park barbecues.

The world turned a blind eye to Philadelphia's Sesquicentennial. With the loss of money and international prestige came a monumental blow to the city's ego. After that, Philadelphia seemed to go into hibernation. Then came the Depression and the bleak World War II years, ensuring Philadelphia "joke status" on late-night talk shows.

Chapter 1

HOUSES OF MANY MASTERS

*T*he property on which Strawberry Mansion sits was deeded to Swan Swanson, Woolly Swanson and Andrew Swanson jointly on June 3, 1683, from William Penn, proprietor and governor in chief of the province of Pennsylvania. The property was exchanged for six hundred acres of land along the Schuylkill River in exchange for land in Northern Liberties in the county of Philadelphia, or today's Center City area.

Judge William Lewis (1752–1819) bought the property from Joseph Swift and his wife on August 8, 1783. Lewis then began an extensive remodeling project, completing the enlarging of the farmhouse in 1789. An opening party was held on July 4, 1789. The estate soon began to be known as Summerville.

Lewis was an iconoclastic force in the American legal world. He was a member of the Pennsylvania legislature and a delegate to the Pennsylvania Constitutional Convention, and he defended colonists accused of treason. One of his most famous cases involving treason was his defense of Aaron Burr. As an aide to both Washington and Hamilton, he was also instrumental in writing the first law in the United States abolishing slavery. In 1780, the Pennsylvania legislature passed "An Act for the Gradual Abolition of Slavery," the first law against slavery passed by any governmental body in the world. The Chester County native was home-schooled until the age of seventeen, after which he enrolled in Philadelphia's Friends' Public School to study Latin.

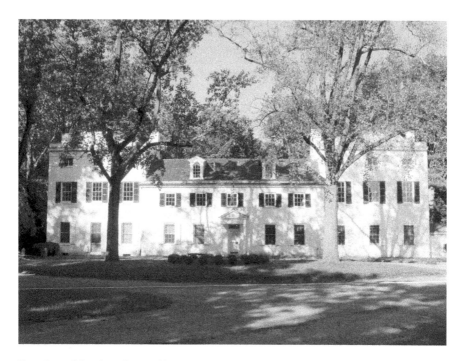

Strawberry Mansion. *Courtesy Tyson Gardner.*

Lewis was also the author of a small book, *Black Acts,* printed in 1800 by J. Amiston of Philadelphia, which documented the legislative acts concerning the abolition of slavery that he introduced to the General Assembly of Pennsylvania.

Sarah Dickson Lowrie wrote in *Strawberry Mansion: The House of Many Masters* that Lewis disliked concessions and that he wore knee breeches and kept his hair in a queue and powdered. This marked "his lasting protest against the violence of the French Revolution, and his ineradicable distrust of the French."

A compulsive smoker, Judge Lewis's discarded cigar butts dotted the ground around his person like an array of fallen seedlings. His critics said that it was outrageous the way he even desecrated his courtroom with his tobacco. His doctor, either Dr. Physick or Dr. Shippen or Dr. Rush, warned him that his excessive smoking—and, in fact, excessive drinking—would kill him presently. Even his friends deplored the tobacco habit; his wife found it unforgivable.

The Federal-style, two-and-a-half-story-high building during Lewis's tenure did not yet have the two Greek Revival wings that later came to

define the mansion. The wings, with their low-pitched gabled roofs, were added by the mansion's second inhabitant, Judge Joseph Hemphill (1770–1842), a judge of Philadelphia's District Court elected six times to Congress. Born in Thornbury Township, Pennsylvania, Hemphill graduated from the University of Pennsylvania in 1791 and began his law career in West Chester (then Turk's Head) in 1793. Hemphill used Strawberry Mansion as his summer home from 1821 until his death in 1842.

Lowrie wrote that during Hemphill's residency, "Talk raged there and wine flowed and the food was very abundant; the strawberries and cream, among half a dozen desserts, were greatly acclaimed."

Hemphill became a well-to-do man mostly because of his marriage to Margaret Coleman. The marriage enabled him to live in a large townhouse, and it also put him on the receiving end of a gift from Margaret's father, Robert, who purchased Somerton for the pair. The gift, as Lowrie suggested, "was a handsome investment for the future," especially since all the important families of wealth and "consequence" lived nearby.

"Hemphill," Lowrie wrote,

> lent an air to the local committees, partly because of his Southern friends in and out of Congress, and partly because he had a certain dash and manner which made it perfectly evident that he had traveled in Europe, was a friend of other well-known French notables, besides the Marquis de LaFayette, and in fact, had gone very far afield from his parent's farm in Chester County. There seemed nothing of the plain Quaker left in him. Scarcely any of the mere Philadelphia World Quaker either. As Robert Coleman's son-in-law, he had grown too to have very much the air of a sportsman, and by now was obviously quite the man about town, with a regency cut to his clothes, and the regency wave to his hair.

After Judge Hemphill's residency, the mansion became a dairy farm owned by the Grimes family. Misguided legends have it that the estate began to be called Strawberry Mansion at this time, presumably because of strawberry crops, but the truth is that the estate was known as Strawberry Mansion during Judge Hemphill's time, probably because William Penn himself titled the area Strawberry Hill in his seventeenth-century maps. After the Grimes family left, the mansion became a multipurpose structure. Elizabeth Sloane noted in her article "Strawberry Mansion—from Mansion to Ruins and Back Again" that "beginning in 1867, the building was used for a variety of purposes. Some of these

uses included an Italian restaurant, a 'sailors' rendezvous,' a rumored-of speakeasy, and a beer garden....Then the house fell into disrepair and social 'disgrace.' The city threatened to tear down the building, but Strawberry Mansion found a savior. The Committee of 1926, a group of women dedicated to preserving colonial life history, took on the project of restoring the building. They opened the mansion to the public as a historic house museum in 1931."

The building's brief tenure as a restaurant attracted international notables such as novelist Henry James. With a spectacular location atop cliffs rising above the Schuylkill River, the mansion's grounds were also an ideal picnic spot.

Today, the house stands as one of the city's crown jewels, thanks to a recent $2 million renovation. Tour groups regularly meet there, and the house is also rented out for banquets, wedding receptions and the like.

Not far from the mansion is the Dell Music Center, an impressive 5,284-reserved-seat outdoor amphitheater that some say is the best amphitheater in the country. The Dell has experienced its own growth odyssey. In 2007, the concert venue was closed, but adequate funding saved the day and led to its rehabilitation and reopening in 2010. Along with the Dell's seating capacity, its lawn can also seat 600 concertgoers.

As with every big concert or sports venue, you will also find a large number of tailgaters. There's nothing wrong with a good tailgate party. Tailgate parties are a big sports tradition, most notably near the stadiums in South Philly. There are many varieties of tailgate parties, including those with fully stocked bars in car trunks where the participants don seersucker suits, white straw hats and bow ties. These are Radnor Hunt and Devon Horse Show tailgating parties. Unfortunately, much of the tailgating that goes on outside the Dell during concerts has become rather trashy.

Pretend for a moment that you are part of a wedding party, celebrating on the lawn of historic Strawberry Mansion. It's an evening wedding, and the sun is beginning to set. A little earlier in the evening, you and fellow wedding guests noticed the rows of cars and SUVs parking illegally all over the mansion lawn. You probably guessed that the rogue parked cars have something to do with the music coming from the Dell. Since you have already gotten a little used to the loud music and have all but given up on trying to hear the violin trio that the bride's father hired for the occasion, you're okay with the cars. You realize that you have to make some concessions in the big city. Like it or not, in a city, loudspeaker-style, surround-sound music seems to rule.

After a while, you notice the bride's parents trying to maintain brave, tolerant smiles as more and more cars drive up alongside the mansion's lawn, parking anywhere they please after leaving huge track marks on the grass. Although there are barricades and yellow tape prohibiting rogue vehicles from entering the mansion's property, people are getting out of their cars, moving the barricades and cutting the yellow tape so that they can park wherever they please.

You join the bride's parents and watch as more people drive sloppily over shrubs, sometimes backing into flower beds. The mansion house manager looks at the scene with a growing sense of alarm. He knows that historic Strawberry Mansion, the largest of the historic Fairmount Park houses, has just been through an extensive restoration. This has made the mansion a major tourist spot, but now it is being ruined by bellicose tailgaters.

You are chatting with friends when you see figures moving along the edge of the lawn. One of the figures crouches down in a bathroom position and—you can hardly believe your eyes—defecates on the grass. A moment later, another person follows suit.

"Where are the police?" someone in the wedding party asks. Isn't running over flowerbeds and removing barricades an offense of some sort?

You try to forget the scene for a moment and head into the house, where things are a little quieter. You down a cocktail or two, and then you hear a loud *thump*. No, it is not a Dell drum concert sequel from Chaka Khan, Boney James, Jeff Bradshaw or Monifah. Instead, it is a car-colliding-with-something *thump*. You go outside and have a look around and see that a car has actually backed into a fire hydrant, upending it and pulling it out of the ground. At this point, the wedding party has become a little like a freak show. More tailgaters are piling in; there's a rush as if a dam has burst.

The house manager tells a few of the guests that the scene they are witnessing has been a problem at Strawberry Mansion for years, but no matter what they do—write letters, make telephone calls—the mansion's complaints go unanswered by City of Philadelphia officials. This doesn't make sense to anybody connected with the mansion; with all the tailgaters, the Dell is losing parking money. At the same time, the property of the city's largest historic house is slowly being ruined. The wedding guests then notice that the tailgaters are setting up cook ranges, tents and pieces of outdoor furniture on mansion property. BBQ smoke begins to rise over the tree tops as slabs of meat are piled on the grills. Picnic baskets appear.

The wedding guests spot another public exhibitionist, but the shock isn't so great this time—proving novelist William Burroughs's observation correct:

human beings can get used to anything. Still, the wedding guests wonder why the tailgaters can't be more discreet. Why not hide behind a tree? Why the blatant show-and-tell? By this time, every wedding guest knows that the tailgaters are not paying Dell customers at all, and of course it bothers them that there are no provisions for bathrooms or garbage collection.

Sadly, the mansion bears the cost of its own grounds keeping, including making repairs to damages caused by tailgaters. This includes repairs to damaged infrastructure and planting new grass where the cars have driven. Walk around the mansion lawn after a Dell concert and you'll see some shocking sights, such as tampons and diapers in the grass. You'll also find beer bottles, chicken bones and a variety of Styrofoam food containers.

Historic Strawberry Mansion is not the only historic house museum affected by these Dell tailgaters. One mansion official called the situation "lawless" and asked why no police are present to hand out tickets or prohibit illegal parking during concerts. He's right. If the Dell parking lot is too small and insufficient to handle the huge crowds that make it such a popular concert venue, then why not build a multi-level deck over the present parking lot—especially if the Dell is making profits? If the construction of a deck is against some obscure city code, why not grandfather it in? Barring this, how about just hiring parking regulators?

Historic Strawberry Mansion has already petitioned the city to make these changes, but the questions remain: Will the city listen this time? How long will it take before the changes are made?

A Trek to Mount Pleasant

The year is 1797. Somewhere on Spruce Street in a tiny rented room sits an ailing seventy-five-year-old man. The roomer has a nurse who comes to visit him during the day because his condition is not good. Outside his window, the man can hear the bustling sounds of the new republic, although it's impossible to know if the robust voices he hears in the streets offer him any consolation.

Who is this roomer who lives like an abandoned castaway? Is he a debauched derelict who wasted his life in intoxicating pleasures at the expense of career and family? Or is he someone on the receiving end of karma, as so many people alive today like to say about people who seem to bring about their own demise?

The nurse who cares for the man knows his history. No doubt she spends plenty of time listening to his stories and offering her condolences whenever appropriate. "Why did a city you did so much for turn its back on you? Why is Philadelphia ignoring one of its greatest sons?" I can hear her asking.

Imagine the deplorable confinement of living in a rented room in the house of the widow of one of your former business partners. Such is the case with our penniless roomer. He is completely dependent on the financial kindness (charity) of the Carpenters' Company. Only God knows that when he turns seventy-six years old, he will be dead, and the Carpenters' Company will pay all his funeral expenses.

Day in and day out, the nurse listens as roomer Thomas Nevell recounts his life as an architect. He tells her how he designed one of Philadelphia's greatest mansions, Mount Pleasant, a house that so impressed John Adams that when he visited Mount Pleasant in 1775, Adams said it was "the most elegant seat in Pennsylvania." Mount Pleasant, with its classical design, brick quoins and exquisite interior woodwork, was designed by Nevell for Scottish sea captain John Macpherson (1726–1792), who lost one arm during his high seas buccaneer days.

The Georgian-style house, with Italian Renaissance accents like Venetian windows and rusticated entrances, sits on one of the cliffs overlooking the Schuylkill River. What's unusual about Mount Pleasant are the two outbuildings that flank the primary house. This must have been a fascinating panorama when Mount Pleasant sat on 150 acres of fields, pastures and orchards.

As one of Philadelphia's most famous historic homes, Mount Pleasant's main claim to fame was that in 1779, Benedict Arnold purchased it as a wedding gift for his new wife, Peggy Shippen. A beautiful woman despite her mercurial and manipulative tendencies, Shippen was the daughter of one of Nevell's former clients. The Arnolds never actually lived in Mount Pleasant because Benedict was appointed to a military post at West Point immediately after the purchase.

Mount Pleasant had several owners in the 1780s. Jonathan Williams, the first superintendent of West Point and a descendent of Benjamin Franklin's, lived in the house with his family for twenty years. After his death, his children sold the mansion to Fairmount Park. The mansion then fell into a variety of public uses.

At one point, it was a dairy farm and then a beer garden. It wasn't until 1926 that the mansion was restored, thanks mainly to Sidney Fiske Kimball, a Massachusetts native who later became the first director of

the Pennsylvania Museum of Art (later the Philadelphia Museum of Art). Kimball was known as a brusque and bullish man, but he was able to get things done. A colleague, Carl Zigrosser, wrote a description of Kimball in 1975 for a *World of Art and Museums*:

> *Kimball had a commanding, almost formidable, physical presence, a height of over six feet, with ample girth, created, as he used to say, by his wife's Marie's good cooking. There was a touch of gaucherie in the movement of his bulk; he often reminded one of a bull in a china shop. His most formidable feature, however, was his cannonball head with its roundness emphasized by the shortness of his haircut. From it emanated persuasive ideas and an undeviating purpose.*

As for Nevell and his probable conversations with his nurse, no doubt he talked about his childhood and how he, as one of Philadelphia's most famous personalities, fell from grace.

That saga began with his birth in 1721 as an only child who was later orphaned at age nine. Then there would be the story of how he was sent off to foster families until he was finally apprenticed to architect Edward Whooley. This stroke of good fortune would keep him by Whooley's side during the latter's twenty-year-project designing and building the Pennsylvania Statehouse, the largest building in colonial America at that time.

Nevell would go on to tell the nurse that he grew up to become a fairly well-known architect and carpenter. Success was his in 1781 when he was awarded the contract to design and construct a new roof and steeple for Independence Hall. The plum job put him on the list of eighteenth-century people to watch. Life was good for the little orphan, who was also creating gun carriages and coffins for clients while his reputation as "an ingenious house carpenter" grew. At this time Nevell had no money issues. He lived in a simple yet formidable house at Fourth and Pine Streets. He even rose to the top of his profession and made enough money to become the second-largest donor for the building of Carpenters' Hall. In 1771, he founded the nation's first architectural school. That's when he and his business partner, John Lort, built a two-story wooden classroom behind his Fourth Street house. An ad for the school appeared in the *Pennsylvania Gazette*, the biggest newspaper in the colonies:

> *Whereas I have been requested by sundry persons, anxious to improve themselves in the art of architecture, to undertake the teaching so necessary*

a mystery as the carpenters' business, I will take upon me to instruct a small number of youth or others.

He would tell the nurse how life changed for him in 1773, when the British imposed heavy taxes on tea. In the city of Boston, the tea tax led to the Boston Tea Party, in which colonists dumped boxes of imported English tea into the bay. Philadelphia's reaction to the new taxes was not so dramatic, but it was significant enough to get Nevell to walk away from architecture and devote himself to the Revolution. He closed his architectural night school and was soon under contract from the Continental army and navy to make gun carriages. He was put in charge of the construction of underwater river defenses, called "chevaux-de-frise," and within a year's time, he went from being a private to a lieutenant colonel of the Philadelphia Artillery Battalion.

We can imagine Nevell's nurse fidgeting in her chair and drumming up the courage to ask the ailing architect about the Imperial-style arch he designed that spanned Sixth and Market Streets. The arch was an exercise in Roman Empire pomposity, and it was also built to celebrate the end of the Revolutionary War and the formation of the United States of America.

The grand arch enticed none other than Charles Willson Peale to decorate it after covering the whole thing in canvas before illuminating it in candlelight. As Carl G. Karsch wrote in *History.Org*, "A spectacular result was predictable. Fire turned the arch into a blazing torch, igniting fireworks including rockets in an explosive grand finale to the Revolution."

But an even more daring question from the nurse is how our hero architect met the "Black Widow Spider," or Mrs. Weed, a woman who had a house at Front and Arch Streets where she lived with her teenage son, George. Who knows what Nevell was thinking when he gave his heart and married Mrs. Weed, widowed three times (it was his second marriage), and then allowed his new wife to keep the terms that put her house in trust for George when he turned twenty-one, this despite the fact that Nevell had already paid all the taxes on the property.

Love may be blind, but when it leads one into poverty and personal disarray, it becomes the kind of love that should be shelved like aged lima beans.

When Mrs. Nevell (née Weed) died in 1790, the full brunt of Nevell's mistake came back to haunt him, as twentysomething George opted to live alone, meaning that Nevell had to find another place to live. Misfortune

struck again when the City of Philadelphia failed to renew Nevell's contract as a "street regulator."

"Mrs. Weed's very name should have been a warning to you!" I can hear the kindly nurse saying to Nevell, now asleep in his chair, his mind at rest but the frown on his face indicating that the poison from the poisonous widow had thoroughly done its job.

Philadelphia's Fairmount Park is a vast treasure encompassing some 4,076 acres. Started in 1812 as a much smaller tract of land—a mere 5 acres called Faire Mount, the present-day site of the Philadelphia Museum of Art—the park's immense trajectory covers neighborhoods as different as City Line Avenue, Germantown, Roxborough and Chestnut Hill.

Woodford Mansion was built by American Patriot, merchant and later provincial justice of the Pennsylvania Supreme Court William Coleman as a summer house for him and his wife, Hannah. The one-and-a-half-story red brick structure, which includes a servants' house and a stable, was built in the spacious Georgian Palladian style on twelve acres of land. In Woodford, William and Hannah raised their orphaned nephew, George Clymen.

Ben Franklin said of Coleman, "He has the coolest, clearest head, the best heart, and the exactest morals of almost any man I ever met."

After Coleman's death in 1769, the mansion was sold to Alexander Barclay, and after Barclay's death in 1771, it entered its most interesting phase when it was purchased by David Franks (1729–1793), an agent for Great Britain and a Loyalist to the Crown. Philadelphia in the 1770s had a large Loyalist population. Historian John C. Bogle wrote in *Reflections from a Philadelphia Physician*:

> *The American population at this time has been described as one-third rebel, one-third Tory, and one-third trying to hunker down and try to see who would win. Many of the seriously committed Tories had fled from Philadelphia when the rebels took charge, while pacifist Quakers were a little hard to classify. Generally speaking, the prosperous merchant class had never been persuaded King George was all that bad, while the less prosperous artisans were the fervent patriots. Under such conditions, many people who privately leaned in either direction found it was best to seem non-committal. The British were billeted in private homes, the Officers in the best houses of the merchant class, the common soldiers generally housed in the homes of the artisans. Although the soldiers and the artisans did not mix very well, circumstances permitted the aristocratic officers getting on pretty well with the merchants whose houses they occupied.*

Franks, who loved to entertain British officers, built Woodford's second floor and its rear two-story addition. The Jewish merchant, who had married into a Christian family, had four children, the youngest of whom was a daughter who attracted the attention of British General Howe. But Franks, like all Loyalists, was living on borrowed time, and in 1778, Benedict Arnold was ordered by Congress to arrest Franks. Franks and his family were ordered to leave the country.

Woodford was sold to Thomas Paschall in 1781 as part of an arrangement to settle a debt when Franks was forced to leave the country. Paschall never lived in the mansion but instead became its first landlord. In 1793, the mansion passed into the hands of Isaac Wharton, who used it as a summer house until the end of the Civil War. Woodford was sold to the City of Philadelphia in 1888 and shortly afterward became a police station and the main headquarters for the Fairmount Park Guard.

In 1927, the mansion was selected as the ideal place to house Naomi Wood's unique collection of colonial-era antiques. Wood, a Philadelphia socialite, had the benefit of family funds so that she could amass an enormous collection of colonial household gear, which later became the Naomi Wood Trust after her death in 1926. This trust signed a long-term lease with the City of Philadelphia and provided the funds for the restoration of the mansion into a house museum, which opened in 1930.

THE STEPHEN GIRARD HOUSE

While the City of Philadelphia may honor Stephen Girard, the founder of Girard College and the primary financier of the War of 1812, not much is known about his wife, Mary Lum Girard. Who was Mary Lum, and why has her name been undersold in a city that purports to honor its historic figures?

A clue can be found on the first floor of Pennsylvania Hospital. A large plaque honoring Stephen Girard's contributions to the hospital also mentions that his wife, Mary Lum, lies buried somewhere near this spot. Plaques of this size and stature don't usually tell lies, and if Mary Lum is buried somewhere on the grounds of the hospital, where is she and why isn't her grave noted?

These questions irked federal government Signal Corps retiree Joe Vendetti for almost twenty-five years. Mr. Vendetti traced his interest to Mary Lum to his friendship with Girard College grads Charlie Roseman

and Colonel Bob Ross, two World War II–era pals of his who spent a lot of time talking about their college days. "When I retired in 1973, I took up research about Stephen Girard, and I thought, 'Oh my God. Stephen Girard's wife has been forgotten and ignored.'"

Biographies of Stephen Girard indicate that during Mary Lum's marriage to Mr. Girard, she was committed to a mental ward in Pennsylvania Hospital (in 1790) until her death in 1825. Because of Mary Lum's special status as the wife of Stephen Girard, she was permitted to have a series of rooms and a parlor on the hospital's first floor. Other patients had a much harder time of it, as they lived in what Dr. Benjamin Rush (who was responsible for committing Mary Lum) described as rooms that were damp in the winter, hot in the summer, lacking in ventilation and a bit malodorous. Mary Lum's status as a mental patient no doubt had everything to do with the fact that she is buried in an unmarked grave somewhere on hospital grounds. But for Joe Vendetti's 1939 classmates, an unmarked grave was hardly acceptable, so they purchased a tombstone for Mary Lum and donated it to the hospital.

Mr. Vendetti said that the first gift of a tombstone, which occurred some twenty years ago, was not accepted by the hospital. He noted that Girard College wasn't all that eager to help with the tombstone project either. A shadow of embarrassment and shame seemed to cover Mary Lum's legacy, proving that the stigma of mental illness, while far worse in the nineteenth century, still carried considerable weight in modern times.

Mr. Vendetti's crusade to get the hospital to accept the tombstone included solitary street demonstrations during which he'd stand on the sidewalk outside the hospital wearing a specially printed T-shirt that asked why Pennsylvania Hospital wouldn't accept the tombstone. "The T-shirt led to some misunderstandings," Mr. Vendetti confessed good naturedly. "Some people came up and asked me why Pennsylvania Hospital was banning Tombstone pizza."

When asked about Mary Lum's commitment at the hospital as a patient, Stacey Peeples, curator and lead archivist at UPHS, said she was not permitted to discuss any patient. "Whatever you may find in another source [about whether Mary Lum was a patient here] is fine, but as a representative of the hospital, I am not permitted to discuss any patient information," Ms. Peeples said.

Ms. Peeples stated that she was not aware of a plaque indicating that Mary Lum was buried on hospital grounds; however, she asked that she be informed right away if such a plaque existed. For Mr. Vendetti, there was never any question of the plaque's existence. While the plaque in question

does not pinpoint the exact grave, it does state that Mary Lum Girard is "buried somewhere near here." No doubt "here" refers to the hospital, not a spot several blocks away or even as far away as Manayunk. It's easy to understand how a specific plaque could be overlooked, given the sheer numbers of plaques that adorn the hospital's historic hallways.

Ms. Peeples said that she was "not privy to any conversation" about the hospital's ever having rejected a tombstone for Mary Lum. "At the moment we are restoring the building, so until everything is completed with the restoration, we would not be able to accept anything. When the time comes, we can discuss a tombstone but at this moment we cannot," she added.

But Mr. Vendetti sees no reason why the hospital can't place Mary Lum's tombstone in the small courtyard beside the lone tombstone of Charles Nicholes, a hospital benefactor.

According to Mary Lum research scholar Dr. Marilyn Lambert, a former member of the Department of Education at La Salle University, that's where Mary Lum is most likely buried. Dr. Lambert researched the lectures of William Wagner (founder of the Wagner Institute of Science and a friend of Stephen Girard) and noted that Wagner witnessed the burial of Mary Lum in the Pennsylvania Hospital garden.

"Towards the close of the day," Mr. Wagner wrote, "after the sun had withdrawn his last beams from the tallest sycamore that shades the garden, Mr. Girard was sent for and when he arrived with all his family the plain coffin of Mary Girard was carried forward to her resting place in deepest silence."

So who was Mary Lum Girard? "If the biographies mention her at all, they mention her appearance, which was apparently stunning," said Dr. Lambert. "She was considerably younger than Stephen Girard. But there are no pictures or portraits of Mary, though Girard had a portrait done of his housekeeper. The descriptions of Mary were wonderful: there was her beauty and long black hair, she was also very sociable and friendly."

She was also not of Stephen Girard's class but rather a humble chambermaid. Girard, in fact, kept the fact of his marriage to her away from his family for a time, although they eventually came to admire the woman.

"Stephen and Mary had a happy period for a while in which they got along well. Then from 1785 to 1790 Stephen began to report in letters to his brother a kind of melancholy and change in her behavior. During this period she became hostile and violent. Stephen responded to these mood swings with whatever was available at the time," Dr. Lambert said. "He started with consulting a doctor who lived next door. Opium was tried. It was a

fairly standard treatment then. There was a place in upstate Pennsylvania that handled mentally ill people. Mary was sent there. Then Stephen sent her back to his Mount Holly, New Jersey home [built when Girard, who was French, wished to escape the British invasion of Philadelphia], where she lived with her mother. In each of these cases, when the treatment began, she was exhibiting violent behavior, but then she'd get well and Stephen would bring her back home."

Dr. Lambert admitted she originally thought that Mary's deterioration had more to do "with a rich guy trying to do away with his wife" than a mental illness. Then she spent more time going over Stephen Girard's meticulous records regarding his wife's decline. Dr. Lambert believes that Mary Lum was probably bipolar, and had she been alive today, she'd be on prescription pills and that would be that.

As for Mary Lum's tombstone, it rests on Dr. Lambert's property until permission is granted to move it to the grounds of Pennsylvania Hospital.

THE JOSEPH LEIDY JR. HOUSE

The neighborhood near Philadelphia's Thirteenth and Locust Streets in the late 1960s was a rustic patchwork of small pizza cafés, countercultural button and literature shops, a strip joint on the corner of Locust Street and luncheonette eateries like Dewey's and Robert's Deli. At the southeast corner of Broad and Locust Streets stood the remains of the Hotel Walton (later renamed the John Bartram Hotel), a dark, draconian-looking palace designed by Angus "Anxious" Wade, an artist who later became an architect. Opened in 1896, the ornate interior included Pompeian brick, vaulted ceilings, symmetrical stairs and Elizabethan strapped-pattern ceilings. The hotel was demolished in 1966.

The area is also home to Camac Street, or "the Little Street of Clubs," with its fine array of two-story nineteenth-structures that house some of the most artistic and Bohemian clubs in the city. Often referred to as "Egg Head Row," on this one-block radius between Walnut and Locust Streets you'll find the Sketch Club, the nation's oldest artists club; the Plastic Club, the nation's oldest arts club for women; and the Franklin Inn Club, founded in 1902 but located on Camac Street since 1907. The Franklin Inn Club was originally founded as a meeting place for literary artists and journalists with the intent to promote the city's literary scene.

In 1966, a prominent new building in the area was the new Library Company of Philadelphia building at 1314 Locust Street. This pleasant-looking "soft Modernist" structure blended well with the streetscape. Facing the Library Company on the other side of the street were the Poor Richard Club and the club's adjoining Charles Morris Price School of Journalism and Advertising. The Poor Richard Club was a private club made up of professionals from the field of advertising. Its aim was to encourage (and even enforce) ethical guidelines in advertising and promote business and social relationships among its members.

Say the words "Poor Richard" and most people think of Ben Franklin. While the club was named after the imaginary "philomath" (or scholar) of Franklin's almanac, the club and school were not founded by Franklin. Some confusion still exists around this fact, probably because the name Poor Richard has such rich historical roots that people naturally assume that Franklin had a direct hand in its founding. A January 2011 obituary in the *Palm Beach Daily News*, for instance, noted that the town's vice-mayor, Leon Sol Zimmerman, "graduated from the Charles Morris Price School of Advertising, which was founded by Benjamin Franklin."

Philadelphia's Poor Richard Club was founded in 1906, one year after the establishment of a Poor Richard Club in New York. From a humble 75 members by 1911, membership climbed to 350. From an original clubhouse in a large Victorian house at 239–41 Camac Street, the club moved to 1319 Locust Street in 1925.

Old Philadelphia buildings generally live many lives. Before the amassed army of ad men in bow ties and spectacles laid claim to the Locust Street address, the Wilson Eyre Jr. Colonial Revival domestic single-dwelling building—with its armory-strong exterior of brick, sandstone and brownstone—was the home and office of Joseph Leidy Jr., MD. While there was no relation to noted paleontologist Joseph Leidy (1823–1891), who headed the Wagner Institute of Science of Philadelphia and was a professor of anatomy at the University of Pennsylvania, Liedy Jr. was a city doctor who probably worked on patients in rooms that later became the classrooms for the Price School.

Wilson Eyre Jr.'s Philadelphia projects include the University of Pennsylvania Museum, the Mask and Wig Clubhouse and the fountain at Logan Square. Noted for his country houses and Shingle-style residences, Eyre Jr., although born in Florence, Italy, began his architectural career in Philadelphia. He was president of the Philadelphia chapter of the AIA from 1897 to 1902.

The Joseph Leidy Jr. House was declared a National Historic Landmark in 1980, one year after it was sold. The Poor Richard Club folded a few years later, followed by the Charles Morris Price School.

Today, the building is the headquarters of the National Union of Hospital & Health Care Employees, District 1199C. While this name has a lackluster ring, the structure could have fared a lot worse: a Poor Richard's Urban Outfitters or a University of the Arts affiliate student dorm (with its antecedent "I burned the pork chops" false fire alarms) would have meant a renovated (i.e., destroyed) interior. Historic buildings that are forced to reinvent themselves in order to avoid the wrecking ball inevitably lose much if not all of their original identities. Most people passing what was once the Poor Richard Club today see it as just another old Philadelphia structure, although I have often heard it referred to as "an old church," "a small Masonic temple" or "that Locust Street Armory building."

News pertaining to life cycles of historic buildings cannot match the culture's major distractions in Hollywood and elsewhere. Scholars and the determined, of course, will always dig for history, but most people will not. Still, if there's such a thing as an ethereal depository of history, this means that the walls of the old Poor Richard Club are rich in archival memory.

In 1933, the club was crucial in the establishment of the Benjamin Franklin National Memorial. The club's Annual Gold Medal of Achievement was a national news event, beginning with award winners such as Amelia Earhart, Walt Disney (1934), Will Rogers (1935), Henry Ford II (1954), Bob Hope (1945) and Clare Boothe Luce (1955). Even President William Taft spoke at the club's annual 1914 dinner, held at the Bellevue-Stratford Hotel.

THE CHARLES MORRIS PRICE SCHOOL

Price School students did not enter through the Poor Richard Club but had a separate side door entrance. A narrow Hitchcock-like staircase of not quite thirty-nine steps led to the foyer/office of the school registrar. A main classroom, with windows overlooking Locust Street, accommodated about fifty students. With courses like Writing for Magazines, Creative Selling, Public Relations, News Reporting, Marketing and Public Speaking, students in the late 1960s dressed in jacket and tie or professional business attire. Smoking was permitted in the classrooms—some students even brought their own ashtrays. Lunchtime was an hour to explore the

restaurants along the Thirteenth Street corridor or on nearby Broad Street, such as the Harvey House, with its signature plank steak, or steak served on a wooden board. A small bar at the corner of Thirteenth and Walnut, Alvin's Alley—famous for its dark oak interior, conversation and cheap draft—attracted many male students after class. Alvin's Alley was known as a newspaper reporter's bar long before the days of Pete Dexter and Dirty Frank's. Al's had a Glenn Ford film noir look. In fact, the stench of stale beer was scripted in its walls.

Price students came in two varieties: the advertising and marketing majors who wished to become business professionals and the writers or journalists who wanted to become reporters, magazine writers or novelists. The first group outnumbered the second, leaving the latter wondering if they were even in the right school. Because the Price School was a professional "graduate" school, the ages of students ranged from eighteen to fifty.

Famous Price teachers at the time included the bespectacled and very bald Mr. Seltz, who could quote Dale Carnegie while standing on his head and who often peeled apples at his desk with a silver knife; the unflappable, Irish, reserved and always well-dressed Margaret Mary Kearney; Betty Bramble, the school secretary; and W. Dayton Sumner, an editor at *Atlantic* magazine. Then there was Dean Kaplan, as tall as a California redwood tree and who with his with his owl-shaped tortoise shell glasses looked like he belonged in a *New Yorker* cartoon.

The Historic Morris House

In Philadelphia's Morris House at 225 South Eighth Street, I extend my hand to Julie Morris Disston, whom I am meeting for the first time. The quick handshake connects me to one of Philadelphia's oldest families, the Anthony Morrises, a line going back to 1685, when Anthony Morris was mayor of the city.

But Anthony was only one notable in the Morris family gene pool. Later, there was Captain Samuel Morris, who fought in the Revolution, and then the captain's son, Luke Wistar, who became a manufacturer. For most legacy families, this would have been enough, but the Morrises, like the growing plant wisteria (named after Luke), just keep going.

Julie, who sits with me at a large table in the dining room of the Morris House Hotel, is reflecting on the house that has been in the Morris

family for seven generations. The hotel guests in the other room enjoying morning coffee and muffins strain to hear what Julie is saying about what has changed in the house since she left it as a girl in 1932, the year the family left the home forever.

In the dining room, for instance, where trays of edibles are displayed for guests, Julie gestures toward the fireplace and informs me that there used to be bookshelves on either side of it. She informs me that the portrait above the fireplace is not the same portrait that hung there when she was a child. She offers another twist: the current sitting room where the guests gather was once the real dining room, while the room where we are talking was the original sitting room. "It was very cozy in here then," she tells me, "especially with the bookshelves and a big chunk of cattle coal burned in the fireplace."

Philadelphia was a different city then. You could hail a cab without being killed or ride in a cab without being pulled out of the cab and into the street, although times were tough in a different way. During the Revolution, a musket fired by the British managed to shoot holes in the pendulum of the William Ericke clock that still stands in the first-floor hall of the Morris House.

Every age has its dangers, of course, but for young Julie Morris, childhood held a degree of protection. Growing up in the house, she and her older brother, Bucky, would be escorted to school every morning by English and German governesses.

Julie went to an exclusive French-speaking school on the second floor of a house on the southeast corner of Rittenhouse Square. "We had two rooms up a flight of stairs; there were 21 of us of various ages up there speaking French," she remembered. "As children we would walk up Walnut Street past the costume designers for the theater. My brother went to Haverford Friends, and we would walk to the old Broad Street Station when it was steam engines, and we'd put him on the train and then walk to Rittenhouse Square....They [the governesses] walked for miles and miles. They would walk us and walk us everywhere."

Her grandfather Effingham B. Morris (1856–1937), president of the Girard Trust Company for forty-one years as well as a onetime director of the Pennsylvania Railroad, was a noted financier and civic leader. Her father, Effingham B. Jr., a lawyer who went into banking, married Julia Peabody Lewis, who died in 1938 at age forty-seven when, according to *TIME* magazine, "a horse she was riding caught its knees on a fence in mid-jump [and] somersaulted into her."

Luke Wistar and his wife, Ann Pancoast Morris, were the first Morrises to live in the house. For those who can't keep their Morrises straight, there can be some confusion with Robert Morris, signer of the Declaration of Independence and the U.S. Constitution. While there's no relation between the two families, the Morris House bears a special relation to the first White House built at Sixth and Market by Robert Morris, who later handed it over to Washington and Jefferson in 1790 when Philadelphia, for a short ten years, became the capital of the nation.

The first White House, which was demolished in 1832, was a mirror image of the Morris House, the only noticeable difference being "in the number of dormers, the number of entrance steps and the treatment of window heads," according to a 1950 pamphlet entitled *The Morris House* published by Ayer Publishing.

Today, the Morris House can properly be called the real President's House, as opposed to the modernist Septa subway stop design posing as a President's House, with its video enactment displays and minimalist references that, ironically, do not even mention Robert Morris.

"They tell me there are more Morrises in England than there are Joneses or Smiths," Julie tells me with characteristic good humor.

What was life like here? During a guided tour of the upstairs rooms, which are now all handsomely decorated hotel suites, Julie tells me where the nursery used to be. As we enter the room, she lets out an audible sigh. "My, oh my, what they've done to this room—beautiful!" she says, pointing to a bathroom that decades ago was a closet. The nursery was where Julie and Bucky were required to play; it is where Bucky kept his toy trains and where Julie (presumably) kept her dolls. "We played up here; nowhere else." When her parents had dinner parties, she and Bucky would dress up, go downstairs and entertain the adults with poetry readings: Julie would recite Joyce Kilmer's "Trees," and Bucky would recite Kipling's poem "If—." Afterward, they would both be escorted back upstairs.

"I had a dog at home," Julie tells me, "because we had a big enough yard to have pets. It was very much like everybody's growing up. Most of the little girls at the French School were the daughters of doctors at Pennsylvania Hospital who lived a couple streets over. Two French ladies who ran the school didn't permit you to speak a word of English—you had math in French, history in French; everything was in French."

Recess at the school meant roller skating in Rittenhouse Square. Skating past the wading pool had been a tradition for children since 1914, when

roller skating for boys up to the age of ten and girls up to the age of fourteen was officially approved by the chief of the Bureau of City Property. Marion Willis Martin Rivinus, author of *The Story of Rittenhouse Square*, noted that child skaters in the Square were approved about the same time that Rodman Wanamaker "presented two benches which he had imported from France." Then as now, there were problems with vandalism in the Square. In 1914, the chief concerns were the marking and defacing of railings and complaints about public spitting.

Walks around the city and other playtime activities in Julie's world were structured affairs. In the immediate neighborhood, she told me that the governesses would walk them "solemnly" around Washington Square (where you could not roller skate because there were flagstones), into Independence Square and finally down along the Delaware River, which in those days she remembers as being filled with "big, big ships."

At ninety, Julie still retains elements of her youthful country girl looks, an athletic "can do" persona that, combined with her seasoned optimism, produces the impression of someone who is ageless. It's no shock, for instance, that her favorite words seem to be *fun* and *terrific*. She still refers to her grandfather as "the man who built Girard Bank, and who stayed there forever." Ask her about her father's switch from lawyering to banking, and she'll tell you, "Banking to me is wonderful, but it's not as much fun as being a lawyer."

When Julie asked if I'd like a tour of the house, I got the distinct impression that this was her first walk-through in years, perhaps even since 1932.

"Grandfather was scared of fire," she says, beginning another story. "Evidently fires then used to happen through the attics, and it would get going and that would be the end of it." To protect his family, and the house, Grandfather Morris bought the houses on either side and then had them demolished.

Inside her brother's old room, she recalls Bucky's "great big sleigh bed, a big double bed," as well as the hallway (now replaced by a bathroom) that used to take her into her own room. "That door wasn't there but that one was!" she adds suddenly, as if remembering something profound.

When we come to the attic, excitement is evident in her voice. "The ghosts were up there," she says. "There was creaking and all kinds of noises. There were very definitely ghosts on the third floor, and there was always a stairway that could come down. I never went up there alone; someone was always with me. It was very dark and it has some windows, but it runs all the way back over my old room."

We stop on the stairway landing so that she can look out the window. "That looks familiar," she says, pointing to an old house standing alone among a sprawling Pennsylvania Hospital addition. "I remember looking at that house as a girl." She reminds me that the woodwork is all original, the venerable railings like dense material pathways straight into the eighteenth century when Jefferson, Washington or Franklin, while stepping up or down the Morris House stairs, applied his hands to these same railings for support.

Images of the Founding Fathers climbing stairs reminds me of what Washington said of the first President's House, the one owned by Robert Morris, as being "the best single home in the city." If Washington could come back, he would feel right at home here.

Life for the Morris family changed when work began on the N.W. Ayer building, later known as an Art Deco masterpiece but in 1920 regarded as a hazardous construction site, especially for the two Morris children, who were told they couldn't play in the backyard anymore. "The builders used to drop ribbons down into our garden, and Mother was kind of nervous—that's one reason I think she was ready to move," Julie said. When the Morrises left, the builder of N.W. Ayer bought the Morris House and began renovations. "He put steel girders under the house; it was sitting on brick, the old way of building, and the whole thing would have shaken down had he not done that, but after Harry it went through many owners."

From Philadelphia, the family moved to a farm in Whitemarsh Township that Julie's father had bought in the spring of 1929. Named the Silver Springs Farm, it was Effingham Jr.'s version of Effingham Sr.'s farm to end all farms, Bolton Farm in Bristol—"a beautiful thing," Julie describes, "that had everything: horses, Angus cattle, pigs, chickens and a pony with a cart." At Silver Springs, she learned the hard work of farming, in time getting to know a friend of Bucky's, a guy named Bill Disston (from the famous family who founded the Disston Saw Works), who would gradually come around to regard her as not just Bill's little sister but as someone "to watch."

"I met Bill out hunting on a horse," Julie recalls. "So I had to do some fast riding to catch up with him." They married in 1942 when Julie was twenty. World War II was at full tilt, and young Disston had just transferred from the First City Troop, which had just been federalized, to the Army Air Corps. "He didn't want to go into the mechanized cavalry, so after the transfer we went to the south after the wedding and he went through training." From Columbia, South Carolina, Disston was sent overseas and assigned to a bomber in Corsica, where he flew over the Brenner Pass

seventy-seven times and survived, no small feat when most bombers then went down in flames.

After South Carolina, the couple lived in Florida for ten years and then moved to California for sixteen years. They raised three boys. "They are all married; they have eight children between them. There are eight more great-grands down the way, so it's just wonderful," Julie adds.

Bill Disston died many years ago.

Near the time of this interview, Julie's family was preparing to throw her a ninetieth birthday party in which the portraits of Luke Wistar Morris and Ann Pancoast Morris that used to hang over the fireplace in the former sitting room during the early nineteenth century would be unveiled as gifts and restored to their proper place, both portraits having been lost for years and then serendipitously discovered at a Freeman's house auction by none other than the current owners of the house, Eugene Lefevre and Deborah Boardman.

The idea to restore the portraits to their rightful place on Julie's ninetieth birthday was yet another exciting chapter in the long history of the house. When I asked Julie if she knew about "a secret unveiling of some found portraits," she said she did not, so I decided to let the matter rest.

THE HOUSE THAT LEFEVRE BUILT

The man behind the purchase of the portraits of Luke Wistar and Ann Pancoast Morris on occasion of Julie's ninetieth birthday is Eugene B. Lefevre, owner of the Morris House Hotel and *M* restaurant. In France, the name Lefevre is comparable to the name Smith or Jones in the States. Eugene calls himself Gene and says he had his fifteen minutes of fame when he and business partner Michael DiPaolo saved the Lit Brothers building from destruction.

"I was president of Growth Properties then, and Michael and I were just dumb kids," he told me. "We had done a bunch of stuff in Old City and noticed that the people who bought Lit Brothers were trying to turn it into suburban office space. But when you do renovations of historic buildings, you have to go in the grain, rather than against it. It wasn't working for the owner, so he gave up and started to tear it down."

When that happened, the city exploded in protest. "The owner was the bad man in Philly at that point," Gene said, "so we bought the thing with a little bit of money and a lot of financing."

Finding a tenant was difficult, but then in came the Mellon Independence Center and Lefevre and DiPaolo were declared municipal heroes. *Philadelphia Magazine* awarded Lefevre its 1989 "Developer to Watch Out For" Award in its "Best of Philly" issue. "I liken that to being on the cover of *Sports Illustrated*," Gene said in total seriousness before delivering a surprise salvo. "But within a year, I was insolvent. *Philadelphia Magazine* didn't want to do a follow-up because being noted like that is a curse. I called the guy who nominated me and I said, 'You've ruined my life!'"

Gene said that he didn't like the limelight anyway, despite the fact that Ed Bacon had become his friend on the radio interview circuit. "The Morris House had been on the market for a while from a pension fund that had foreclosed on it," Gene said. "DiPaolo and I made a couple of offers on it, and eventually they sold it to us. After the Morris family moved out, it was sold to a woman named Gee Elliot, a wonderful grande dame of a woman whose husband was a neurosurgeon at Pennsylvania Hospital. They then sold it to another person who turned it into office space."

That was O'Brien Energy, a co-generation company that Gene says was a big thing for investors at the time. "He raised a lot of money, spent it on cars, this building and a bunch of other things and then went broke, causing the people at the finance company to take it back." While O'Brien Energy owned the building, little carving scars on the historic wooden floorboards were being executed by various styles of women's high heels—whether they were stiletto gashes or sensible shoe gashes is anybody's guess, but the heels dug in with the same sort of might as the British bullets that hit the pendulum on Julie's grandmother clock.

When Lefevre and DiPaolo bought the building from the finance company, it was love at first sight. "Once we bought it, we kept looking at it and looking at it, and since our business is to try to add value to buildings and then keep them or sell, we turned this into a hotel."

The first challenge was to install what Gene called "fine grain" bathrooms where there hadn't been bathrooms. Then they installed a hidden sprinkler system and new heating and air conditioning. Most of the building's woodwork and plaster was restored. As a preservation architect and a member of the Preservation Alliance, Gene said that he knew what he had to do when it came to retaining the form and shape of all the rooms.

O'Brien Energy's one positive legacy was the addition of a porte-cochère with pediment and big Georgian columns on the north side of the building. "It's a grand entranceway for a hotel to what once had been a modest Quaker house," Gene said. Yet making the hotel safe for guests meant slicing

the house in half in order to create two zones that were distinctly separate for fire purposes, as well as putting in a second staircase and renovating the backyard, which had been all grass sans the lone path that Julie remembered being there when she was a child.

The three separate buildings on the site, Gene said, include the carriage house, which had been a garage. The carriage house includes three suites, or one-bedroom apartments. There is a total of fifteen guestrooms in the Morris House Hotel; *M* restaurant seats fifty.

The complicated process of renovating a historic house sometimes brings good fortune. In Gene's case, he found a major surprise in the wall near the grand entranceway created by O'Brien Energy. In what had been the kitchen of the original colonial house but what is now the foyer and reception area was a rather large bump visible underneath the drywall. Gene kicked it open one day and found an old fireplace complete with a rack and two large copper pots. Today, this fireplace is a central feature of the Morris Hotel.

Attics, of course, carry their own mystique. "The attic was basically a low space, a place you could barely walk around in. It must have been perfect for a kid; it's scaled for a kid. A couple dormers light it. We ended up putting all the AC and ductwork that serves all the rooms up there," Gene told me, adding that when one of the pumpkin pine floorboards in the house needs replacement, they are retrieved from the attic.

I first met Gene when the hotel's *M* restaurant hosted a private menu tasting event to introduce its new Italian chef, Aaron Bellizzi. The three-hour hors d'oeuvres and cocktail party was also a celebration of the restaurant's solvency, thanks mainly to Gene's wife, Deborah, who single-handedly ended a cycle of sloppy kitchen management and, in some cases, poor hires. "Gene," Deborah told me later, "is a humble, self-effacing man. He does not have a towering ego."

A former ballet dancer and a well-known city head shot photographer with her own studio not far from the Morris, Deborah met Gene while in the middle of changing careers. Getting *M* restaurant off the ground was a struggle, though. "When we opened two years ago, we started off with a chef friend of mine, an old family friend," Gene said. "Then we hired a chef whose girlfriend worked as our manager. When their relationship went sour, it made things a little crazy; she left, and then he left. As for our current chef, his girlfriend does *not* work here!" Gene said, in no way attempting to stifle a laugh that not too long ago was probably closer to tears. "But today we feel like we've crossed some kind of threshold, where the whole team between the hotel and restaurant is working like clockwork."

"We are a boutique hotel," he continued, "and very popular with academics and Europeans. Europeans prefer small hotels when they come to the United States. But small boutique hotels couldn't exist without the Internet. Years ago, unless you had what they called a 'flag,' or a name which you had to pay for on an annual basis, you couldn't have a hotel. The only way you got people to come to your hotel was to be a network of Hiltons or Holiday Inns or Comfort Inns. When the Internet came, you didn't need that anymore. People can find your hotel by going on sites like 'really-cool-hotels.com.'"

Gene actually prefers to call the Morris an inn "in the classic sense" because it is much more than a B&B. "Boutique," in the style of minimalist modern hotels like the Gault in Old Montreal (where there are no rugs because the heat comes up through the floors and where it can take fifteen minutes to discover how to turn on the lights) or Klaus K in Helsinki (a beautiful hotel but where the room furniture is made more for Cubist sculpture display purposes than for comfort), does not begin to describe the Morris's uniqueness. "We are definitely not the Hotel Gault," Gene said, letting out another patented laugh. "We're not that. If this was the '60s, we would be Earth shoes and macramé."

A self-described "reverse Carpetbagger," Gene's parents brought the family up from Florida when he was still a boy. "They think of us as sort of old Philadelphians because my father was the first Democratic member of the Union League. But when we got here, my parents asked, 'What are we supposed to do?'" They were told to enroll their kids in Episcopal Academy or the Agnes Irwin School and go to church at the Church of the Redeemer in Bryn Mawr and "you'll be fine."

At one point during my chat with Gene, Deborah joined us briefly while on her way to check the doings in the kitchen. We'd been talking about traveling in France, and I was telling Gene about my experiences in the George Sand House in Nohant, France, where visitors can touch and even play Chopin's piano or sit at Sand's dining room table.

"You know," Deborah said, "the Morris Hotel is reminiscent of driving along a little route in France and coming to a little French village, walking up to an ivy-covered building and noticing a Mom and Pop working in the garden. And you ask them where to have dinner, and they say, 'But of course, here!'"

Gene and Deborah seem to have incorporated this model as their life's theme. They told me about their country getaway, a 1755-built farm in Frenchtown that is older than the Morris House and located in the middle

of a field and woods, an isolated and beautiful spot where it is possible, Deborah added, "to grow as much as we can for the restaurant."

As for those stunning portraits of Luke Wistar and Ann Pancoast Morris that used to hang over the sitting room fireplace, when Gene discovered them at the annual Pennsylvania auction at Freeman's in 2010, he knew he had to act. "When they were cataloguing the portraits, they put estimated values on each item. It was estimated that the pictures would be $5,000 apiece. The Morris family were looking at the same thing but decided they didn't want to bid. I put in a lowball bid because I am a bottom-feeding creepy real estate developer."

The next day, Gene was informed that he got the portraits. "While the artist's name cannot be verified, they are attributed to 1817. Luke and Ann had seven children, four of which survived," he said.

When Gene took the portraits off the wall to let me have a look, the feeling was energizing, reminding me of Deborah's comment earlier that visiting the Morris garden was cheaper than therapy, causing many to ask, "Why do I feel so rejuvenated?"

That sense of rejuvenation certainly seemed to quicken Julie Morris Disston's steps when she showed me the garden and pointed to the top of the N.W. Ayer building as well as to another high-rise, the St. James, built a few years back yet situated at such an angle that it didn't block the sun in the Morris backyard.

"The Morris House was very lucky to have survived all these changes," I told her. "So many buildings did not."

"Yes," Julie said. "Yes—it will be here forever!"

ELSTOWE MANSION

Nothing great is ever achieved without much enduring.
—Saint Catherine of Sienna

The Dominican nuns who inhabited the former Elstowe Manor in Elkins Park were a sight to see in their long, flowing, traditional robes. If anything, the Elkins Park nuns reminded the casual observer of a certain age of John Huston's 1957 movie *Heaven Knows, Mr. Allison*, starring Robert Mitchum as a U.S. Marine stranded on a South Pacific island with a nun (Deborah Kerr) in a Dominican-looking habit.

Renamed the Dominican Retreat House, the former Elstowe Manor's forty-two-acre estate was built in 1898 by William L. Elkins and came to be known as a rare architectural and design treasure. With its frescoed ceilings, exquisitely hand-carved mahogany panels, French crystal chandeliers and handsome marble columns, the manor was the epitome of lush excess in the Gilded Age.

The mansion, a combination of Italian High Renaissance and Elizabethan Revival architecture, managed to maintain its structural dignity after it was sold by the Elkins family to the Dominican Sisters of St. Catherine de Ricci sometime in 1932. The mansion began to be used for religious retreats in 1933.

The nuns owned the mansion until 2009, when they closed the Retreat House and sold it to the New Age nonprofit Land Conservancy of Elkins Park. The selling of the mansion in 2009 was the end of an era. For more than half a century, the mansion saw thousands of Catholic schoolgirls and women enter its doors to stay several days or a week at a time. This era was probably the greatest for the Catholic Church in the United States, but by 2009, that had changed. Not enough women were interested in coming to the mansion for religious retreats, and the numbers of nuns had also dwindled.

Elstowe Mansion, later called the Dominican Convent of Elkins Park. *Courtesy Marita Krivda Poxon.*

Those who know the history of Catholicism in the United States would be hard-pressed to express why the popularity of the retreat house declined. Some would argue that the change could be attributed to the Second Vatican Council of 1962, when every facet of Catholic life experienced a nosedive. This was a time when liturgical changes in the Catholic Mass became the norm, when seminaries and convents emptied out and when Sunday Mass attendance dropped significantly.

Vatican II's imprint on the liturgical life of the Catholic Church—the changing of the old Latin Mass far beyond the use of the vernacular—also affected Catholic Church architecture: beautiful churches were stripped of their high altars, statues and mosaics. In the American church especially, experimentation and excess imploded with clown and jazz masses, as well as modern Gucci-style nuns in lipstick, some of whom began calling God "Mother Goddess."

Through most of these changes, the Dominican Retreat House remained a staple of liturgical normality, generally bypassing the wacky 1970s era, when in many churches a priest might jump out from the sanctuary and do dance numbers in front of the congregation as if reliving his youth in New York's Peppermint Lounge.

According to Michael Rose, author of *Ugly as Sin: Why They Changed Our Churches from Sacred Places to Meeting Spaces—and How We Can Change Them Back Again*, the catalyst for the change was a duplicitous 1978 draft statement by the U.S. Bishops' Committee on Liturgy entitled "Environment and Art in Catholic Worship."

Rose asserted that this document was "cunningly published in the name of the National Conference of Catholic Bishops, implying approval from Rome. But the Vatican II document, *Sacrosanctum Concilum*, which was cited in the draft statement as the reason for the 'wreck-o-ovation,' did not call for the wholesale slaughter of traditional Catholic Church architecture."

What Vatican II actually said was that "the practice of placing sacred images in churches so that they can be venerated by the faithful is to be maintained."

The "spirit of Vatican II," then, became a catchphrase in the Catholic world. The seemingly benign phrase was used to justify everything in the modern church from a more charitable attitude toward non-Catholics to the use of raisin oatmeal cookies at Communion time. It also meant plain wooden altar tables rather than high marble altars with images of saints and angels, carpeted rooms, plain glass-stained windows, potted plants in place of traditional Catholic artwork, small and nondescript Stations of the

Elstowe Mansion. *Courtesy Marita Krivda Poxon.*

Cross that disappear into the walls, churches in the round resembling MTV soundstages and the elimination of altar rails and sanctuary lamps. Crucifixes were replaced by wooden crosses or geometric plus signs; the traditional baptismal was transformed into a hot tub. Older churches, including many cathedrals, were stripped bare as high altars were removed and dismantled, and historic frescoes and icons were whitewashed.

It's no wonder, then, that the Dominican Retreat House closed its doors, since religious retreats were seen by many as a thing of the past, just as William L. Elkins's estate was eventually seen as too grandiose to be livable.

Elkins, along with Peter A.B. Widener, built the Philadelphia Railroad Company and the Philadelphia Rapid Transit Company. On the estate sits the Chelten House, commissioned in 1896 for Elkins's son George. Elkins had three other children: William Jr., and Ida Ameila and Eleanor. The Chelten House is a remarkable example of Tudor-style splendor, with its Wissahickon schist and dark timber exterior.

When I toured the estate with writer Marita Krivda Poxon, we were directed to follow caretaker Amy Ragsdale throughout the mansion's many rooms, including the music room, the smoking room (where a slight aroma of tobacco still seemed to accent the air), the grand industrial kitchen, the wine cellar, the servants' quarters, the countless bedrooms and the immense imperial staircases. One room caught our attention because of its relative simplicity. It was, in fact, a model of utilitarian blandness until Amy told us that the room's grandeur was destroyed by a fire sometime during the nuns' occupancy. The cause of the fire seems to be a mystery; however, the damage was so great that the nuns opted only to restore the room to bare-bones functionality.

People say, "If only these walls could talk." If Elstowe's walls could talk, they would undoubtedly mention Elkins's daughter, Eleanor Elkins Widener Rice, whose first husband, Peter Widener, went down with the *Titanic* in 1912. Life's good fortune conferred on Eleanor the ability to spend her days collecting eighteenth-century French furniture and English silver. Tapestries by Boucher were also among her favorites, and all these treasures and more filled her New York townhouse at 901 Fifth Avenue. After Peter's death, Eleanor married Alexander Hamilton Rice Jr. (1875–1956), a graduate of Harvard who became an Amazon explorer. Rice's grandfather Alexander Hamilton Rice (1818–1895) was a Union College of Schenectady graduate and a mayor of Boston who suffered major facial disfigurement after a fall from a horse. The fall also caused his speech to be impaired, although he eventually was able to correct this shortcoming. Alexander Jr.'s brother, Edwin A. Rice, helped build General Electric and knew Thomas Edison. In 1884, Edgar Rice married Helen K. Doen. Of the couple's three children, Mary Rice married Philadelphia architect Frank V. Nickels (the author's grandfather) in the 1950s.

The online publication *Hidden City Philadelphia* describes this handsome structure as having a façade fortified in Wissahickon schist and dark timber. "Its upper floors are covered in cream-colored panels of prickly pebbledash."

The interior walls are suited in Tudor-style wood paneling, and a lavish web of Gothic tracery weaves geometric texture into the ceiling. Both mansions contain large, industrial kitchens where, in the tradition of the French manor, the simplicity of worn, rustic wood and abraded stainless steel contrasts with the overwhelming splendor of every other room in the estate."

In 2017, *Hidden City* reported that in 2014, the Cheltenham Township Board of Commissioners approved three zoning amendments to clear the way for luxury hotelier Apeiron to purchase Elstowe and convert it into a boutique hotel with full-service luxury apartments. This plan called for

Elstowe Mansion, the music room. *Courtesy Marita Krivda Poxon.*

using a portion of the forty-two-acre property for a public arts and cultural destination. "To date, Apeiron's plan has not moved beyond the proposal stage and no other projects for the estate are on the table."

It has often been said that Philadelphia's Cheltenham Township in the nineteenth century had more millionaires per square inch than in any other place in the country. Despite the erratic inclemency of northeastern U.S. weather, the industrial baron class found the area to its liking. Besides William L. Elkins and Peter A.B. Widener, the township's other Gilded Age residents included Jay Cooke, John B. Stetson, William Welsh Harrison and John Wanamaker.

Wanamaker, a merchant and an inventor of modern department store and the commercial price tag, once said, "When a customer enters my store, forget me. He is king." He believed that a department store should be a temple of consumption.

Left: Elstowe Mansion, general grounds. *Courtesy Marita Krivda Poxon.*

Below: The Chelten House, Elstowe Mansion employee house. *Courtesy Marita Krivda Poxon.*

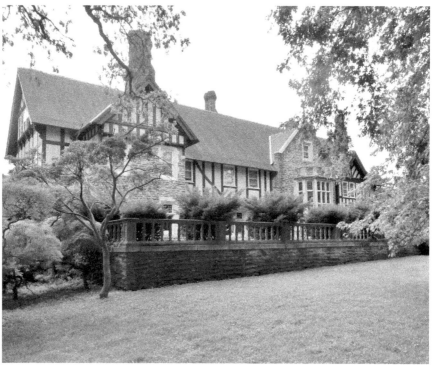

Philadelphia's Wanamaker Building was designed by Chicago architect Daniel Burnham (1846–1912), a former theological student who designed the Flatiron Building in New York City and Union Station in Washington, D.C. John Wanamaker, who had a religious side, envisioned his department store as looking somewhat like a cathedral, with its great organ and first-floor sky-high atrium with the French-influenced faux glass "ceiling."

Philadelphians have come to know the building for its Florentine style and its imposing granite presence along the narrow Thirteenth Street corridor. Walk from Market along Thirteenth and you'll notice that the side walls of the iconic structure appear plain and utilitarian, almost fortress-like. The lack of columns or adornments of any kind seems strange unless Mr. Burnham knew that any embellishments there would be useless since they would be hidden from view. That changes considerably when you look at the structure from Chestnut Street—it's then that you get a cinematic sense of the building's grandeur.

Who doesn't have a story about the Wanamaker building? In the 1970s, I worked there as a waiter and met none other than Margaret Hamilton from *The Wizard of Oz*. In those days, the football field–sized Crystal Tea Room could cook seventy-five turkeys at the same time in the massive kitchen ovens. Waiters had their own upstairs lockers and dressing rooms, and customers could go directly to the Tea Room from the first floor of the store without "detouring" through the Juniper Street entrance. The Tea Room's soup and tea sandwich special drew in hundreds of people per day. When the Tea Room closed in 1995 to become a private dining hall, the tea sandwich industry also seemed to crash. I've been on a hunt for these delectable "bitties" ever since.

John Wanamaker was a sort of "do it yourself" patron of the arts in that he loved to hang religious paintings throughout the store. He commissioned African American artist Henry Ossawa Tanner to paint religious scenes for the store. A strict Protestant teetotaler and moralist, Mr. Wanamaker also banned sales of Walt Whitman's *Leaves of Grass* from the bookstore.

The first Wanamaker store was in the Independence Hall area but then was later moved to the old Pennsylvania railroad station, where Mr. Wanamaker transformed it into a Grand Depot (department store) before deciding in the early twentieth century to rebuild on the same spot. On December 30, 1911, the new building was dedicated by President Taft.

Wanamaker owned houses in Cape May Point, New Jersey; New York City; Florida; London; Paris; and Biarritz. In Philadelphia, he had a townhouse at 2032 Walnut Street, where he died. His grand country estate was the

Lindenhurst Mansion on York Road near Washington Lane. Lindenhurst was designed by New York architect E.A. Sargent but burned to the ground in 1907. Wanamaker lost his art collection in the fire. The mansion was rebuilt in the French classical style but was demolished in 1944.

If you were to walk the perimeter of Peter A.B. Widener's Lynnewood Hall today, you would see endless acreage enclosed by a fence, with the enclosed grounds overgrown with trees and weeds so that the area resembles a wild, sizeable zoo. The foreboding estate is said to have a number of wild animals roaming about inside with a rather cantankerous guard dog employed by the present owner to ward off (or intimidate) would-be intruders. The 110-room estate, of course, used to be a grand affair, modeled after Prior Park in Bath, England. Widener commissioned Horace Trumbauer in 1898 to build the estate for his art collection and family. In 1910, another wing was added to the building, called the Van Dyck Gallery, where Widener hung his paintings in the floor-to-ceiling European tradition. Included in the gallery were numerous paintings by Rembrandt and works by Manet and Renoir.

Jules Allard and William Baumgarten and Company were the firms selected to decorate many of the interiors. Allard's library/drawing room was called the Louis XIV Room and contained paintings by Pierre Puvis de Chavannes, Gustave Courbet, Alphonse-Marie-Adolphe de Neuville and Baron Hendrik Leys. The room became a ballroom after Harry Elkins Widener's death on the *Titanic*. The dining room was originally walnut-paneled but was later remodeled with green-and-white marble walls.

In her book on the Philadelphia-area architecture of Horace Trumbauer, Rachel Hildebrandt wrote:

> *The façade of Lynnewood Hall features a pediment supported by massive Corinthian columns, and Palladian pavilions grace each side of the long façade. After Widener relocated his family [from their mansion on North Broad Street] to the new residence, Trumbauer converted Widener's Broad Street mansion into a branch of the Free Library of Philadelphia. At Lynnewood Hall, Trumbauer redesigned the central pediment in 1910, introducing a round window and carved figures. The firm also built an addition on to the art gallery wing of the house.*

After Peter's death at age eighty in 1915, three years after the demise of his son George Dunton Widener and grandson Harry Elkins Widener on the *Titanic*, the art gallery was pared down by Peter's only surviving

son, Joseph, from five hundred paintings to one hundred. Other works of art were added as the collection was opened to the general public. After Joseph's death in 1943, the mansion and its contents were auctioned off. The Robinson family purchased the estate but sold it to Carl McIntyre's Faith Theological Seminary in 1952 for $102,000. McIntyre was a conservative religious broadcaster. In 1996, the mansion was purchased by present owner Dr. Richard Yoon, founder of the First Korean Church of New York, who bought the property at a sheriff's sale.

Both P.A.B. Widener, the builder of Philadelphia's Widener Building on South Penn Square near City Hall, and Horace Trumbauer, the architect of the structure, were self-made men. Widener, the wealthiest man in Philadelphia at the time of his death in 1915, started out as a butcher's assistant. He made a fortune selling meat for the Union army during the Civil War. Trumbauer was educated in Philadelphia public schools but dropped out at age sixteen to work as an apprentice at the architectural firm of G.W. and W.D. Hewitt. During his career, he designed more than forty buildings in Philadelphia, including the Adelphia House, the St. James building at Thirteenth and Walnut Streets and the Music Pavilion at Willow Grove Park.

In its day, the eighteen-story Widener Building was the most state-of-the-art office tower in the city. The interior is devoid of woodwork, and the floors are either marble or cement. The exterior is Indiana limestone and bronze.

Designed in the classical Beaux-Arts style, the structure's tri-level plastered façades, steel ornamentation and steel-framed windows complement the buildings around City Hall.

Trumbauer's European-style shopping arcade, originally consisting of two floors of shops, is the most fascinating. This open passage allows the city to literally flow through the building's lobby from South Penn Square to Chestnut Street. The arcade was closed in 1963, but Francis Cauffman Foley Hoffmann Architects began restorative work in 1992. "The exterior of the building was once jet black because of the way the buses go around City Hall," said Anthony Colcighi, a partner in the architectural firm. "The building was cleaned beautifully."

Colcighi told me that the three-foot gradual ground slope from South Penn Square to Chestnut Street meant that restorative architects had to take special care in adding doorways as well as leveling the restored lobby floor with elevators. "Original drawings indicate that the Widener had a kind of lower mezzanine restaurant," he said. "Apparently, back in the 1920s, it was quite a fancy place, with a grand stairway going down from

the lobby." The remains of the restaurant include ceiling ornamentation and some large restrooms.

The biggest wear and tear on the building was the obliteration of the historic fabric done in the 1960s and '70s. Colcighi said that people put in drop ceilings and that his firm "had to re-create the entire Chestnut Street façade from street level to the third floor."

RONAELE

This fifty-room mansion situated on 114 acres was designed by Trumbauer to resemble the fifteenth-century Compton Wynyates Mansion in Warwickshire, England. Ronaele (the name Eleanor spelled backward) was the home of Eleanor Widener Dixon and Fitz Eugene Dixon. The Widener-Dixon marriage occurred just two weeks after Eleanor's father and brother died on the *Titanic*. Built on the site of Jay Cooke's famous mansion, Ogontz, it had greenhouses and an eight-room butler's cottage and hosted a significant agricultural and cattle breeding industry. The Tudor Revival structure also had twenty-eight chimneys, and most of its rooms were designed by Charles of London.

In 1950, the Christian Brothers of La Salle University purchased the estate and transformed the main building into a dormitory for students and religious brothers, renaming it Anselm Hall. La Salle, in turn, sold the building and much of the estate to developers in 1973. The main house was demolished in 1974.

The son of Eleanor and Fitz, Fitz Eugene Dixon Jr., was a Philadelphia civic leader who signed Julius Erving when he owned the Philadelphia 76ers. At his death in August 2006 at age eighty-two, the *New York Times* reported:

> *Mr. Dixon is perhaps best known for bringing Erving, known as Dr. J, to town in 1976 by paying him about $6.6 million—only a few months after buying the team for $8 million. Under his ownership, the 76ers reached the N.B.A. finals twice, but never won a championship. He sold the team in 1980 after financial losses and a decline in attendance.*
>
> *One of Dixon's most visible contributions to Philadelphia is the Robert Indiana sculpture "LOVE," which stands in John F. Kennedy Plaza, popularly known as Love Park.*
>
> *Indiana lent the sculpture to the city for its bicentennial celebration, but took back the work because the city said it could not afford the $45,000*

price. The sculpture had become a beloved part of the cityscape, so Dixon offered Indiana $35,000 to return it, and Indiana accepted.

ARDROSSAN

With its imposing stone walls and balustrade that surrounds the mansion's front courtyard, the fifty-room, Georgian Revival estate in Radnor was designed by Horace Trumbauer. The original estate comprised 750 acres, its interior designed by the prestigious White Allom and Company of Buckingham Palace fame.

The mansion was built for Colonel Robert Leaming Montgomery and his wife, Charlotte Hope Binney (Tyler) Montgomery. The couple moved in at the end of 1912. The home was named after the family's ancestral Scotland home.

The house was also important to Philadelphia art history because inside the mansion there were a number of works of art, including six Thomas Sully portraits, two paintings by Gilbert Stuart, one by Charles Willson Peale, one by George Healy and a 1776 work by George Romney.

Built between 1911 and 1913, the estate became the inspiration for the 1930 Philip Barry comedy, *The Philadelphia Story*, later adapted into a film by the same name in 1940 starring Katharine Hepburn and Cary Grant. Perhaps an even greater inspiration for the play and film was the personality and character of the Montgomerys' first daughter, Helen Hope Montgomery Scott, who became what *Vanity Fair* magazine called "the unofficial queen of Philadelphia's WASP oligarchy." In *The Philadelphia Story*, Helen Hope Montgomery Scott inspired the character of Tracy Lord, played by Hepburn.

The move of old Philadelphia moneyed families from the city to the suburbs had its start in the 1920s, according to Nathaniel Burt, author of *The Perennial Philadelphians* (1963), who wrote, "The last Old Philadelphian townhouses were built around 1900, and from then on, fashionable city life was doomed. The 1920s saw the almost complete removal of upper- and middle-class Philadelphia from the city to the suburbs. Meanwhile, in the bosky bumps and dells of the Pennsylvania countryside, up the rushy glens along the west bank of the Schuylkill as far as Valley Forge, out along the railroad tracks to Paoli, up the Wissahickon to Chestnut Hill, in the more flat and open reaches of Whitemarsh, Bryn Athyn, Ambler, Penllyn, Philadelphians from 1880 to 1930 built up their private dream world, a rural

fantasy…of vast estates surrounded by miles of walls, with miles of driveway leading to great craggy mansions."

Ardrossan was one of those mansions. Colonel Montgomery was also a dairy farmer who raised a prized herd of Ayrshires. Later in life, he took up aviation and had a hand in the development of a plane called the "autogiro" that he often flew to England.

Historians like to say how the family was always Episcopalian and "Republican by herd" but that they had "Democratic tendencies" in the arts. The Montgomerys were against prohibition. J.F. Pirro of the *Main Line Times* wrote that "the colonel was for drinking parties. To him, it was the equivalent of taking away his foxhunting."

The *Philadelphia Evening Bulletin* reported in 1922 that "Miss Helen Hope Montgomery [later known as Hope Montgomery Scott], the very pretty daughter of Mr. and Mrs. Robert Leaming Montgomery, is the one debutante who defends bobbed hair…and when it comes to a question of husbands, the ideal HE must be tall, good-looking, good-natured; he must have a million. Breathes there such a man?"

At her coming out or debutante parties, Helen Hope Montgomery received a number of marriage proposals but rejected them all. Later, she would meet Philadelphia investment banker Edgar Scott. After their marriage, Scott joined his father-in-law in 1929 to form Montgomery, Scott and Company, now known as Janney Montgomery Scott.

Mr. Scott's *New York Times* obituary in May 1995 (Helen Hope died in January of the same year) read:

> *Mr. Scott was born to wealth and privilege in Paris, where his father was a second secretary in the United States Embassy. He was a grandson of Thomas A. Scott, ruler of a railroad empire that included the Pennsylvania Railroad. Edgar Scott's college education was interrupted by World War I, when he volunteered as an ambulance driver in France. He was a former governor of the New York and the Philadelphia-Baltimore Stock Exchanges. He was a past president of the World Affairs Council of Philadelphia, a vice president of Bryn Mawr Hospital, a Radnor commissioner and dean of the Shakespeare Society of Philadelphia.*

Hope Montgomery Scott was a dazzling figure who danced with royalty and with Josephine Baker in Paris. Her society parties at Ardrossan were legendary. "Hope had that 'lockjaw thing,' upper class Philadelphia accent," wrote *Philadelphia Magazine*'s Amy Korman in 2005. "She didn't

live at Ardrossan [toward the end of her life] but on Abraham's Lane in a farmhouse on the estate's grounds."

Thacher Longstreth, in his autobiography, *Main Line Wasp*, recalled, "In the mid-to-late 1930s, I found myself plunged into an awesome—and, in retrospect, ludicrous—round of debutante parties....During the year that a girl 'came out,' she and her friends might be invited to a hundred parties. That's no exaggeration: A single wealthy debutante like Frances Pew, the daughter of Sun Oil's chairman, J. Howard Pew, might be the guest of honor at four or five different parties. If you lived on the Main Line in the 1930s... you were sent to the Wednesday Afternoon Dancing Class at the Merion Cricket Club....If you lived in Chestnut Hill, of course, you attended the Tuesday Afternoon Dancing Class, which was conducted at the Philadelphia Cricket Club."

La Ronda

The name La Ronda could easily be the title of an opera or symphony, or even a ballet by Igor Stravinsky. There's certainly no foreboding element in the name, although the sad ending of the estate in 2009, when it was demolished by a developer, was a tragedy that many preservationists attempted to prevent.

The story of La Ronda begins with the Foerderer family. Robert Foerderer was an enterprising gentleman who invented a tanning process using chrome, which transformed goatskin leather into a soft and supple material. Robert married Caroline Fischer (1861–1934) in 1881. The couple had two children, Florence and Percival Edward. At that time, the couple lived on Philadelphia's North Broad Street in North Philadelphia. In 1893, the family moved to a large estate in the city's Torresdale section, formerly owned by Charles Macalester, a banker and close associate of Abraham Lincoln's. The Italianate mansion, built in 1850, was once called Glengarry until the Foerderer's renamed it Glen Foerd. Glen Foerd, unlike La Ronda, is still standing. At this time, there are no developers with an eye to demolishing this beautiful estate on the Delaware.

Robert Foerderer's tanning business ("Vici Kid" leather) continued to be successful until the onset of an illness that made it necessary for young Percival to leave his medical studies and work for the family at an entry-level position. In 1908, Percival became president of the company.

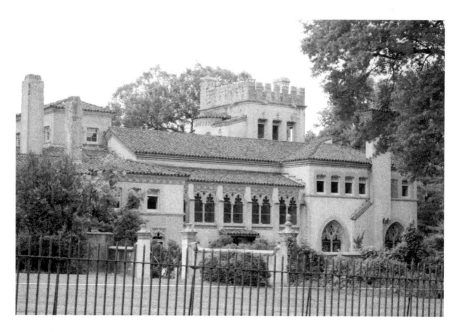

Bryn Mawr's La Ronda Mansion before demolition. *Courtesy Carla Zambelli Mudry.*

Percival married Ethel Brown (1885–1981), who hailed from a prominent Philadelphia textile manufacturing company, and they had three daughters: Mignon, Florence and Shirley. During the first year of their marriage, the couple lived in Rittenhouse Square, but in 1929, they were ready to move into their Addison Mizner–designed La Ronda in Bryn Mawr. The 17,500-square-foot Mediterranean-style mansion was built on the former site of Brookfield Farm, owned by Pennsylvania lawyer Wayne Mac Veagh, who died in 1917.

Christopher C. Paine wrote in the *Palm Beach Daily News* that "Addison Mizner was the son of a diplomat who was posted to Central America. It was during a year in Guatemala that he was first exposed to Spanish architecture. It was also during this time that Mizner decided to take up art as a profession. He would attend the Spanish university at Salamanca where he would refine his artistic vision." Paine also noted that Mizner's parents shipped him off to China with his older brother. "During that period, Mizner was exposed to Asian architecture. Gardens there would shape his ideas regarding landscaping. Afterward, he learned the practice of his trade from San Francisco architect Willis Polk, where he eventually became a partner."

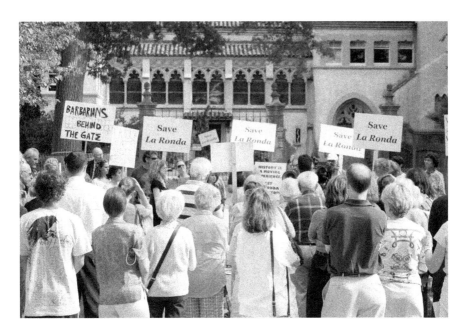

Protests outside La Ronda. *Courtesy Carla Zambelli Mudry.*

"In the 1900s the daughters of wealthy, influential and powerful Main Line families often spent their time being educated at prestigious private schools, entertained at swanky soirees and dazzling debutante parties and showcasing their equestrian skills at events like the Devon Horse Show and the Radnor Hunt," wrote Kathy O'Loughlin in *Main Line Media News*. "As a successful leather merchant, Percival Foerderer was more than wealthy enough to provide all that and more for his three daughters. But they actually knew little of that opulent lifestyle, living an almost cloistered life, often hidden behind the gates of their magnificent Bryn Mawr estate that was home to the palatial 51-room La Ronda mansion."

O'Loughlin continued: "Although the Foerderer's family life appeared to be perfect, it was not. Daughter Florence was born with a form of dwarfism which seemed to cause her parents Percival and Ethel much embarrassment. Unlike their other two daughters, Mignon and Shirley, Florence was just three and one-half feet tall."

Dr. Frederick V. Wagner Jr. who had once treated the Foerderer family, wrote a small pamphlet about his experiences, *Percival E. Foerderer: A Mr. Jefferson*, in which he reported that "Florence's arms and legs were very short, although she had a normal torso. Because of that, her parents were

embarrassed about her and she grew up in isolation until she went to college. In fact, her sisters were also home-schooled and not allowed to have playmates to their house. With that large an estate, it was possible for the family to keep Florence hidden. The daughters were raised there and kept secluded from the world." Florence was just three and a half feet tall, but Dr. Wagner believed that she was the brightest of the three daughters.

When Percival died in 1969, his family sold the estate to Villanova University. In March 2009, La Ronda was sold for $6 million to an anonymous owner, who had the estate demolished. The anonymous owner was later identified as Joseph Kestenbaum, president and chief executive of ELB Capital Management. Sadly, the Lower Merion Historical Commission could not raise the funds to save the building. Preservation efforts were so intense that Benjamin Wohl, a Florida real estate developer with an appreciation of Addison Mizner's work, offered to buy La Ronda and move it to Florida, saving Kestenbaum some $300,000 in demolition costs. The deal was rejected, and La Ronda was destroyed on October 1, 2009.

At that time, the *Philadelphia Inquirer* reported:

> *The plan is to raze the 17,500-square-foot Spanish Gothic house and build a single-family house of about 10,000 square feet on the 3.2-acre site.*
>
> *The new dwelling would lack the historic stature of La Ronda as the only remaining house in Pennsylvania built by Mizner, whose flamboyant architecture is so prevalent in South Florida that an 11-foot-tall statue of him stands in Boca Raton. The preservationists hope the new owner can be talked out of demolition or persuaded to sell La Ronda to a possible deep-pocketed benefactor.*

In an age when many churches are designed to look like sterile bank vaults or corporate lobbies, St. Mark's Anglo-Catholic Church at 1630 Locust Street honors the best in ecclesiastic tradition. Traditionally it has been the chosen place of worship for some of Philadelphia's best and oldest families.

The eye-catching, rich polychromed figures above the red Fiske doors—the church's main entrance—have fascinated passersby for decades. The scarlet red doors were considered scandalous in their day. They certainly provide a striking entrance into one of the most beautiful churches in Philadelphia. Designed by architect John Notman (1810–1865) in the Decorated Gothic style of the late thirteenth and fourteenth centuries, St. Mark's was built between 1848 and 1849. The church had a plain interior

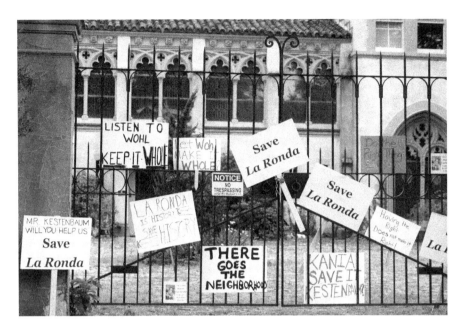

More protests outside La Ronda. *Courtesy Carla Zambelli Mudry.*

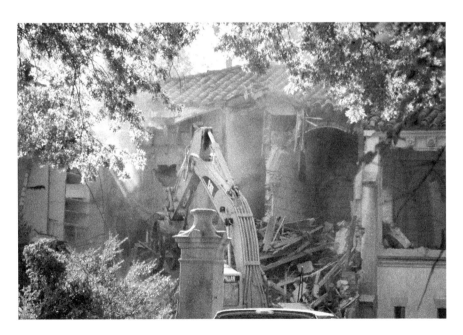

Demolition of La Ronda. *Courtesy Carla Zambelli Mudry.*

prior to the growth of the Oxford movement within the Catholic wing of the Anglican Church. The Oxford movement stressed ritual, solemnity and liturgical beauty.

Notman, one of Philadelphia's most notable architects and a founder of the American Institute of Architects, also designed Philadelphia's other Anglo-Catholic church, St. Clement, at Twentieth and Cherry Streets.

St. Mark's rich iconography can be seen in the seven Renaissance-style sanctuary lamps that hang near the high altar; the exquisite pulpit, designed by church architect Ralph Adams Cram, who also designed the Cathedral of St. John the Divine in New York; and the Lady Chapel, with its silver altar and altarpiece, built as a funeral chapel by Rodman Wanamaker, son of John Wanamaker, for his deceased wife, Fernanda, in 1900. The church organ and organ case were renovated by Henry Vaughn, one of the great ecclesiastic architects of Gothic Revival.

St. Mark's may be the only church in Philadelphia with a stained-glass window restored with funds from the Andy Warhol Foundation and an AIDS memorial adornment on a nave altar.

Renovations were made to the church in the late nineteenth and early twenties centuries. In the 1960s, the high altar was renovated in order to make it freestanding, something that was done in order to comply with Vatican II regulations that the main altar in a church should be reconfigured.

Chapter 2

Skytropolis, or Howard Hughes Comes to Visit

Germantown

Few areas of Philadelphia have undergone as radical a transformation over time as Germantown. Settled in 1683 by thirteen families from the banks of Germany's Lower Rhine region, Germantown's first homes were made of logs and rustic dark stone. The houses were noted for their overhanging hipped roofs, small windows and doors that swung on hinges to keep out stray animals. The old Germantown settlement resembled a German village where English was rarely spoken.

Philadelphia's yellow fever epidemic caused outsiders to quickly move into the village and broaden the demographics of the area. In the twentieth century, Germantown flourished in relatively affluent middle- to upper-class comfort until after World War II, when the area began to decline. W.E.B. Du Bois blamed the slow decay of Germantown on white flight at the first signs of racial integration and on the poor quality of education available for blacks.

Sadly, the area today is a conglomeration of boarded-up buildings, crime and empty, overgrown lots. Developers just don't think of Germantown when it comes to urban renewal.

The month of February, besides being Black History Month, might also be described as Germantown History Month. At Philadelphia's venerable Stenton Mansion (built by James Logan, secretary to William Penn, in 1730),

archaeologist Doug Mooney lectured on the lives of James Dexter and Reverend Gloucester and Philadelphia's free black community. Reverend Gloucester was the first African American to be ordained a Presbyterian minister and was one of the primary organizers of the Underground Railroad in Philadelphia.

No visit to Germantown is complete without a walk or ride along Germantown Avenue (once called "the Great Road"). Here you will see more historic colonial and pre-colonial houses than anywhere else in the city, with the possible exception of Society Hill, or Old City. The Deshler-Morris House, Clivden, Johnson House and the Wyck House are all famous Germantown historic properties. One of the oldest is Grumblethorpe.

Built by German immigrant and wine importer John Wister in 1744 as a summer retreat, Grumblethorpe was made of stone quarried from the Wissahickon area and from wood from nearby oak trees. The house is a prime example of domestic German architecture: the rooms have low ceilings, and there are pent eaves, double front entrances, front and rear balconies and a large colonial kitchen.

The expression "If these walls could talk" aptly sums up Grumblethorpe. Go into the parlor and you will see faded bloodstains on the floor from the time of the Revolution. Here is where British General James Agnew, who had ordered the Wister family out of their house when the British captured Germantown, bled to death after General George Washington led a surprise assault. General Agnew was shot while leading British troops up Germantown Avenue. He was taken to Grumblethorpe to recover but died in the house instead. Since that time, all attempts to bleach or clean the stains have failed.

Grumblethorpe also houses the famous writing desk used by Owen Wister, a friend of Henry James and Teddy Roosevelt and author of *The Virginian*.

The Harvard-educated Wister worked for a time as a bank teller in Boston, but in his youth, he headed west to recover from a health problem. Wister made many trips to the Wyoming countryside and recorded his encounters with ranchers, thieves, cowboys and Native Americans in a diary that would later become the inspiration for *The Virginian*, published in 1902. Wister's book later became the basis for the television show of the same name, which debuted in 1962.

Another famous Wister family member, Frances Anne Wister, raised funds to save historic houses and the Academy of Music in the 1920s; she led the efforts to save the Academy from being transformed into a movie palace. During the Depression, she also raised money for the Philadelphia

Orchestra. Frances Wister was also author of the first published history of the Philadelphia Orchestra, *Twenty-Five Years of the Philadelphia Orchestra 1900–1925*. She was chairman of the Women's Committees of the Philadelphia Orchestra from 1910 until her death in 1956. Frances Wister's genius for fundraising also saved her ancestral home, Grumblethrope, from demolition.

The name Grumblethorpe came from Charles Jones Wister, a horticulturist and inventor in the early nineteenth century. This Wister family member also winterized the house and made other structural changes. It is said that Charles Wister had been reading an English novel and came upon the name Grumblethorpe, liked it and began calling the house by that name. The Wister family owned and occupied Grumblethorpe for more than 160 years.

My research took me into Germantown from North Philadelphia three days after a snowstorm. With ice still on the roads and curbside piles of snow blocking easy pedestrian passage, I waited for the one city bus with the most Germantown access, the Southeastern Transportation Authority's (SEPTA) Route 23. Delays and obstacles of all sorts prevented the bus from coming on time, but when it did arrive, it was standing room only, a nerve-jangling situation that later got a few passengers riled up when the conditions unhinged one female passenger to such a degree that some schoolchildren rose to challenge her inappropriate outbursts. Chalk it up to one of those raw inner-city moments when bad language filled the bus with tension and drama until a fed-up woman spoke up as if shouting to a multitude at the base of a mountain: "I tell you all, by the blood of Jesus, stop this right now.…By the blood of Jesus, remember your ancestors on whose shoulders you stand. Do not disgrace them, by the blood of Jesus." Amazingly, the ruckus subsided, and there was quiet even as the woman bellowed another plea just to make sure that the peace would hold: "By the blood of Jesus!"

The epic outburst was a fitting introduction to Germantown's Johnson House, officially called an Underground Railroad Station and House Museum, built in 1768 by John Johnson Sr., a Quaker, for his son, John Johnson Jr. and his new wife, Rachel Lavezey. The brick stone structure would house five generations of the Johnson family, who would live in the house until 1908.

It would be the third generation of the Johnson family that would turn the house into a station of the Underground Railroad, although by the Civil War, the house had already survived the ravages of the Revolutionary War, especially the Battle of Germantown, in which exploding cannonballs and musket shots shrouded it in smoke and ash.

The Johnson house's penchant for controversy started from the day that it was built. "The Johnsons were Quakers, and the possession of such a substantial and commodious residence indicated worldliness and ostentation, this causing grave anxiety among the strict Friends," wrote Robert Vlle in the *Johnson Home News*.

Vlle also noted how in the 1860, the census revealed a black community in Germantown of just 143—but still nearly double that compared to 1850. "Many of these people lived as servants to the wealthy Whites of the town. Benjamin Chew had two Black coachmen to drive him to church at Saint Luke's [on Germantown Avenue] and elsewhere. But increasingly Germantown's Black community was living in independent households, and was engaged in creating a strong and livable community for themselves and their children."

Vlle went on to explain how in the early nineteenth century, when a black worker for a man named Reuben Haines at the nearby Wyck House disappeared, Haines feared that he had been kidnapped and spent considerable time and effort in an attempt to rescue him from what the clutches of (assumed) Southern assailants. This proved not to be the case when it was discovered that the worker had simply "tired of laboring in the hot fields for Haines and had walked away."

Although the Johnson House is the best-documented Underground Railroad station in the city, there were other stations, namely the houses of Samuel Nice and Jacob Knorr near the corner of Washington Lane and Germantown. Vlle recorded an observer from that time:

> *The slaves would be driven up the drive which ran along the north side of the Knorr house and hidden in the back buildings to wait a chance to be carried onward, usually at night, by some interested neighbor, usually one of the Johnson's.*
>
> *A Mrs. Josiah Reene lived in the area as a girl and remembered how as a small girl she wondered why so many Black people lived in the attic for only one night and then were gone.*

The offices of the Germantown Historical Society are set back from Germantown Avenue in a Colonial Williamsburg–like setting. The handsome buildings are a place for scholars and amateur researchers, although just a few blocks away, the neighborhood area begins to deteriorate so that GHS officials don't recommend sightseeing walks for out-of-town researchers from Iowa—clad in a Henry Fonda hat,

suspenders and white khakis—who might wish to visit the old homestead of a personal ancestor.

Had our friends from Iowa, or anywhere else for that matter, walked to the corner of Walnut Lane and Tulpehocken Street, they might have encountered the Queen's House at 9 West Tulpehocken Street, built in 1851 for Queen Isabella II of Spain. This Victorian Gothic structure may not be the size of the Ebenezer Maxwell Mansion at Green and Tulpehocken, but it is beautiful in its own right.

Ruth Seltzer, society columnist for both the *Philadelphia Bulletin* and the *Philadelphia Inquirer* until her death in 1986, wrote that "Queen Isabella, whose life was threatened by annihilation, intended to seek refuge in Philadelphia. But the trouble blew over. Isabella didn't give up her throne. Neither did she come to Germantown."

Seltzer interviewed the Queen's House owners, Ray and Miriam Spiller, about their art collection, which included relics from antiquity, an antique Spanish mirror, contemporary art by Ray Spiller and an eighteenth-century polychrome carved wooden Madonna.

The Victorian house was really the McMansion of the late nineteenth century. With their vast rooms and high ceilings, the idea then was more to impress and dazzle all who entered. Compared to the building standards of an earlier era, the Victorian house was built more cheaply and faster than its regal predecessors. Some of the reasons for this were that machine-made nails were popular and reduced construction time and that new tracts of land were not only made available for settlement but were also easy to reach because of the development of rail and trolley lines.

The Ebenezer Maxwell Mansion was designed by architect Samuel Sloan sometime in 1858, with construction starting the following year. In 1850, Maxwell was a businessman living on Philadelphia's Strawberry Street, and in 1854, he moved to 327 North Eighth Street. The year 1854 was also when Germantown merged with the city of Philadelphia, creating a perfect alignment of sorts for Maxwell's move into the mansion in 1860. The history of the mansion is rich and complex. Chris Banks, a Philadelphia writer, related a conversation he had in 2010 with then Ebenezer Maxwell executive director Diane Richardson.

"He [Maxwell] built the mansion in 1859 for $10,000 and sold it in 1862 for $13,000, so it was almost like an investment property for him," Richardson said when asked about the history of the building itself. In 1862, Maxwell sold the house to the Hunter family. "Unfortunately, four years after the Hunters moved in, Mr. Hunter was killed in an unfortunate accident in New

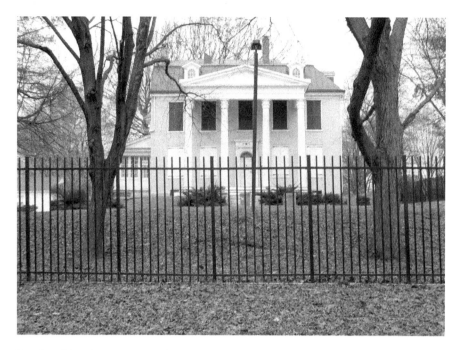

Loudoun Mansion was built by Thomas Armat in 1801, with additions added in 1810 and 1830. During the Battle of Germantown, the site became an impromptu hospital for wounded and dying soldiers. *Courtesy the author.*

York City. His wife then remarried a guy named Stevenson," Richardson said. The Stevensons, who were far wealthier than either the Maxwells or the Hunters, had several properties besides the mansion, including homes in New York City and Newport.

Chris Banks wrote that the mansion, with its stone façade, stands boldly in stark contrast to the modern family homes that surround it. "The style of architecture itself conjures up images of haunted houses in the suburban neighborhoods of modern children's stories, with the tall Victorian roof, the many windows that are scattered across the building's exterior and the dense shrubbery on the property."

Charles Addams likely based the family home in *The Addams Family* on the exterior of the Ebenezer Maxwell Mansion, noted Alexander Bartlett, librarian/archivist at Historic Germantown. Addams was a graduate at the University of Pennsylvania. It was during his college career that he became familiar with the Maxwell Mansion.

Maxwell did not live a long time in the house, as by 1868, he was not listed as a resident or as a businessman anywhere in Philadelphia. Then,

suddenly, his name reappears in 1870 when he is listed as a partner in Bings & Maxwell at 109 West Tulpehocken Street. He was, in many ways, a mystery man, as after his death on September 10, 1870, at age forty-two, he seems to disappear from public record. His name and legacy are nowhere to be found, not even in any society records prior to 1965, when Margaret Halsey, a writer for the *Germantown Courier*, searched cemetery records and records of probated wills to find out about the man who had been so elusive.

Halsey discovered a lot of information, although she claimed that one cannot be sure whether it was the same Ebenezer Maxwell, or his son, who "reappeared" in 1870 as a partner in Bings & Maxwell. "Was Ebenezer Maxwell a self made man of the 1850s? Did the Civil War, disrupting the country's economy, destroy his wealth and force him to sell his mansion? Or did he find that he simply could not settle down? He was a man who kept moving. He may have gone West, looking for new worlds to conquer. Perhaps he came back to Tulpehocken Street in 1870 but couldn't buy his house back; perhaps it was his son who brought his name back briefly," Halsey wrote.

Maxwell's funeral procession, Halsey continued, went to Laurel Hill Cemetery. "There he lay in the receiving vault for six weeks, during which his widow, Anna G. Maxwell, purchased a plot in Woodlands Cemetery."

GERMANTOWN TOWN HALL

Located in Philadelphia's Fourteenth Police District, Germantown Town Hall stands as a reminder of the lost grandeur in one of the city's most historic areas.

Like a ruined relic from a kinder and gentler era, the quickly deteriorating masterpiece—designed by John Penn Brock Sinkler to resemble William Strickland's Greek Revival Merchants' Exchange Building in Old City—is on its last legs.

While most of these historic properties are protected by the National Park Service, Germantown's Town Hall is the area's historic orphan, left vacant since 1998, when the City of Philadelphia closed the few remaining offices in the building and left the structure to the mercy of the elements.

The exterior of Town Hall—with its crumbling stonework and wood trim, depleted railings (mostly stolen for scrap), broken windows, litter, graffiti and

nests of pigeon occupiers that have splattered the interior a balsamic vinegar "white"—is a testament to what a latter-day Edward Gibbon might dub the "Fall of Philadelphia."

If you've not been to Germantown recently, visit the Historic Germantown website. You'll notice how the site attempts to warn the visitor about the neighborhood. Describing Germantown as "undoubtedly a very urbanized region" (read: enter at your own risk), the site makes no mention of Germantown Town Hall. That, perhaps, would be an embarrassment.

Along with the exterior disintegration of the building, there are many historic treasures inside, such as the 1828 clock made by Isaiah Lukens that once hung in Independence Hall. Before 1923, the spot was home to a city services building designed by Napoleon LeBrun & Sons, architects of the Metropolitan Life Insurance building in New York. In the 1860s, there was a Civil War hospital on the site, perhaps once visited by Walt Whitman, as the poet was known to visit hospitalized Civil War soldiers.

When I visited the building several years ago to take photographs, I was struck not only by the area's war-torn environment but also by the callous disregard for a building that was once Germantown Avenue's signature structure. Although I was able to walk up the front steps, I did so with a certain feeling of trepidation since fencing blocked off the more vulnerable parts of the structure.

It was obvious to me that objects had been thrown through some of the windows, although I did not see chunks of stone and wood that others reported seeing alongside the building.

There may be hope for the building yet, thanks to the Germantown Conservancy, which was founded as a 501(c)(3) community development corporation to implement urban renewal through Act 135, the "Abandoned and Blighted Property Conservatorship Act," signed into law in 2008 by Governor Rendell.

The Conservancy has noted more than three hundred endangered buildings between Wissahickon and Stenton Avenue. The organization believes that rehabbing one building in a blighted area while ignoring other surrounding blighted properties is more often than not a futile endeavor, preventing progress.

In 2010, *Philadelphia Neighborhoods*, a publication of Temple University's Multimedia Reporting Lab, reported on a petition circulating throughout Germantown that called for the restoration of Town Hall into a justice and civic service center. While Germantown residents overwhelmingly support the idea, the petition has not been able to effect the desired change.

Maura Kennedy, press secretary to former Mayor Nutter in 2010, directed the managing director and the finance director to convene four

subcommittees to address the vacancy issue. The subcommittees worked to eradicate the problem of abandoned and vacant buildings.

"There are about forty thousand vacant buildings in the city," Kennedy said. "The city is the largest owner of blight, so the question becomes—how do we correctly deal with this issue?" Kennedy noted that the city has already made significant progress in amassing a databank of the owners of blighted properties. "We are slowly working our way all over the city," she said.

Alaina Mabaso, a writer for Philadelphia's *Flying Kite*, reported on the status of Germantown Town Hall in 2016:

> *Meanwhile, efforts to find a buyer for the twenty-thousand-square-foot city-owned building (dubbed surplus public property) continue, with the Philadelphia Industrial Development Corporation handling the marketing and sale. The Fairmount Park Conservancy has also stepped in on the marketing side.*

"We continue to show the property," said Senior Director of Preservation and Project Management Lucy Strackhouse. Potential buyers have mulled everything from senior or veterans' housing to artist studios, and there has been an uptick in interest since the recent recession eased.

"The dilemma is that almost everyone who sees the building says we can't do this without some kind of public subsidy," explained Stackhouse, noting the extensive renovations needed. The challenge lies in coming up with "a use for the property that makes sense for the neighborhood, for Germantown itself, and have some funding."

WALT WHITMAN IN GERMANTOWN

The poet Walt Whitman visited Germantown on a number of occasions. Perhaps his most noteworthy visit was recorded by Katherine Abbott Sanborn (1839–1917), a New York City newspaper columnist and an author and lecturer on literary history, who describes the "au naturel" bard's behavior in the Germantown home of Mrs. Hannah Whithall Smith in her book *Memories and Anecdotes*:

> *Visiting in Germantown, Pennsylvania, at the hospitable home of Mrs. Hannah Whitehall* [sic] *Smith, the Quaker Bible reader and lay*

evangelist, and writer of cheerful counsel, I found several celebrities among her other guests. Miss Willard and Walt Whitman happened to be present. Whitman was rude and aggressively combative in his attack on the advocate of temperance, and that without the slightest provocation. He declared that all this total abstinence was absolute rot and of no earthly use, and that he hated the sight of these women who went out of their way to be crusading temperance fanatics. After this outburst he left the room. Miss Willard never alluded to his fiery criticism, and didn't seem to know she had been hit, but chatted on as if nothing unpleasant had occurred. In half an hour he returned; and with a smiling face made a manly apology, and asked to be forgiven for his too severe remarks. Miss Willard met him more than half-way, with generous cordiality, and they became good friends. And when with the women of the circle again she said: "Now wasn't that just grand in that dear old man? I like him the more for his outspoken honesty and his unwillingness to pain me." How they laboured with "Walt" to induce him to leave out certain of his poems from the next edition! The wife went to her room to pray that he might yield, and the husband argued. But no use, it was all "art" every word, and not one line would he ever give up. The old poet was supposed to be poor and needy, and an enthusiastic daughter of Mrs. Smith had secured quite a sum at college to provide bed linen and blankets for him in the simple cottage at Camden. Whitman was a great, breezy, florid-faced out-of-doors genius, but we all wished he had been a little less au naturel.

Walt was born on May 31, 1819, in West Hills, New York, and died on March 26, 1892, in his Mickle Street house in Camden. He went to a Brooklyn public school but dropped out at age eleven, a common thing in those one-room schoolhouse days. He didn't write very much about his school experiences, although he did manage to write a short story, "Death in the School Room (A Fact)." The story detailed the frequent use of corporal punishment by teachers in those days. You might say that public school life then was the reverse of what it is today: tyranny by students.

As a young writer, Walt liked to concentrate on themes like cruel or apathetic parents and their depressed, angst-ridden sons. One of the poet's first jobs was in the printing office of Samuel E. Clements, a Quaker who wore an enormous broad-brimmed longhorn hat in the summer months. According to one of my favorite Whitman biographers, Jerome Loving, young Walt learned how to "parse and spell" at Clements's composing table, the same way that Benjamin Franklin and Mark Twain learned to write.

The first newspapers in America were simple operations—the reporter was often also the printer. That later changed when the printing was done separately.

Young Walt worked for a variety of printers. Later, he became a schoolteacher but returned to printing when he started his own newspaper, the *Long Islander*. The best part of having your own newspaper, Walt recalled, was delivering the papers on horseback. Walt's earliest published poem was "Our Future Lot," about the one common denominator that unites humankind: death. Walt also wrote essays about the evils of smoking, flogging, fashion and materialism and the stupidity of quarreling.

Loving reported that in 1840, a former student of Whitman's recalled that "the girls did not seem to attract him....Young as I was, I was aware of that fact." Part of the universal appeal of *Leaves of Grass*, the poet's greatest work, was its bisexual view that both men and women can be equally desirable comrades in the arena of love. Walt was the seminal poet of male bonding. He also wrote, "To a Common Prostitute/Not till the sun excludes you do I exclude you."

Walt was too much of a poet to be a good newspaper or editorial writer. One has only to read *Democratic Vistas* (1871) to see how much of a rambling prose writer he could be.

Walt opposed capital punishment and, for a time, was an advocate of the temperance movement, writing a novel, *Franklin Evans; or The Inebriate. A Tale of the Times*. The book was published in 1842 as a small novel and its author listed as Walter Whitman. Sometime later, Walt called the book "damned rot." The story was a sensationalistic screed against the evils of alcohol. Walt later disavowed the temperance movement and was an immoderate drinker only for a short while. When he lived on Mickle Street, his last address, he enjoyed (very large) frosty mugs of champagne and other liquors like elderberry wine. In his bohemian years, when he lived in Manhattan, he would frequent Pfaff's cellar restaurant and saloon, a carousing, boisterous "arty" place that attracted artists of all types. Even then, it is said that the poet would sit back and nurse a lager or two for the longest time while his friends drank themselves under the table.

Walt became editor of the prestigious *Brooklyn Eagle* from 1846 to 1848. He was a moderate on most political issues, and although he tended to approve of socialistic movements in foreign countries, he was quite the opposite when it came to his own country—though he also had some pretty awful things to say about capitalism.

In 1857, the *Brooklyn Daily Times* described Walt as "a tall, well-built man [who] wore high boots over his pants, a jacket of heavy dark blue cloth,

always left open to show a woolen undershirt, and a red handkerchief tied around his brawny neck."

His masterpiece, *Leaves of Grass*, was hugely controversial during his lifetime, in some cases ending friendships and even getting him fired from his job in Washington with the Bureau of Indian Affairs. Critics either loved or hated him. To some, he was the devil incarnate because he dared to call *Leaves of Grass* the new Bible. His book was banned in Boston, but his champions included many literary greats like Oscar Wilde, George Eliot and (to some degree) the cantankerous Ralph Waldo Emerson.

Walt gave a number of Lincoln lectures in Philadelphia and Boston after the president's assassination. During the Civil War, he worked for a number of years as a volunteer nurse in the Civil War hospitals of Washington, D.C., where he looked after dying and wounded Union and Confederate soldiers. Walt favored the Union, but he would not take sides when it came to his hospital work. His most intimate male friend, Peter Doyle, for instance, was an ex-Confederate soldier who was present at Ford's Theatre when Lincoln was assassinated. Walt wrote to his mother about his visits to the hospital: "I fancy the reason I am able to do some good in the hospitals…is that I am so large and well—indeed like a great wild buffalo, with much hair—and they take to a man that has not the bleached shiny & shaved cut of the cities and the east."

Walt abhorred slavery, but he did not call himself an abolitionist. In an editorial he wrote for the *Brooklyn Times* in 1858, he noted, "Who believes that the Whites and Blacks can ever amalgamate in America? Or who wishes it to happen? Nature has set and [*sic*] impassable seal against it." Before anyone rushes to judgment and calls Walt a racist, it is good to remember that these were the thoughts of Abraham Lincoln and everyone else of the period save a very small circle of abolitionists.

Walt always believed that the nation's capital would be moved from Washington to one of the cities of the West. "Why be content to have the Government lop-sided over on the Atlantic, far, far from itself—the trunk [West], the genuine America?" he wrote.

Before moving to Mickle Street, the poet stayed with friends in Philadelphia at 1929 North Twenty-Second Street, where in the summer he would sit with his host family on the stoop or doorstep. Whitman's voice, according to one friend, was "full-toned, rather high [and] baritone." This same friend said that when Whitman read books, "he would tear it to pieces—literally shed its leaves."

One of the poet's favorite pastimes was, as Loving stated, "keeping track of his fame in the press." Walt was also obsessed with personal cleanliness,

but wherever he lived, he created immense disorder, with papers stacked on the floor and the curtains of his room twisted in the style of ropes to let in more sunlight.

Walt also spent a lot of time in Germantown and on the banks of the Wissahickon. He would ride the ferries on the Delaware in all kinds of weather, leaning over the boat like an old ship captain. He claimed that he once hobbled halfway across the frozen Delaware but then turned back when he sensed that the ice was getting thin. He observed, and commented on, the view of Philadelphia City Hall during its construction. He liked to hang out at the base of Market Street, where he would converse with workers, roughnecks and tramps, but when evening came, he would head to the opera. Before his death on March 26, 1892, he was able to purchase a wheelchair on credit from Wanamaker's.

In a 1986 issue of the *Walt Whitman Quarterly Review*, Dennis R. Perry wrote of Whitman's influence on Stoker's *Dracula*:

> *In the novel, which Stoker began working on in 1890 (only three years after last seeing Whitman), Dracula is the only character who speaks with a sense of rhythm, parallelism, and balance that is characteristic of Whitman. Dracula's use of synonymous and antithetic parallelism and medial reiteration flow easily from Stoker's pen, mastered as they were in his letters to the poet in his college days. In addition to this verbal legacy he bequeaths to Dracula, Whitman also seems to be at least partially the physical model for the vampire. Though Dracula does not sport a beard or slouch hat, Stoker often uses similar language when describing Whitman and the vampire, noting that both have long white hair, a heavy moustache, great height and strength, and a leonine bearing. Though not conclusive, the parallels are striking.*

At the time of Walt's death in his bed on Mickle Street (an autopsy was performed on the first floor of the house, where there was also a viewing), he was the most famous poet in America.

NORTHEAST

Rarely, if ever, does the design of a new prison get the attention of the architectural community. What usually happens is that old, abandoned prisons get noticed for quite different reasons. Philadelphia's Holmesburg

Prison, for instance, was built in 1896 and designed by an architectural firm, Wilson Brothers & Company, whose name sounds more like a shoe manufacturer than a reputable architect on the order of, say, John Haviland, who designed Eastern State Penitentiary. In general, architects of note seem to rarely design prisons, almost as if they find the whole process counter-inspirational.

The Holmesburg design copied the layout of Eastern State Penitentiary, especially the way the lighting of individual prison cells came through sunlight slits in each cell's roof. Holmesburg's fieldstone walls have a foreboding and medieval look, and the prison's spoke-and-wheel design radiates outward à la Eastern State, a kind of mandala or stone sun radiating not light but rays of appalling conditions, like abuse and torture.

Holmesburg, of course, was a prison steeped in scandal, going back to 1922, when the *Evening Public Ledger* called it "the worst prison in the United States." This summing up practically duplicates Charles Dickens's comments on ESP when he toured it in 1842, as Dickens wrote in "Philadelphia, and Its Solitary Prison" (in *American Notes*):

> *I was accompanied to this prison by two gentlemen officially connected with its management, and passed the day in going from cell to cell, and talking with the inmates. Every facility was afforded me, that the utmost courtesy could suggest. Nothing was concealed or hidden from my view, and every piece of information that I sought, was openly and frankly given. The perfect order of the building cannot be praised too highly, and of the excellent motives of all who are immediately concerned in the administration of the system, there can be no kind of question.*
>
> *Between the body of the prison and the outer wall, there is a spacious garden. Entering it, by a wicket in the massive gate, we pursued the path before us to its other termination, and passed into a large chamber, from which seven long passages radiate. On either side of each, is a long, long row of low cell doors, with a certain number over every one. Above, a gallery of cells like those below, except that they have no narrow yard attached (as those in the ground tier have), and are somewhat smaller. The possession of two of these, is supposed to compensate for the absence of so much air and exercise as can be had in the dull strip attached to each of the others, in an hour's time every day; and therefore every prisoner in this upper story has two cells, adjoining and communicating with, each other.*
>
> *Standing at the central point, and looking down these dreary passages, the dull repose and quiet that prevails, is awful. Occasionally, there is a*

drowsy sound from some lone weaver's shuttle, or shoemaker's last, but it is stifled by the thick walls and heavy dungeon-door, and only serves to make the general stillness more profound. Over the head and face of every prisoner who comes into this melancholy house, a black hood is drawn; and in this dark shroud, an emblem of the curtain dropped between him and the living world, he is led to the cell from which he never again comes forth, until his whole term of imprisonment has expired. He never hears of wife and children; home or friends; the life or death of any single creature. He sees the prison-officers, but with that exception he never looks upon a human countenance, or hears a human voice. He is a man buried alive; to be dug out in the slow round of years; and in the mean time dead to everything but torturing anxieties and horrible despair.

The small and otherwise quaint town of Holmesburg took a particularly hard beating from Philadelphia when it was selected as the dumping ground for incarcerated undesirables. Up the street from Holmesburg Prison is the Curran-Fromhold Correctional Facility. Two buildings in such proximity give a good portion of the town the look of a barbed wire camp. This is no Neiman Marcus strip mall. No doubt the people of Holmesburg never wanted their town to be a force field for medical testing in the 1950s, when University of Penn dermatologist Albert Kligman got the green light to test radioactive isotopes on unsuspecting convicts, or when the CIA did its part when it tested psychotropic drugs on prisoners. Prisons designed today may not have the look of ESP, but what happens when architect-designers start acting like sociologists?

Is it possible to build a smart-looking prison that would make prisoners feel comfortable about being incarcerated there? In 2012, two students from the Penn School of Design, Andreas Tjeldflaat and Greg Knobloch, set about doing just this. Their goal was to design an alternative to traditional prisons in the United States. Called the 499.Summit—Skytropolis, the final design of this new urban penitentiary included three towers in the shape of an arch, with each arch symbolizing incarceration, transformation and integration. "Static" this design is not. The circulatory feel of the proposed structure is an illusion because it is really something akin to frozen treachery on the verge of unfreezing and lashing out, a sort of pit bull cyclops or a robotic cop straight out of George Orwell's Ministry of Love in *1984*. It is clearly evident that the architects have never known or visited someone in prison. The implied mission statement of the design is that it would reduce recidivism because of the symbolic flow of the "healing" of the building's

circulatory parts (symbolizing transformation and integration) that resemble monstrous human appendages.

Skytropolis is nothing but an academic exercise in dark satire. Where, after all, has anyone read that exterior spaces can work interior changes in the lives of prisoners? Buildings may soothe, comfort and provide a sense of aesthetic pleasure, but to say that they can change internal psychology comes close to being delusional.

MY ARCHITECT (AND HOWARD HUGHES)

I'm waiting for a bus in the city's Riverwards area when a guy passing on a bicycle skids to a stop in front of me. The stranger takes off his helmet and introduces himself: Anthony Campuzano, a Pew Fellow artist with work in the Philadelphia Museum of Art and PAFA. He also tells me that he grew up in my grandfather's house at 40 West Albemarle Avenue in Lansdowne. I do a double take and check to see if I've been struck by lightning.

My grandfather Frank V. Nickels was a Philadelphia architect of some note (his papers are archived at the Athenaeum of Philadelphia). He designed the house at 40 West Albemarle Avenue sometime in the early 1920s and sold the mansion to the Campuzano family shortly before his death in 1985. The mansion was a place I visited many times as a child. I can still recall its old-world charm: the museum-style oil paintings, wall tapestries, hand-carved Chinese furniture, a Steinway piano, shelves of books and an immense bust of Dante Alighieri on the high living room fireplace.

Anthony told me that he's been trying to track me down for a while because he wanted me to contribute to an exhibit, Beyond Cold Polished Stones, by artists with ties to the Lansdowne area. I agreed to send him photos of my grandmother in the living room of 40 West, as well an original poem and some items related to my grandfather's architectural career.

At the exhibit's opening reception, I learned that one of the legends of twentieth-century America visited my grandfather sometime in 1936 or '37. The occasion was the negotiation of land rights for the proposed building of Nazareth Hospital in Northeast Philadelphia. Because my grandfather was hired by the Archdiocese of Philadelphia to design Nazareth, he was asked to try to get an agreement of sale from the owner of the land. Without land rights, the hospital could not be built.

The owner of the land was the six-foot-four Hollywood playboy and movie producer Howard Hughes, who had made a name for himself in

1928 when his comedy *Two Arabian Knights* won an Oscar. Hughes had also co-directed the 1930 film *Hell's Angels*, a film about World War I combat pilots starring Jean Harlow. Hughes's inherited family wealth enabled him to buy all the combat planes used in the film. A natural daredevil and pilot himself, Hughes took part in the filmed combat dogfights in which three pilots died. He was, as Hemingway would say, a man's man.

As Hollywood's most eligible bachelor, the handsome Hughes had affairs with Katharine Hepburn, Ava Gardner, Joan Crawford, Rita Hayworth and many others. In later years, he had the habit of collecting beautiful women with movie star aspirations. It was his habit to put them up in apartments or small houses while paying their rent and daily living expenses. Initially, Hughes may have shown a romantic interest in these women, but over time this interest would wane. He was content to call them once a month as he continued to send them checks, sometimes for years. He was also attracted to male stars like Cary Grant and Randolph Scott, but this part of his life was kept secret, given the tenor of the times. In 1939, two years after his meeting with my grandfather, he flew around the world and was honored with a ticker tape parade in New York City.

Let's backtrack to 1937, when Hughes piloted his own plane to New York and then to Philadelphia's Northeast Airport, where my grandparents stood waiting for him on the tarmac. My grandmother Pauline Clavey Nickels, a former opera singer from Wilmington, was probably wearing one of her big hats, and no doubt Frank was dressed in his herringbone best.

When Hughes arrived, pleasantries were exchanged, and then the group went off to a meeting near the grounds of the proposed hospital. What was said then can only be imagined. No doubt Frank and Pauline were a little starstruck, especially when Hughes accepted Frank's offer to go back to 40 West so that he could have a look at his proposed hospital design.

I wonder if the group had lunch on the way to the mansion. Did Pauline ask about Rita Hayworth, or did Hughes inquire about the stern bust of Dante on Frank's mantelpiece? Did Hughes let it slip that in two years he planned an around-the-world solo flight? What I do know is that both Howard Hughes and Frank Nickels were eccentrics (although my grandfather was not mad), so I'm sure there was an instant bond.

Frank, one of four brothers and a sister, was born in 1891 to William Bartholomew and Dorothy G. Nickels of Roxborough. As a young man, he was already setting his own style: he had a penchant for getting his shirts dry cleaned and then carrying them on hangers on various local trolleys. In 1914, he graduated from Drexel with a diploma in architecture, and after that,

Pauline Clavey Nickels at the piano in her Lansdowne home, where Hollywood's Howard Hughes met with architect Frank Nickels to negotiate land rights for the building of Nazareth Hospital. *Courtesy the author.*

he established architectural offices in Center City at 15 South Twenty-First Street, 225 South Sydenham Street and, later, in the Land Title Building. His concentration was industrial and commercial projects, as well as schools and churches for the Archdiocese of Philadelphia and in the Reading area.

Several years ago, I had an opportunity to tour two of his buildings, 1521 Spruce Street and the Frances Plaza Apartments at Nineteenth and Lombard Streets. For many years, Frank partnered with architect C.J. Mitchell, whose papers are also archived at the Athenaeum. Frank split with Mitchell when the latter challenged him in a bid to design a school for St. Philomena School in Lansdowne. Somebody who knew grandfather told me that he never spoke to CJ again.

Frank and Pauline Nickels raised three children—Frank, Thomas C. (my father) and Joan—in the Albemarle mansion. Frank's bonsai garden behind the mansion was so famous that local Cub Scout packs would organize tours of the space.

Both Hughes and Nickels were basically shy men with loner tendencies. My grandfather was not a joiner. As far as I know, he never was a member

of the Philadelphia AIA or the "must do" T Square Club, unlike C.J. Mitchell, who was a member of both. Both men had a difficult time controlling their tempers.

When grandfather and Hughes met at 40 West, it is possible that they reviewed the Nazareth plans in the dining room at the long table for sixteen situated under a chandelier. Grandfather's drafting room was on the second floor overlooking the bonsai garden and carriage house, so perhaps he and Hughes retired there as Pauline played a few bars of Chopin on the Steinway downstairs.

"Frank, I like your plans for Nazareth. I really do," I can imagine Hughes saying. "The design is modern with a touch of Art Deco, and I like the way the building meets the sky. There's something about your design that reminds me of aviation. I'll tell you what, Frank. I'm going to give the Archdiocese of Philadelphia this land for free. You can tell them that down at the Chancery....Now I'm going to fly off to one of my ladies on the West Coast."

The truth is, Hughes admired the hospital plans so much that he gifted the land to the Archdiocese of Philadelphia at zero cost. Perhaps they sealed the deal with a drink, a toast of port or a round of straight-up Manhattans whipped up by Pauline at the cocktail bar.

Grandfather must have told this story at Sunday dinner parties or at Thanksgiving and Christmas years after Hughes had become a recluse, living as a hermit at the top of the Desert Inn Hotel Casino in Las Vegas or jetting around the world to hole up in other darkened hotel rooms with his ten-inch-long fingernails and long gray hair and beard resembling the Orthodox monks on Mount Athos.

What is amazing to me, however, is that not long after Hughes's visit to 40 West, he opened the Howard Hughes Medical Institute. But before that, in 1935, he designed the H1 Silver Bullet, the world's fastest racing airplane, noted for its sleek, modern look. As I checked out images of the H1, I couldn't help but think how the plane eerily reminded me of Nazareth Hospital.

How can a plane remind anyone of a hospital? Well, I can only conclude by saying that the plane had a sleek, modern look that conjured up the feeling of Art Deco.

THE BARNES AS PARKWAY MANSION

The new Barnes Foundation Art Education Center on the Parkway has some beautiful features. The architectural firm of Todd White/Billie Tsein (TWBT) of New York chose Ramon Gold/Grey Gold stone for the exterior walls. The stone was quarried in the Negev Desert in southern Israel, and its rough texture and creamy color makes it beautiful to look at. Referred to as a mosaic of stone artwork, this translucent fortress wall blends into the Parkway scenery so discreetly it's easy to imagine missing the museum from a moving vehicle.

And that's the problem with the new Barnes. There are too many walls, in effect giving the impression of a fortress. The Convent of Divine Love on Green Street (The Pink Sisters) is less fortified than this monastery of 181 Renoirs, 69 Cézannes, 59 Matisses and more. The low-level unobtrusive design reminds me of the son of royal parents being told to dress down for his first day at a city charter school. An exterior design like this would excel in the Southwest desert or in red clay New Mexico, but along the Parkway, the building is barely noticeable. Inside the fortress, the Ellsworth Kelly totem is the only concession to urban verticality, but given the walls, it suggests the feeling of an Old West American outpost. Viewed another way, perhaps the walls are the inevitable result of the new security state, a protection against the unknown in the post-9/11 age.

When the press was invited to view the new Barnes close up in May 2012, I headed to the museum from Twenty-Fourth Street and the Benjamin Franklin Parkway. The sight of the walls had me guessing where the entrance was, and it was only because I overheard one of the parking attendants mention that one could enter *through the lot* that I proceeded by instinct around yet another wall, which did in fact open up to a beautiful arboretum-like space.

The flaunting of peacock feathers occurs inside the fortress, where the museum becomes a mega space complete with café, meditation or transition rooms where visitors can sit while going from exhibit to exhibit, a glassed-in court and a reading room. The idea, of course, as the *New York Times* so eloquently put it, is to "draw out the experience," a design plan with superfluous space that has visitors walking and walking, so that by the time they arrive, "they'll need a drink." The *Times* also asked, "Can a design convey an institution's feelings of guilt?" referring, of course, to the breaking of the will of Dr. Albert C. Barnes concerning the Merion estate.

As museums go, the walk referenced by the *Times* is nonetheless a beautiful stroll that might get you thinking along Japanese lines. The Zen-invoking

TWBT window design near the monumental entrance archway manages to keep things on a modest human scale, but once inside, an explosion of space ends all understatement. The "architecture of guilt" seems accompanied by strains of music by Vivaldi—or Wagner.

I last visited the Barnes Foundation in Merion as a Chester County high school senior. Our art teacher arranged for a special tour with Dr. Barnes's assistant, Violette de Mazia, who walked us through the exhibit and provided commentary. Before the class trip, we were briefed rather extensively on proper Barnes etiquette, namely not to step beyond the electrical tape on the floor of the exhibit rooms in an attempt to get a closer view of the paintings. Since one could hardly miss the floor tape in the old Barnes, there were no law breakers; however, in the new building—where the perfect duplication of the Merion exhibition rooms had me thinking that nothing had changed— there's no electrical tape on the floor but rather a discreet line that could easily double as a design flourish rather than a barrier. Many on press day, this writer included, were asked by wandering guards to "please step back behind the line," causing many looks of puzzlement until the guard pointed out that the design on the floor was actually the border.

On press event day, journalists arrived by buses from New York and then headed inside to join their Philadelphia peers at a breakfast buffet. Two DJs near the Light Court podium played a sad compendium of French songs reminiscent of Edith Piaf, although I was later informed that the music was a soundtrack from Cirque du Soleil. The bittersweet melodies invoked something vaguely existential and possibly troubling—images of the controversy surrounding the move of the Barnes from Merion to its present location came to mind—although this was obviously not the intention of the music makers.

The opening speeches propelled the event forward. Ms. Tsein from TWBT, her heart full, nearly lost it when she described how remarkable it was to see the Barnes plan now a reality, the vast space filled to capacity.

Derek Gillman, in the King's English, remarked how the new building's state-of-the-art lighting had caused some to ask if some of the paintings had been cleaned.

Art and architecture tours were arranged for interested press. Those on the tour saw classrooms with large American walnut desks, learned about the diffusing light elements in the Light Court and inspected the auditorium, referred to as "like a college-style lecture hall" because of its emphasis on the spoken word rather than music. The auditorium has a wool fabric–style ceiling and designer Italian leather seating for at least

Albert C. Barnes at
his Merion estate
sometime in the
1940s. *Courtesy Barnes
Foundation.*

150 people, although 12 or more people could easily be added along the sides in a setup arranged, as one tour guide explained, "to get people to challenge the lecturer."

The world of Barnes art can be a fleshy collective of reclining female nudes in all manner of repose—from Georges Seurat's *The Bathers* to the nudes of Modigliani—giving way, if one were prone to sensual analysis, to mental impressions of Mr. Barnes's preferences in theoretical love, as laid out in stark contrast to the high-rise projectile of Ellsworth Kelly's phallic totem, something that "Dr. Barnes would not like because his tastes were focused on the soft and circular," as an artist friend informed me.

The large room devoted to Dr. Barnes's correspondence is extremely apropos, but why not include a large portrait of Dr. Barnes in the Light Court so that it's the first thing a viewer sees upon entering the building?

The museum, sans the walled, desert-dwelling exterior, is a winner. The *New York Times*, despite its first review, was thoroughly won over and praised it as "comfortable and user-friendly," maintaining that the Barnes Foundation is an "egalitarian aggregate of the fine, the decorative and the functional" and that the whole thing "comes across more clearly, justifying its perpetuation with a new force."

But other publications, like the *Sacramento Bee*, called the design and layout of the new museum "a bland new 93,000 square foot building," as well as a "convoluted design." The *Bee* found nothing to like about the new Barnes. "The result is one part Colonial Williamsburg, where authentic and ersatz mingle; one part Lehman Wing, where an excellent New York collector's

expensive period taste is enshrined in a Metropolitan Museum of Art…and one part Disneyland Main Street USA, where a spiffed-up version of what time has torn asunder offers commercial entertainment."

Would the new Barnes have been even better if it had been designed near the Delaware, not far from Penn Treaty Park? This idea goes against the original plan to promote the Benjamin Franklin Parkway as a kind of "Museum Boulevard," with the new Barnes joining the Rodin, the Philadelphia Museum of Art and, at one point, the proposed Alexander Calder museum. But now that plans for a Calder museum have been scrapped, there's no reason to suppose that yet another museum will be built on the Parkway to replace it.

A Barnes museum near Penn Treaty Park would have been a boon for the city and something that Dr. Barnes, who was born into a working-class neighborhood, might have found agreeable. His idea, after all, was to establish an educational establishment dedicated to promoting the appreciation of art for an intended audience of factory and shop workers, since he had already made powerful and wealthy enemies in Philadelphia.

A Barnes museum outside the cultural loop ghetto would work to bring art into the lives of those who feel separated or alienated from art, due to finances or some perception that art and culture is for the rich and the (bow tie wearing) privileged few. Philadelphia in the 1940s and '50s was a terribly structured city in terms of social hierarchy, where mostly only old Social Register families stood to benefit. But Dr. Barnes did not care whether your name was Wanamaker or Strawbridge or whether you came from a rich line of Episcopalians. His goal was to bring art to the common people.

PURE MUMMERY

The most interesting architecture can sometimes be found in out-of-the-way places. The Mummers Museum at Second Street and Washington Avenue, for instance, defines its mostly undistinguished surrounding space with the marked "centeredness" of a cathedral.

The building's front exterior has an Art Deco tower and patterns of colorful imported Belgian tile that evoke the sequined braids and plumes of the Philadelphia Mummers. This frontal "flourish" costumes the building in much the same way that costumes change the appearance of the men and women who parade up Broad Street on New Year's Day. "The building

is like walking back into the '70s," the museum's executive director, Palma Lucas, once told me.

Opened in 1976 as part of the city's Bicentennial celebration, Ms. Lucas said the design of the building had to be approved by the Bicentennial Art Commission but that some things didn't sit well with them. "But they went over these minor details again and again and came up with the idea of a façade, which represents the Mummers' back piece," Ms. Lucas said.

Planning for the 1976 Bicentennial began as early as 1964. Although millions of dollars were spent on the construction of the Bicentennial Chestnut Street Transitway (an area of Chestnut Street closed to vehicle traffic from Eighth Street to Eighteenth Street), the celebration was an economic failure for the city. Less than half of the expected visitors came to Philadelphia. In addition, the Transitway deteriorated into a desolate and sometime dangerous street filled with dollar stores and check cashing venues. Philadelphia's only Bicentennial "success story" was the refurbishing and completion of Independence National Historic Park and Penn's Landing.

Although not part of the partially federally funded Bicentennial failure, the (still thriving) Mummers Museum would definitely qualify as a success story from that era. Designed by award-winning Philadelphia architect and novelist Tony Junker, a partner in the firm of Ueland Junker McCauley Nicholson, Mr. Junker has also designed buildings all over the nation, including the St. Augustine Center for the Liberal Arts at Villanova University and the Flynt Center of Early New England Life in Deerfield, Massachusetts.

Mr. Junker told me that the museum's doors are currently too small for today's massive Mummers floats to be moved into and installed at the museum. This fact can hardly be categorized as a design flaw. "The Mummers have all their clubhouses along Second Street," said museum tour guide Eileen Garbarino. "The clubhouses are like garages; that's where they meet and build their floats. We have no room for the floats in the museum."

The museum contains an abundant collection of Mummer memorabilia and paraphernalia. There are costumes from the turn of the twentieth century, Mummers products in an on-site gift shop and a number of museum programs for adults and children. "We have two original adult costumes and one child's costume from the 1920s," Ms. Garbarino added. "We also have a Ferrico captain's costume from 1985 which is on permanent display. People are surprised to hear that in 1985 this hand-made costume cost $5,000. Costumes are donated to the museum. We display them because we like to give all the bands a chance to get a little publicity."

In the world of mummery, the captain's costumes are most festive and elaborate. "We have an original wooden captain's costume from the 1970s," Ms. Garbarino told me. "Picture wooden scaffolding built around the body. These wooden costumes were called old frame suits. They weighed at least a hundred pounds. You'd have to open the costume up to see what the frame looked like. The captains carried these frames the full length of the parade. Today there are still backpieces that weigh up to 150 pounds."

The museum experiences its busiest season right after the Mummers Parade on Broad Street. "After the parade, we get Mummers fever. A lot of people from out of town that stay for the parade then come over and visit us. Most of the time, attendance at the museum is seasonal. In the summertime, our art classes are very busy."

PHILADELPHIA'S MORMON TEMPLE AS MANSION

In 2016, I participated in a press tour of Philadelphia's new Mormon temple. On the way to the event, I thought of my introduction to Mormonism as a teenager.

After a Mormon family moved into our neighborhood, I quickly read the only Mormon book in my high school library: Joseph Smith's *No Man Knows My History*. Joseph Smith, the founder of the Mormon Church (established in 1830), claimed to have had a visitation from an angel who showed where to dig to find the ancient religious history of American civilization on a hill near Palmyra, New York. That history was engraved on metal plates and became the Book of Mormon, which purports to be the story of Jesus Christ's presence in the Americas after his death and resurrection in Jerusalem.

One other memory concerns a trip I made with my parents to the 1964–65 New York World's Fair. Here I saw a number of religious sites, such as the Vatican Pavilion, a Russian Orthodox chapel and the Mormon Pavilion. What stood out for me in the Mormon Pavilion was a copy of Thorvaldsen's *Christus* statue in Copenhagen. The tall, imposing white statue of Christ was conceived by the Mormon Church for the $3 million pavilion. Its sheer size and dominance not only commanded attention, but it also helped put the church into the popular consciousness. The *Christus* statue followed the accepted Mormon practice of representing Jesus as striking and extraordinarily handsome. Representations of Mormon Jesus were not dark and swarthy Rembrandt likenesses but rather cleft-chinned, blue-eyed,

well-built and golden- or auburn-haired. This is the Jesus of Jeffrey Hunter in *King of Kings*, not the thin, ascetically inclined Jesus in Pier Paolo Pasolini's wonderful *The Gospel According to Saint Matthew*.

The New York World's Fair, in fact, was a pivotal moment for the Mormon Church. "The huge leap forward initiated by the Mormon Pavilion must be considered a seminal event in the evolution of the Church's use of media in spreading the gospel message to the world," wrote Dean of Religious Education Brent L. Top of Brigham Young University. "From that time to the present day, the Church's outreach through its use of technology and media has increased steadily and exponentially." I'll say.

This fact was clearly in evidence during the Philadelphia temple's first media tour. The press group of about twenty-two people included print and broadcast media. A *Fox News* reporter was there along with her camera crew. There were other unidentified camera crews and a number of photographers, although no pictures were permitted inside the temple itself since it is considered the House of the Lord. The press met in the less than inspiring Robert A.M. Stern–designed Meeting House, the place for Mormon Sunday worship, since the temple is reserved for marriages (and the "sealing" of those marriages for eternity) and for the baptism of the deceased. The tour was to last two hours with light refreshments at the end.

There are 112 operating Mormon temples worldwide. At times, the building of a temple or a Mormon institution has caused some controversy. In 1984, when ground was broken in the Mount Scopus area of Jerusalem for the Brigham Young University Jerusalem campus, all hell broke out. Ultra-Orthodox Jews saw this invasion of Mormons from Utah as a proselytizing threat and sought to have construction halted. The Mormon Church had to hire security guards to proceed with the project. A famous Ultra-Orthodox pop star, Mordechai Ben David, even composed a hit single titled "Jerusalem Is Not for Sale":

> *Jerusalem is not for sale!*
> *Voices, crying, thundering throughout our cities,*
> *You better run for your life, back to Utah overnight,*
> *Before the mountaintop opens wide to swallow you inside.*

Today, the BYU Jerusalem campus hardly raises an eyebrow, although students there must sign a contract promising not to missionize.

Our Philadelphia temple tour guide was the Harvard-educated Larry Y. Wilson, who serves as executive director of the Temple Department in Salt

Lake City. The silver-haired Wilson had a sleek *Father Knows Best* demeanor. He took us from the Meeting House to the temple entrance, where coverings were put over our shoes. The shoe coverings were to keep street dirt off the meticulously clean temple floors and rugs.

Inside the temple, Wilson described the furnishings and the commissioned art on the walls, including several original murals. He also explained how the temple's features were aligned to fit a southeastern Pennsylvania and Philadelphia theme, right down to the temple's main door and frame, with its bas-relief mountain laurel "Pennsylvania" blossom design. "We believe that the founding of this country was divinely inspired," he said.

The interior of the temple is an extravaganza of quality craftsmanship. Nowhere will you find the flimsy/cheap construction materials you see in new construction all over town. There are no thin walls or doors that weigh a few ounces. One astonished journalist asked how the temple was able to ward off the sound of outside traffic. Wilson replied, "With very thick walls."

Press questions about the Mormon religion began early on. This was to be expected, given that much of the tour included references to Mormon theology and doctrine. These references were woven into descriptions of the temple's Ionic, Doric and Corinthian columns; the decorative lighting; the flooring; the outside fence; walkways; and the landscaping. "We believe that this is the Lord's House," Wilson reiterated, something that many Christian denominations might ascribe to in theory, but that in practice falls short, especially when one considers those Protestant sanctuaries that are used for services on Sunday but on Tuesdays are transformed into jazz festival arenas or concert halls.

Emanuel Swedenborg (1688–1772), a Swedish scientist, mystic and founder of the Swedenborgian Church, wrote that heaven is filled with cities and houses of many different types. There are mansions and simple homes, lavish communities and humble communities. We reap in heaven what we sow in life, meaning that those who were *terrifically good* in life live in afterlife mansions of marvelous splendor, while those who lived mediocre lives on earth inhabit less than spectacular "heavenly" neighborhoods.

Swedenborg claimed that he was guided by God to visit the realms of the afterlife in spirit form and wrote volumes on what lies beyond this life. Among his many books, *The Lives of Angels* posits the premise that there's cosmic sex in the afterlife, but only for married couples.

Swedenborg reported that an angel told him the following during one of his heavenly tours: "All men who are newcomers are examined, as they come up towards heaven, to see what kind of chastity they have." They

are brought into the company of young women, heavenly beauties, who sense from their tone of voice, their speech, their eyes, their body language and the aura they emit what kind of people they are in regard to their love for the opposite sex. If they are unchaste, the young women flee and tell their companions that they have seen satyrs or priapuses. The newcomers themselves change as well, and to angels look all hairy, with feet like calves or leopards. Before long, they are expelled so that their lust will not pollute the region's aura.

Swedenborg said that married partners experience the same love in heaven as they did in life, only it is stronger and with greater feeling and sensitivity. What comes from sexual intercourse in heaven, however, is not the birth of children, but spiritual offspring. "The marriage of goodness and truth is a marriage of love and wisdom, and love and wisdom are the offspring of this marriage. Since in this situation the husband is wisdom and the wife is its love, and since both are spiritual, the only offspring that can be conceived and born are spiritual."

That's not all. Rather than the so-called letdown that usually follows earthly intercourse, in heaven there is only a cheerful "constant flow of new vitality" that refreshes and illuminates the couple. Swedenborg also reported that there are various levels of heaven and that there are cities, towns, magnificent houses and palaces that could very well rival some of the mansions described in this book.

In Mormonism, there's a belief that non-Mormon ancestors in the afterlife are free to accept or reject the offer of baptism into the Mormon faith by relatives or friends still living on earth. If the long dead consent to be baptized in the afterlife, they would then immediately be upgraded into a greater heaven with more beautiful mansions.

In the Philadelphia temple, each floor is designed as a kind of stairway to heaven, so as one goes higher the furnishings and the chandeliers on each floor become more elaborate until one reaches the apex, or the Celestial Room, the most sacred and beautiful room in the temple. In the Celestial Room, the hanging chandelier fans out into the room like an exploding comet. Visiting Mormons in good standing (Mormons must get a recommend pass from their bishop or stake leader in order to enter the temple) pray and meditate here despite the fact that this room, as well as the entire temple, tends to resemble a lavish Ritz-Carlton hotel with a lot of pictures of Jesus.

The press's fascination with Mormonism peaked at the baptismal font. Generally, a concerted design effort would be necessary to transform a baptismal area into a secular-looking space, but one can see elements of

that here, for it is not hard to imagine someone perceiving this space, despite its sacred nature, as a hot tub of the highest quality, perhaps a faux Disney re-creation of the baths of ancient Rome. Still, "spectacular" doesn't begin to describe the font area that had journalists gazing into the pool of water as if lost in the bliss of hypnosis. Like characters in a Robert Altman film, we journalists formed a long line along the circumference of the curving marble barrier that overlooked the oxen-accented pool as questions about Mormonism ricocheted back and forth like tennis balls.

The baptismal font was to me the highlight of the tour, although later in the marriage sealing room, where couples kneel facing each other across a small altar to have their marriages sealed for all eternity, things got a little dicey. A journalist inappropriately dressed in shorts, a tight T-shirt and a frayed baseball cap asked Wilson if same-sex marriages are performed in the sealing room. The question seemed to come across as a triggering device, designed to set off a series of consecutive explosive comments from other members of the press, all related to same-sex marriage and engineered to put Wilson on the defensive. It just wasn't fair, since everybody knows the Mormon position on same-sex marriage.

Perhaps it was possible that a reporter in this day and age had no clue about the Mormon stand on same-sex marriage. Many Americans, after all, are tremendously ignorant about religion. This is why the wife of one visiting Mormon Elder told me that people who should know better mistake her for a Mennonite or Amish. "But would an Amish woman wear these kinds of heels?" she asked me, showing me her feet ensconced in the brightest of the bright Frederick's of Hollywood heels that would attract a hearty thumbs-up at an haute couture fashion gathering.

As for that baseball-capped reporter, his question did set off a few follow-up comments, although the savvy Wilson was able to defuse whatever small bombs lay hidden in the reporter's initial inquiry.

PHILADELPHIA AND PARIS

Over the years, many comparisons have been drawn between Philadelphia and Paris. Some of the comparisons are exaggerations based on wishful thinking, while others draw sensible parallels.

One commonly cited similarity is the Benjamin Franklin Parkway's resemblance to certain sections of the Champs-Élysées. I say "certain

sections" because anyone who has traveled to Paris knows that the Benjamin Franklin Parkway, to date, is relatively free of commercial establishments—not counting bars and cafés—while the Champs-Élysées, especially near the Arc de Triomphe, is heavily dotted with Times Square–style movie theaters and even a neon-lit McDonald's.

While in Paris several years ago, I walked from the Arc de Triomphe to I.M. Pei's Pyramides at the Louvre by way of the Cour des Comptes and the Tuileries. The weather was typically pre-April: gray and rainy. But when you're in Paris for the first time, you're willing to tolerate anything, so I kept telling myself, "This is Parisian rain; I'm walking where André Gide once strolled, so bring it on."

There's a vibrant and even sordid nightlife along parts of the Champs-Élysées. Forget the sedate crowds you see on the Benjamin Franklin Parkway. Here you'll see groups of men—Algerians, Moroccans, West Africans and some Parisians—huddled in groups seeming to make secret deals. Along the avenue, I noticed many upscale Muslims—women in elaborate silk veils and gold jewelry, some heavily perfumed, and always trailing their husbands. An occasional American student looked ridiculous in a baseball cap and baggy clothes, especially compared with the European men in tight jeans and low-riding belts.

THE SHAPE OF A MODERN CITY

Another, subtler comparison is made: both Philadelphia and Paris have iconic pyramids that were built at roughly the same time and evoked similar reactions.

Paris's Pei pyramid, at the entrance to the Louvre, breathes new life to traditional architectural forms (as represented by the Louvre) with its complex interlinked steel structure frozen in reflective glass. The Paris pyramid is actually two, one visible from the Louvre courtyard and the other linked at the base of the first but descending into the ground, its point touching an interior cultural center, shopping mall, auditorium and parking garage. (It is also a hangout for teenagers.)

When the Pei pyramid was built in the late 1980s, it generated as much controversy as the building of Philadelphia's Mellon Bank Center, with its pyramid top, during the same period. The French newspaper *Le Monde* referred to Mr. Pei's pyramid as "an annex to Disneyland," and French

The BNY Mellon Center, formerly the Mellon Bank Center, was completed in 1990. Located at 1735 Market Street, the building is home to the Pyramid Club on the fifty-second floor.

environmental groups insisted that it would be a fine structure, "but only in the middle of a desert." Other critics said that Mr. Pei's warm, ocher-tinted glass structure disturbed the balance of the old Louvre courtyard, the seat of government before the construction of the Palace of Versailles.

In Philadelphia, the big issue of the 1980s was the breaking of the height limit for buildings. Philadelphia's architectural reactionaries fought to prevent the construction of buildings like the Mellon Bank Center because they saw tall buildings as a threat to the city's traditional low-rise skyline.

"The Mellon pyramid was a symbolic point in the sky," said pyramid designer Bill Louie, a principal of Kohn Pedersen Fox Associates PC, the firm that designed the Mellon building. "When I worked on it, it was a moment when Philadelphia was addressing issues of height. The Mellon Bank Center, along with Liberty Place, would be the first to break the height limit imposed by the statue of William Penn atop City Hall. The pyramid was a marker; it marked a change in attitude toward planning in the Center City area. The pyramid is about celebrating the breaking of the height limit."

Before overruling the height limit restriction, Philadelphia was losing its edge in terms of attracting tenants and corporate headquarters to the city. "Philadelphia had no architectural draw then," Louie told me. "The height limit forced buildings to be short and squat, while other American cities were building monuments that were truly iconic."

TIME TELLS

Time has proven the critics of both pyramids wrong. In Paris, the Louvre pyramid is now viewed as an example of modernism at its most elegant; it marks the Louvre's induction into the twenty-first century. In Philadelphia, had the architectural height limit not been broken, it is unlikely that the city would have grown as it did, earning the title of "the next great American city."

The Louvre pyramid and the two baby pyramids that flank it provide light and ventilation to the museum's subterranean spaces. It has a more ephemeral presence than the Mellon pyramid, which is really an open, porous grid containing the building's cooling towers.

The sixty-six-foot-tall Pei pyramid resembles a frozen fountain. Prior to its construction, this area of the Louvre was a parking lot. Today, it has become the museum's most popular entrance; nearly two-thirds of the 7.5 million annual visitors to the Louvre enter here.

Initially, Pei was reluctant to take on the Louvre project. He told *TIME* magazine in 1984 that he was not so sure that anything could or should be done about the Louvre. "I certainly did not want to take part in a competition," he said. "I asked for three months to think about the problem—not to draw or design anything; to think."

But his design has gradually become an architectural piece worthy of the fine art inside, and both pyramids have been designated as city "markers."

"Markers mark a moment in history, the winning of a war or a discovery," Bill Louie said. "In this way, the Mellon pyramid became a point in the sky, as was the William Penn statue. I thought about what the site was going to represent and what it needed to do. It really created a dialogue with City Hall by becoming a major point in the sky."

CLASSIC NEON SIGNS TO BRIGHTEN

The classic neon sign of old is slowly coming to be recognized as a form of American folk art. Some American cities have come to be recognized by iconic neon signs. Consider the city of Boston, which for more than thirty years has become linked with the large blinking Citgo neon sign that can be seen from almost any vantage point along the Charles River. Neon used to define East Baltimore Street in Baltimore in the late 1960s and early '70s. Philadelphia had less clustered neon, but there was the Levis Hot Dog neon sign and the Goldman theater sign on Market Street.

Len Davidson is a world-renowned neon collector whose 1999 book, *Vintage Neon*, contains more than 360 photographs of neon signs throughout the country. The photo archive (published by Schiffer) contains neon signs captured by well-known photographers, as well as images from Davidson's own Philadelphia-based Neon Museum on Mount Vernon Street.

Mr. Davidson is an unassuming, down-to-earth guy who used to teach sociology at the University of Florida. An academic career can be much like a life-threatening disease if not monitored carefully. For Mr. Davidson, teaching was certainly not enough to make him feel complete. Back in 1977, when he opened a tavern in Florida as a sidelight to teaching, he decided to decorate the place with old neon signage. It was then that his collector's mania took hold. But for Mr. Davidson, it was much more than just storing artifacts in an attic or basement. He wanted to do something with his neon finds. After the demise of the tavern, his lifetime goal became to establish a neon museum in Philadelphia, a task he's been focused on for the last twenty years.

"My first love when I worked at this bar was putting neon signs on the ceiling. It seemed so magical," Mr. Davidson told me by phone. "I went around collecting signs, collecting stories from old-timers, people who made signs, from architects, business owners and historians. That period set the stage for my book when I became a neon folk art advocate and a writer at the same time."

Establishing the Philadelphia Neon Museum, outside his home on Mount Vernon Street, has not been easy, although Mr. Davidson was lucky enough to secure a five-year contractual satellite neon museum at the Center for Architecture at 1218 Arch Street. Perhaps the satellite museum is a precursor to something bigger, like his dream of a real museum being realized. Only time will time, but for the time being, Mr. Davidson can take consolation in knowing that for those ahead of the curve, there's always a testing, waiting period.

Years ago, Philadelphia architect Robert Venturi wrote a letter of introduction to Anne d'Harnoncourt at the Philadelphia Museum of Art. Venturi's plan was to help Davidson convince the Museum of Art to house his Neon Museum. "Anne d'Harnoncourt wrote me back a very nice letter telling me no," Mr. Davidson remembered. From PMA, Mr. Davidson went on to approach the Franklin Institute. The Franklin Institute accepted the idea initially, but when it was presented before the upper levels of management, the idea was squashed. The same thing happened years ago when Mr. Davidson approached the Pennsylvania Convention Center. "We made a mockup of the proposed Neon Museum. Initially, there was a good reaction, but then the upper levels nixed it," Mr. Davidson said.

"I've had various people who were committed to doing the museum, and for some bureaucratic reason, they couldn't do it. Whenever I talk to regular Philadelphians about a museum, they say, 'Yes, it's a no-brainer, why not?'"

Some progress was made at the new Please Touch Museum when there was serious talk of Mr. Davidson having a hand in the design of the restaurant there. "In the planning stages of the Please Touch Museum, I was told that they would have a restaurant, and that they wanted to do neon in the restaurant. At the time, a group of Canadian designers were designing the museum. They came to my studio and saw my stuff, but they were like clams," Mr. Davidson said. "Either they had no appreciation for neon, or they felt that I was stepping on their territory. They were not open to the idea at all."

With the Pennsylvania Convention Center expansion, Mr. Davidson has been speaking to architects about displaying some neon images and making Arch Street from Eleventh to Broad Street a kind of sign corridor. "This would be three or four blocks of a light show, a neon district, bordering the Reading Terminal and ending at the Hard Rock Café. If this comes about, you will be able to go down Arch Street and see incredible lighting on both sides of the street. This could become a tourist attraction and a nightlife district," Mr. Davidson said.

While Mr. Davidson believes that old neon can be a folk art, he also realizes that it is an underappreciated art because it is all around us. "The people who made it are largely anonymous," he said.

FROM HISTORIC HOUSE TO CIVIL WAR MUSEUM

Thanks to nineteenth-century industrial sprawl, the Frankford section of Philadelphia is mostly an uncelebrated part of the city. But from the early 1700s to the Revolutionary War period, it was the place where Philadelphia's upper classes had their summer mansions.

The historic Ruan House, now the home of the Grand Army of the Republic Civil War Museum and Library, managed to survive the demolition of Frankford's palatial homes like Waln Grove, Chalkley Hall and Port Royal (whose main room was dismantled and is now the "Port Royal Room" in Delaware's Winterthur Museum).

Built in 1796 by Dr. John Ruan, a wealthy physician from the West Indies who became part of Philadelphia's gentry class, the Georgian mansion has stylish Victorian mantels and a cantilevered circular stairway. Next to the mansion is Dr. Ruan's first house, built in 1792 and now the home of the museum's library and archives.

While the home is listed in local, state and national registers of historic places, certain features inside were altered over the years (a secondary staircase was moved to another part of the house), but the structure's integrity remains intact. The main room on the second floor (now the meeting and program room for the museum) was Dr. Ruan's patient area, and the nearby kitchen with the very large window was Dr. Ruan's "in house" operating room.

Along the first floor are the original open-sash Jeffersonian windows, a perfect complement to the museum, which contains thousands of Civil War artifacts and documents. "At some point, Dr. Ruan vacated the house and moved to Florida, and the mansion became a private home," said GAR Civil War Museum vice-president and museum historian Andy Waskie. "The mansion was also a school, and during World War I, it was purchased by the Knights of Columbus. They sold it to the museum in 1958–59."

The original museum was located in North Philadelphia at Twelfth and Wallace Streets, founded as the "Post Home" by Post II of the Grand Army.

"Each Civil War group was known as a Post, but Post II was one of the largest and most influential in the nation. It hosted Civil War veterans'

reunions, and it had thousands of members. But in 1926, the veterans—who were in their nineties and one hundreds—realized they were mortal and chartered the present museum to preserve their artifacts, books and records," Mr. Waskie noted.

As the neighborhoods around North Philadelphia deteriorated, the first museum building fell into disrepair. It was then that the few remaining members of the Post decided to move the museum to the lower Northeast. Membership was not open to the general public then, only to Sons of Union Veterans members. In 1984, that changed when Mr. Waskie, a new member, collaborated with the few remaining members to make changes. "When I joined, there were only six members. We saw the potential for education and changed the bylaws to allow membership to anyone. Today, we have over two hundred members and an all-volunteer staff," Mr. Waskie said.

The museum, which is open only on Tuesdays, also has an active speaker and concert series.

Walking among the museum's rooms, I noticed a display featuring the personal possessions of General George G. Meade, such as the general's field hat (with a bullet hole in it), which he wore in the Battle of Fredericksburg. The hat was then on loan at the Gettysburg Museum of History.

"We have the chair General Meade used at Gettysburg in his headquarters, his prayer books donated by his daughter. We own the horse head, Old Baldy, but it is now in storage after being on loan to Philadelphia's other (now defunct) Civil War Museum," Mr. Waskie said. (The defunct Philadelphia Civil War and Underground Railroad Museum was formerly located on Pine Street in Center City).

On display in the Frankford museum are the handcuffs owned by John Wilkes Booth intended for the kidnapping of Abraham Lincoln. There is also a strip of the bloodstained pillowcase where the head of the dying President Lincoln lay.

There are also Civil War weapons, uniforms and John Brown and Lincoln memorabilia. The rich collection contains scores of letters and diaries of the period, artifacts, paintings, Post records, documents signed by President Lincoln, military orders and various generals' reports issued during the war. Captured Confederate money is also amply displayed. "Union soldiers brought the money home as souvenirs, and they were known to light their cigars with it," Mr. Waskie said.

There is a cannonball-filled tree stump from the Chickamauga battlefield and a section of a stockade from the notorious Confederate Andersonville Prison, where forty-five thousand Union soldiers were imprisoned and

thirteen thousand died from malnutrition, disease and poor sanitation. There's also a pair of Confederate "camp shoes," made from canvas, as well as the military sash worn by Confederate general J.E.B. Stuart, a graduate of West Point before the war.

In the world of the esoteric, the Frankford museum has been the subject of serious research by the South Jersey Ghost Hunters. "I'm a healthy skeptic," Mr. Waskie assured me with a laugh, "but the museum has had them here a number of times to do research and recordings. They have confirmed that we have a number of entities in here, namely two former members who love the place. They also identified people who were here in previous times when Dr. Ruan did his surgery here. There are some strange things that go on from time to time. When you close up at night, you sometimes get a tense feeling that someone is behind you, but this could be anything, you know."

Mr. Waskie, a professor in Temple's Language Department and founder and co-director of Temple's Civil War and Emancipation Studies program, said that the museum is in the best shape it's been in for twenty-five years. The museum is a major attraction for people wishing to do genealogical research and study Civil War battles. Students are also drawn to the museum when they do National History Day projects.

As the last Civil War museum in Philadelphia (the defunct Pine Street museum originally had state funding for a long-term lease in the historic Independence Mall area, but that funding was rescinded by Governor Rendell because of the economic crises; the future of that museum is now in limbo), Mr. Waskie said he would like to see the head of Old Baldy taken out of storage and reunited with the reins on General Meade's horse, currently on display. "The head of Old Baldy was obtained by two members of the Grand Army. They had it preserved and then put the skin over a plaster mold and framed on a wooden fence," Mr. Waskie said.

Perhaps one day, the other historic artifacts once on display in the Pine Street museum—like the playbill that President Lincoln held in his hands when he was assassinated, as well as a lock of his hair and a wanted poster for John Wilkes Booth—will also be redisplayed for the public to enjoy.

Chapter 3

"When They Tore It Down
the Bats Came Out"

Convent Mansions

When Pope Benedict XVI closed Rome's centuries-old Santa Croce monastery in May 2011 for "liturgical and financial irregularities" and transferred the twenty or so in-house Trappist monks to other monasteries, he put an end to a "worship venue" that had become a hot spot for Roman high society. Santa Croce's abbot, an ex-Milan fashion designer, had been told to get out of town by the pope some years before for his part in turning Santa Croce into a celebrity ashram. Madonna loved to visit Santa Croce, although with the closure, Lady Gaga will never get a chance to follow in her footsteps.

"Liturgical irregularities" covers a lot of territory. In Santa Croce's case, it was liturgical dancing. That's when people in chiffon-like costumes succumb to attacks of narcissistic bombast and dance around an altar. Sometimes the dancers get really fancy and hold up incense bowls in a reenactment of Incan pagan ceremonies. Some New Age (read: post-conciliar) Catholics will tell you that this is prayer, that the movements of the dancers' limbs are being guided by the Spirit. But which Spirit?

The star draw at Santa Croce was Sister Anna Nobili, a former lap dancer turned nun whose liturgical dancing stunts became a YouTube sensation. The unconventional Sister Nobili—sans veil, of course—danced around a crucifix in a way that called to mind images of a snickering Larry Flynt in

the days of *Hustler* magazine. Sister Nobili's gyrating put a new twist on the phrase "in the spirit of Vatican II."

Rarely do monasteries fall from grace Santa Croce–style. Most just die a natural architectural death—the building becomes too expensive to operate or a larger structure is needed. There are monasteries that seem to never change and where dilapidation from the centuries is transformed into a venerable patina, much like Orthodoxy's Mount Athos.

Some monasteries, like the Poor Clare Monastery at Corinthian and West Girard Avenue in North Philadelphia's Francisville section, are abandoned and left to rot like discarded tires in a vacant lot. The reasons for that abandonment are explained here in an interview with a nun who lived in the monastery from 1955 until the Poor Clares left North Philadelphia in 1977. First, some history.

Not long after the Poor Clares left the monastery in 1977 for their new home in Langhorne, the property was taken over by 2012 W. Girard Associates. The new owners allowed the buildings to deteriorate until they were deemed too far gone for rehabilitation. Doing nothing to a property until it falls like the Wall of Jericho is an old developer's trick. Once things reach this stage, it's easy to say, "We have to level it. It's beyond salvation."

The three buildings in question—two circa 1890 brownstones framing a 1918-built Romanesque stone chapel—have intrigued passersby for years. The words "Poor Clare Monastery" are etched in large classic script above the main door of the chapel. The script and floral designs engraved in the exterior stone of the chapel stand in stark contrast to the area's row house monotony.

W. Girard Associates' vision is to build two four-story apartment-condo structures on the site. The complex would contain more than forty eight-hundred-square-foot two-bedroom units. W. Girard would also eliminate the old monastery garden area where the nuns used to pray. The plan, however, has not gone smoothly. Not only have preservation groups objected to demolition plans, but Licenses and Inspections is also making it difficult for W. Girard to secure a development permit. Pertinent issues concern height limit restrictions, zoning code violations and the proposal's lack of a proposed rear yard.

Five years ago, the same owner came up with a proposal for seventeen residential units. Although this plan was approved by the community, the units were never built.

While the monastery is part of the general Girard Avenue National Register Historic District, it is not listed in the Philadelphia Register of

Historic Places, hence it's out of the legal purview of the Philadelphia Historical Commission. This means that it is a vulnerable target for an overnight demolition—as in, "It's past midnight, let's fire up these bulldozers and tear up Poor Clare."

"I think it would be a shame for them to be demolished," said John Gallery, former executive director of the Preservation Alliance of Greater Philadelphia. "The development proposed in its place is really out of character, both in style and choice of materials and in density. It seems to be overbuilt for the site."

"The Poor Clare monastery at Girard & Corinthian will indeed be poor, if not preserved, restored and reused," said John Dowlin, president of Philadelphia's Save Our Sites (SOS). "It's a beautifully textured site, with quite the garden on the east side. If and when Girard College needs to expand, it's a logical site to consider. Note that many at UPenn regret that they didn't buy the Old Naval Home, when they could have."

One proposal being considered is giving the three historic buildings a façade-ectomy that would leave the buildings with their historic façades but nothing else. Some would call that a stuffed turkey. Center City architect Alvin Holm, who champions the classical tradition in architecture, said that this is far from an ideal solution. Holm described himself as a "once happy modernist."

Philadelphia's "once happy modernist" architect, Al Holm. *Courtesy Al Holm.*

The affable white-haired head of a small firm on Samson Street in Center City, Holm said that he changed his mind about modernism about twenty years after getting his master's in architecture at Penn. "I always loved the old style," he told me over lunch at the Irish Pub, a restaurant he designed in the classical manner. "But when I began teaching architecture…something happened."

Holm said that what he realized then was that continuity mattered. "And that was not what we were taught in any architecture school courses. We would look at these old buildings and ask our instructors, 'Well, why can't we do something like that?' and they'd say, 'Well, you can't do that anymore!'"

Classicism at that time had become an untouchable subject for instructors, who more often than not took great pleasure in making statements like, "Well, classicism isn't practical because you can't find stonecutters anymore," or "The age of ornamentation is over." Status quo evasions like this plagued Holm for years until he was finally able to see that these were not valid reasons at all but, in fact, were prejudicial aesthetic judgments formed by a prevailing orthodoxy that just didn't want to look back.

Holm's conversion from a modernist ideologue to passionate classicist didn't come easily. For starters, here was a man who once sat at the feet of Louis Kahn and who was mentored by the likes of Vincent Scully.

Holm remembered being charmed by Kahn. "He was a totally loveable human being. I don't think there was anybody who didn't like him—cab drivers, professors; he was charismatic, absolutely," he said, biting into a classic tuna melt. "But I think he was wrong. I think he took us down a path that led nowhere. And I think that's one of the problems with modernism in general. It's idealistic without any particular ideal."

Holm's image conjures up T.S. Eliot's Hollow Man or Tom Wolfe's view of modern architecture in *From Bauhaus to Our House*. Wolfe's view is unambiguous: the architecture world, like the art world and the literary world, is dominated by critics and academia, meaning that its buildings leave most people cold. Much of these "ideal-less" buildings, Wolfe noted, are the products of architects who only want to out-avant-garde the competition.

Although Kahn is credited with providing a link from classicism to modernism, many critics would agree with Martin Filler's essay in the *New York Review of Books* that Kahn "possessed neither the inventiveness of Le Corbusier nor the elegance of Mies." Filler wrote that architecture remained a struggle for Kahn because "he lacked extensive practical experience until well into middle age, and never mastered the appearance of effortlessness that many creators use to conceal their labors."

Kahn, Holm said, wanted to go back to the beginning, or to Walter Gropius's Ground Zero, that ideal-less world where the history of architecture doesn't exist. "Kahn would sit on a stool frequently and his disciples would sit on the floor, and he'd look down for the longest time and then he'd look up and say, 'I'd like to remember that moment when the walls parted and the columns became.' That's quite a poetic saying…but there never was such a moment, because there were columns before there were walls, there were columns before there was anything structural. By going back to the beginning, he erased four or five thousand years of history. He erased the knowledge that was accumulated for a very long period of time."

Holm compared what Kahn did to the kind of amnesia that old people get. "That's what modernism did. How can you call that progress? That's called losing your marbles."

Tough words from a man who in the 1970s worked for Vincent G. Kling, at that time the most famous architect in Philadelphia. "I was an unapologetic modernist until the 1976 Bicentennial got underway with its focus on looking back and taking stock. These were also the years when most architects had little respect for preservation and traditionalism. Architects who celebrated classicism, such as the work of Henry Hope Reed, were seen as part of a lunatic fringe."

Holm has his own version of what constitutes a lunatic fringe. Take Frank Lloyd Wright, for instance. While insisting that he has admiration for Wright's work, he faults Wright's towering ego for taking credit for the Prairie Style when the opposite is true. "A lot of those buildings were done by his peers and in a lot of cases a little bit earlier, but Wright gets credit for it all around the world. The Arts and Crafts movement was an international movement long before Wright came on the scene."

Perhaps the most bothersome issue for this 2009 Clem Laline Award winner—given to an architect for his/her advocacy of humane values in the built environment—is modernism's grip on the architectural schools, where architectural history and classical architecture are simply not taught. Today's architectural students are not looking toward the classical world for inspiration. "To my eye," Holm said, "the dominant style is continuity. And this was not what we were taught in architectural school courses. From a modernist point of view, all the old buildings are artifacts from a culture that doesn't exist anymore. All the books in architectural school are written from a modernist point of view."

Across the Schuylkill River on the Penn campus, William Whitaker, collections manager for the Architectural Archives Facilities at the University

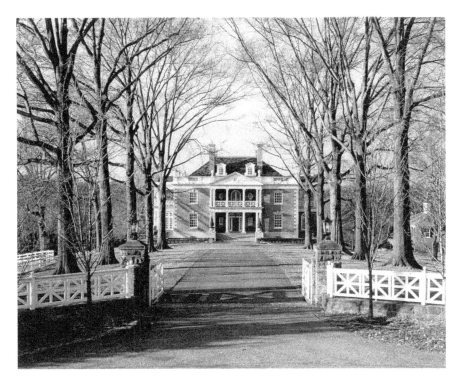

The Al Holm–designed Red Mansion. *Courtesy Al Holm.*

of Pennsylvania, reminded me that "modernism is not a fixed form, although in America it tends to be seen as such."

For Whitaker, the finest examples of American modernism can be seen through residential works, such as the Levitt brothers' houses that sprang up in the early to mid-1950s. These homes, he said, were influenced by the prefabricated building methods utilized in the World War II era during the construction of bomber plants and Ford factories. "So before you condemn modernism, consider that the ever popular indoor/outdoor patio in homes was modernist development, as was the sliding glass door (developed from the sliding screens of Japan)," he said.

Traditionalists believe that when the moderns stripped ornament away, much of the soul in architecture was lost. ("And with it went the soul of our cities," Holm would add.) Whitaker said that the two are not mutually exclusive: "In some architect's hands, when you stripped down the building to its bare essentials, it actually becomes a soulless expression, but in the hands of an able architect the placement of a window could

never be more beautiful because it brings light into the room in a very special and distinguished way.…In the classical tradition, in most cases you are designing from the outside in, but the modernists saw it as design by inside/out."

One criticism of modernism is its insensitivity to history, but Whitaker said the same can be said of Roman and Renaissance times, "where they went in and essentially changed the reigning sensibility," with a kind of "this is old and we want something new" attitude.

"I don't accept the idea that this kind of change is solely a question of modernism, though the modernists did do that," he added. "That's an old argument over modernism, but they certainly did that, there's no question. Even in the building where my office is, the Frank Furness library at Penn, its bright red, incredible detail is everything folks generally detested—and they were not modernists—at the turn of the century when they wanted to knock it down. It's the old giving way to the new, it's part of architecture."

But Whitaker, who graduated with a master's in architecture in 1995, agreed that in more recent times there's not so much an understanding of architectural history in the training of new architects. "What is capturing the imagination of young student architects is the incredible transformation of a global world, issues of how one interprets all this diversity, of both people and information into a given architectural design. This is really what is fascinating them now. It's certainly not something that's looking towards the classical world for inspiration."

And that's a tragedy, according to Holm, who regrets that students are not learning about the fabulous architects who designed the old train stations and the big hotels. Architects like Kendall White and Bernard Sawyer have slipped into—if not quite obscurity—at least disuse. But even Whitaker is quick to point out that you don't have to define modernism as strictly "for" or "against" terminology.

A counterpoint to Kahn, he said, is Bob Bishop, a Philadelphia architect who studied with Wright in Taliesin. "Bishop brought back a wonderful sensibility about space, about forms, and about materials in the 1930s through the 1960s," he said. An example of Bishop's work is the District Health Center at Lombard and Broad Streets in Philadelphia, a soft modernist building with a delicate, refined and un-Kahn-like scale.

As for Holm, who said that City Planner Ed Bacon once patted him on the head in a kind of knighthood and said, "You're on the right track," God is always in the details. And that, usually, spells ornament. "We embellish what we revere," he said. "We adorn that which we love."

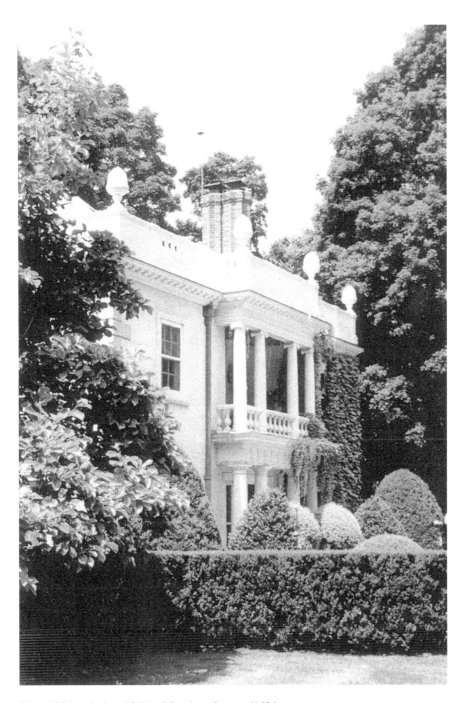

The Al Holm–designed White Mansion. *Courtesy Al Holm.*

But the truth is, they'll always be people who want to minimize that. Holm said that the only façade-ectomy he's seen work has been Philadelphia's Portico Row at Eighth and Spruce Streets. "Philadelphia is alone among American cities in having such a rich heritage of historic buildings. Most of the big cities in the country have taken them down. Kansas City is just a fraction of the city that it was in the early twentieth century. After the Second World War, they just began demolishing office buildings to make parking lots for people who work in the city and commute. Philadelphia never did that."

Holm likes to say that as the Americans were triumphant in Europe and bombed the heck out of Dresden, and as the Germans made their own mess there, once the war was over America began to disseminate and reinvent itself. "People now look back and say, 'How could that have happened?'"

It happened, he says, because modernism took control. "After the war, all the schools in the country changed their curriculum. All the architecture schools stopped teaching the orders of classical architecture. The Poor Clare buildings are very good in themselves and are excellent examples of their ilk in their time," Holm said. "They have a quality above and beyond of just being representative of an era, especially the chapel. They also form a nice relationship to the college across the street."

Holm also believes that the buildings can be retrofitted, specifically in the areas of plumbing and electricity, for contemporary use. "It's generally not true when people insist it's cheaper to tear down old historic buildings rather than bring them up to date," he noted.

Holm wrote in the Spring 2011 issue of *Construction Today* ("Preservation and the New Traditionalism") that as many notable modernist buildings pass the age of fifty, they are achieving historic landmark status but are "notoriously difficult to restore....Traditional buildings that are designed to endure for the long term (by employing time-tested construction techniques) are also relatively easy to maintain, and when neglected, they are not difficult to restore."

The monastery was demolished in 2011.

THE POOR CLARE NUNS AND THE WIDENER MANSION

Founded by St. Clare (a friend of St. Francis of Assisi) in the thirteenth century, the Poor Clares who came to Philadelphia in 1918 were part of the so-called primitive order. Other branches of the Poor Clares include

the strict observance Colettine, who practice mendicancy and perpetual fasts (Lent without end), live in strict enclosure, go barefoot and wear the traditional habit, and the Urbanists, whose rule was modified and made less austere by Pope Urban IV. There are also the Poor Clare Nuns of Perpetual Adoration (PCPA), a Pontifical Order of Cloistered Nuns founded in Paris on December 8, 1854.

When the Poor Clare nuns came to North Philadelphia's Girard Avenue in 1918, it was an area inhabited by wealthy Gilded Age industrialists like Peter A.B. Widener. Widener's Willis G. Hale–designed home was a baroque mansion on the corner of Broad Street and Girard Avenue. This urban castle formed a gateway of sorts to West Girard Avenue and Girard College. The Poor Clares, however, would have only known the building as a branch of the Free Library of Philadelphia, as Widener donated the structure to the city's library system in 1899. It remained a branch library from 1900 to 1946 and then mysteriously burned to the ground in 1980.

The Francisville area in the 1950s and '60s was also home to the Carriage House offices of architect Vincent Kling and Lankenau Hospital. Lankenau was founded in 1860 as the German Hospital of Pennsylvania on North Philadelphia's Morris Street but was renamed when the United States entered World War I, a time when anti-German bias was particularly pronounced.

Recent published news reports of there being a reflecting pool at the monastery might need to be revised after listening to the story of Sister Evelyn Eynon, a Poor Clare nun who began living at the Francisville monastery in 1955.

"There never was a reflecting pool," Sister Eynon told me by phone. "There may have been one before the sisters moved there. I didn't enter 'til 1955, and at that time, it was filled with large rocks from the wall of Girard College. They didn't know what to do with rocks at the time, so they were just put into what—to the people—looked like a reflecting pool. On top of the rocks there was a large cement cross." While Sister Eynon does admit that there could have been a reflecting pool "years ago," she described the garden as "not too big or too small."

The year 1955, or the pre-Vatican II era, was a healthy time for the Catholic Church in America. The Poor Clare monastery at that time housed between forty-two and forty-four sisters, a figure that would drop after Vatican II. By 1977, the year the Poor Clares moved from Girard Avenue to Langhorne, there were twenty-four to twenty-six nuns.

The move to the new monastery, Sister Eynon remembered, was bittersweet. "We knew that there was no way for us to take care of the needs

of the monastery. It needed new electrical fixings, it needed new plumbing. Even the fire escapes had to be redone; it was just a tremendous project. There was no way we could continue. The cheaper thing was to move, so that's what we did."

In the 1970s, of course, the accent was on building something new and modernism in general. This is the decade that—architecturally speaking—wrecked havoc on traditional Catholic Church architecture, when high altars were removed, statues and altar rails eliminated and new church design seemed to ignore St. Thomas Aquinas's assertion that the worshiper's mind is elevated to contemplation through material objects. (This idea is explored in depth in Michael S. Rose's 2001 book, *Ugly as Sin: Why They Changed Our Churches from Sacred Places to Meeting Places—and How We Can Change Them Back Again*).

The monastery itself contained both single rooms and dormitories, and the chapel had pews for visitors. Because they were a contemplative order, the sisters never left the convent, although Sister Eynon said that "two extern sisters took care of whatever had to be taken care of outside the monastery."

In the chapel, there was a wall that separated the nuns from the people. "We had our chapel in the back of the people's chapel with just grates between, and then we had an altar on our side for the exposition of the Blessed Sacrament." I asked Sister what it was like living in a dense urban setting. "Towards the end we would sometimes hear things from the street. On the other hand, I must admit that we were never really bothered. People were very good to us."

Life got a little shaky for the nuns after neighboring Lankenau Hospital moved to Wynnewood in 1953 and the building was demolished sometime later. "When they tore it down, the bats came out. There were bats in the eaves and things like that, so we had to be careful to keep from them."

Unlike country monasteries, which make soaps, jams, baked goods or wine, the Philadelphia Poor Clares made altar breads for many churches in the archdiocese. Visitors to the original monastery over the years included Cardinal Krol, who visited often, and Father Walter Ciszek, the first American Byzantine Rite Jesuit priest to do missionary work in the Soviet Union and whose cause for sainthood is currently being heard in Rome. "But no popes or anybody like that," Sister Enyon quipped.

While the new Poor Clare monastery chapel in Langhorne has the Spartan modernist look common among many Catholic churches built in the 1970s, the new building managed to incorporate the beautiful small round stained-glass window of St. Clare that once looked out over West Girard Avenue.

Selling Mansions

What happens when it becomes necessary to sell a mansion because it is too expensive to maintain in a perpetually troubled economy?

In 2012, CatholicPhilly.com reported that St. Joseph's University would buy the archbishop of Philadelphia's residence in Philadelphia for $10 million. "The Archdiocese of Philadelphia signed a letter of intent with St. Joseph's to acquire the 8.9-acre property and its three-story, 23,350-square-foot mansion that has been the home of Philadelphia's Catholic archbishops since 1935. The property sits across Cardinal Avenue from the university's campus along City Avenue," the press release noted.

Robert Huber of *Philadelphia Magazine* wrote this sardonic profile of Archbishop Chaput in 2015:

> *As archbishop of Denver, he built himself a small rancher with a driveway for his dented 15-year-old Chevy, white with a red interior, in which he traversed the 40,000 square miles of northern Colorado he was responsible for. He lived alone and traveled alone, as befits his calling, but Chaput is a creature of contemporary culture: In Philly, he treats himself to a drive-through lemonade from McDonald's (he's been spotted in a white Buick) or draws stares at Applebee's when he shows up alone, not wearing his collar, for a quick dinner. He loves science fiction, and theater. He has no use for opera. He has a problem with Game of Thrones—it's boring, and the archbishop can't stand to be bored. The summer humidity in the East drives him crazy, and the winter stirs up allergies. His favorite actress is Sophia Loren. He drinks Michelob Ultra.*

Despite the archbishop's unpopularity with the city's left progressive communities, he did a brave thing when he announced that the Archdiocese would be selling its twenty-three-thousand-square-foot, three-story stone mansion at 5700 City Avenue. The sixteen-room, six-car garage structure sits on slightly more than eight acres of land and has been described as a "baronial home." Purchased for $115,000 in 1935 by Cardinal Dennis Dougherty at a time when mansions like this seemed appropriate for "Princes of the Church," the opulent residence has come to be seen as an embarrassment of riches in the wake of financially driven closings of Catholic schools and parishes. Yet Archbishop Chaput's decision to sell the mansion and possibly live in the cathedral rectory had some observers going off the deep end. "Sell everything," they proclaim. "Sell the Vatican museum, sell St. Peter's,

sell tabernacles and centuries old liturgical art." Such die-hard calls for first-century austerity fail to take into account the difference between opulent personal living versus the ancient Jewish belief that nothing was too good when it came to building or decorating "the place where God lives," or the Temple in Jerusalem. For decades, hardworking Catholics gave willingly to build churches that would stand the test of time. Nothing was too good for a *temple*, be it marble altar rails, towering frescoes or a gilded high altar. Living a simpler, "humbler" life should mean downsizing from a mansion to a house, not turning churches into concrete Brutalism bunkers.

THE PRESIDENT'S HOUSE
THAT'S NOT A PRESIDENT'S HOUSE

President's Day 2010 brought considerable attention to newly opened Philadelphia's President's House at Fifth and Market Streets. Much of the attention focused on the positive aspects of the site of the original White House. No mention was made of the controversy that erupted when the new house was designed and built. While it's true that most people will, over time, forget specific criticisms concerning the design of the house, those criticisms will not disappear from the record. I find it hard to pass the President's House without shaking my head and thinking, "What a disaster, a perfect example of a building designed by committee!"

Not only does the "building" resemble a half-constructed modular home, but this skeletal tribute to Presidents Washington and Jefferson also might also double as a SEPTA subway stop. It's not a mansion and it's not a house. The structure's minimalist frame, while pretending to take smart cues from the (nearby) Robert Venturi–designed Franklin House, is a disaster on all fronts. The $10.5 million design tragedy, which incited an eight-year ideological war between the National Park Service and various African American community organizations, could have been a success if political squabbling had taken a back seat to architecture. But it did not. The current President's House is what happens when ideology trumps architecture and design.

This Kelly/Maiello Architects & Planners structure should be laid bare and another architect, like Robert A.M. Stern, brought in to redo the project. Stern, who has designed buildings in the classical tradition for the University of Pennsylvania and is the recent recipient of the 2011

Driehaus Prize for Classical Architecture, could at least be counted on to deliver a substantive building that would give Philadelphians and tourists alike a "real" President's House.

In 2011, *Inquirer* columnist Annette John Hall took the *New York Times* to task for its bad review of the house. The *Times* found the house to be an "ineffectual mishmash that has reached new lows." Hall countered that the present site's focus on slavery is justified because of the slave artifacts found in the building's foundation. "A narrow little inconvenient truth surfaced as plans were made to build a president's house memorial," Hall wrote. "Something conveniently omitted from my history books: Washington unapologetically owned more than 300 Africans, nine of whom he shuttled back and forth between his Virginia plantation and his presidential home in Philadelphia."

Sad but true, but those were slave days when only a few exceptional visionaries abstained from the "sin" of slavery. To judge eighteenth- to nineteenth-century behavior by twenty-first-century standards is both irrational and self-righteous.

The present structure—with its nine cluttered, open-air slave reenactment videos and grade school–like "teaching" storyboards fastened on the brick and granite walls—is an intellectual embarrassment. Visitors get quick *Reader's Digest*–style sound bites (think elementary school!) about the lives of presidential slaves. That's pretty much the entire enchilada. Call it the President's Slaves' House, but mixing oil and water like this comes close to false advertising. This is still true today, when critics, for the most part, have stopped writing about the site. As it is, the only "president" we get is the down-under, glass-enclosed archaeological dig showcasing the foundations of the real house built sometime between 1790 and 1800 (but demolished in 1833). While the framed "dig" works very well as a centerpiece, everything else on the ground floor—the representational door, window and fireplace frames of the original house—points to a curious flipflop as the slave narrative dominates and "enslaves" the story of the presidents (or the evil oppressors in the archeological hole).

It's not that the very important story of slavery in Philadelphia shouldn't be told. Tell it, by all means—shout it, memorize it and preach it from the mountaintop—but don't superimpose it onto another story. The design-message of the President's House seems to be nothing but a judgment of nineteenth-century proslavery views by "enlightened" twenty-first-century standards. As a result, the visitor leaves knowing nothing about some of

the important people who lived in this house, Benedict Arnold and Robert Morris to name only two.

If the mission of the architects was to cast aspersions on the presidents the house is supposed to honor, then they succeeded in equating the Founding Fathers in wigs with rabid Klu Kluxers. But the evangelical zeal with which this message is delivered is like getting hit on the head with a hammer. I'm thinking of those "instructive" billboards placed around the house, especially the one entitled "The Dirty Business of Slavery," which seems to be in the running for the Captain Obvious Award.

We don't need to be reminded like third graders that slavery was "dirty." And we certainly don't need to have this message drummed into our heads as if these billboards were stand-ins for teachers with rulers, ready to "smack" us in case we're not paying attention. Philadelphia deserves better.

TOWERS OF POWER: LITTLE MANSIONS IN THE SKY

From the beginning of the twentieth century to the early 1950s, Society Hill was a down-in-the-dumps fruit and vegetable marketplace. Deteriorating houses, trash, seedy sailor bars and dark alleyways teeming with dirt and squalor defined a place that architectural historian and preservationist Charles Peterson would soon dub "Society Hill."

In the early 1950s, as part of then mayor Richardson Dilworth's effort to revitalize the area, old houses were demolished and parks and walkways were built to replace them. City Planner Edmund Bacon once recalled how he would take friends on tours of the area at that time. "We'd walk past the dead cats, step over garbage and trash. Amidst all this trash and moldering piles, we had about five rehabbed houses. The effort was all to communicate the idea that you guys could live down here," he told writer Stephan Salisbury.

Bacon also told Salisbury, "It's almost inconceivable to think of what Philadelphia would be if Society Hill weren't there. I had a long-range view of what I was doing, and I held in contempt anyone who opposed it."

The crown jewel of Society Hill's redevelopment was architect I.M. Pei's plan to build luxury apartments and townhouses in the area. Pei's project was the winning entry in a design competition. The design called for the construction of a series of townhouses on Third Street. The townhouses were really a gradual segue to the three thirty-story towers built on a five-acre site.

Pei's method of blending structure with the environment and then integrating the two with geometrical design worked to produce an award-winning complex. The towers' rectilinear units (they were built first as apartments but went condo in 1979) included floor-to-ceiling windows with spectacular views of the Delaware River and the city. Pei's use of marble, concrete and glass and his penchant for soaring interior spaces attracted few renters at first because Society Hill was still considered a place to avoid.

The original towers, said longtime resident Herman Baron, were owned by Alcoa. "This was supposed to be a showcase building for aluminum, even though the aluminum window frames in the towers used to have drafts coming up," he said. Baron, editor of a small book, *I.M. Pei and Society Hill: The 40th Anniversary Celebration*, said that there's nothing like watching an approaching storm from a towers window. "Pei himself has said that Society Hill Towers is the best-maintained apartment complex that he has ever been involved with," Baron added.

In the past twenty years, a lot of books have been written and published about Philadelphia. Consider *Philadelphia Then and Now* by Edward Arthur Mauger; *Old Philadelphia in Early Photographs, 1839–1914* by Robert Looney; and the 1982 book *Philadelphia: A 300 Year History* by Russell Weigley, which covered the entire history of the city since its founding by William Penn. There was also my own book, *Philadelphia Architecture*, which was published in 2005.

Izzy Kornblatt, in a review of Gregory L. Heller's critical biography of Ed Bacon for the (Boston) *Phoenix*, calls the revitalization of Society Hill Bacon's "clearest success story":

> *The revitalization of Society Hill is Bacon's clearest success story purely in terms of goal accomplishment. What was once one of the poorest neighborhoods in the city is now safe, well off, connected with beautiful greenways and overlooked by three elegant residential towers designed by the architect Ieoh Ming Pei. No cheap historical imitation architecture was employed in revitalizing the neighborhood. Bacon's approach was innovative for its time: he restored the historic homes and tried to keep the existing feel of the neighborhood, but he insisted that new construction be clearly modern in style so as to distinguish the old from the new. Less fortunately, many poorer people were displaced by the selective demolition that was necessary and by the rising property values that the neighborhood's revitalization caused. Bacon himself was not blind to this. "I knew it was cruel while I was doing it," Heller quoted him as saying. "But think of Philadelphia if Society Hill was still the way it was. It was more important to restore this area than to maintain the low-income residents."*

COMMERCIAL MANSIONS IN WEST PHILADELPHIA

The Thirty-First and Market Streets area used to be an inconspicuous stretch of highway linking West Philadelphia with Center City. For a long time, that area's lone crown jewel was Thirtieth Street Station (formerly known as Pennsylvania Station), but today the station's prominence is split among a number of "competing" structures.

Besides Cesar Pelli's Cira Center, the city's latest architectural tour de force, there's the Edmund D. Bossone Research Enterprise Center and the newly refurbished Furness Centennial bank building, two striking additions to the streetscape that are next door to each other.

The Bossone Center—a sleek, state-of-the-art, $37 million research facility—resembles a futuristic sculpture at certain angles. Designed by Pei Cobb Freed & Partners—that's I.M. Pei of Society Hill Towers fame—the angular building has a seventy-foot-high prism and a three-story atrium that allows sunlight to penetrate the building. The building shimmers at night, its iridescent presence illuminating but not overpowering the old Frank Furness building next door.

The side-by-side buildings provide the sort of architectural contrast that architect Cameron Mactavish, of Voith & Mactavish Architects LLP, jokingly said would likely "roll Furness over in his grave if he could see it."

Mr. Mactavish, of Voith &Mactavish Architects LLP, the firm that refurbished and designed an addition to the Furness building, said that the bank was built so that people visiting the 1876 Centennial (and who were arriving at Thirtieth Street Station) could withdraw cash to spend at the "exhibition city." "As a young man, Furness fought in the Civil War. He didn't have a gun; he carried a long spear. He saw a lot of extremely gruesome carnage, and that affected the way he thought and ultimately the way his buildings looked," he noted.

Centennial bank ceased being a bank in the 1970s when it was sold to Drexel University. Eventually, the university closed the building completely, and it sat empty for decades, unheated and uncared for, with the roof leaking and trees growing out of the eaves and the gutters.

The challenge for the architects was to find a useful purpose for the building that would ensure its survival. Voith & Mactavish decided to restore the bank as an alumni reception center and gallery space. During the restoration process, Mr. Mactavish said that underneath layers of paint they discovered a beauriful thirty-foot-high painted Victorian ceiling. "It had been hidden under three layers of subsequent construction, plaster

and drywall. Another challenge was to design an addition that would harmonize with the Furness original building but also be distinguishable as new. We worked really hard on this. We matched the original brick and we copied the scale and details of some of the windows but did it in such a way that is kind of subtle and not as ornamentally elaborate as the original. It is harmonious without copying directly," Mr. Mactavish said.

Drexel's vast collection of nineteenth-century art (from the private collection of Anthony Drexel) was made available to the architects for use in the gallery. Mr. Mactavish said that his firm selected paintings from the archives and had them restored before putting them on display.

The firm Voith & Mactavish Architects won the prestigious 2005 Palladio Award for an exterior space in Rittenhouse Square, a garden and landscape project completed in conjunction with Victoria Steiger Garden Design (which has also garnered a reputation for its work-related exhibitions). The firm's last highly praised exhibition at Haverford College in 2003 included hand-rendered conceptual sketches, models, large- and small-scale photographs and two- and three-dimensional renderings. Voith & Mactavish's exhibition at the Athenaeum on Washington Square focused on the firm's best work of the last five years.

Among the featured projects at the exhibition were Beth AM Israel Synagogue, Germantown Friends School, the Duffy Arts Center at Malvern Preparatory School, the Residence Hall at Chestnut Hill College, the Paul Peck Alumni Center at Drexel, the Bryn Mawr Film Institute, added exhibition space at the Mercer Museum, exterior renovation at Old Original Bookbinder's, the Math and Science Center at the Millbrook School and the Carnegie Building at Cheyney University. While the exhibition may not have had the grandeur of the Philadelphia Museum of Art's Cézanne exhibit, it was an impressive display when one considers that Voith & Mactavish began as a two-person mom and pop operation in the Manayunk-Roxborough area. That was twenty years ago. Today, Voith & Mactavish is one of the city's top architectural firms, with offices on the twenty-fourth floor of a Center City office building.

Co-founder Daniela Holt Voith is a tall, regal sort of woman with an Anne d'Harnoncourt manner that's saying a lot. Ms. Voith is a self-described "pull up her sleeves" worker, a 1976 alumna of Bryn Mawr College and a lecturer in the growth and structure of cities. She was asked to join Philadelphia's new Zoning Code Commission by Mayor Michael Nutter.

"We had the opportunity to mount an exhibit on Haverford's campus," Ms. Voith told me by phone. "I think that exhibitions are really a wonderful

way to step back and take a look at the body of your work in a way that you don't normally do. It's great for people in the office, and it gives accolades to people who worked so hard on those projects. It's also great as a teaching tool."

One of my favorite V&M exhibition photographs at the Athenaeum was the Rittenhouse Square townhouse garden. "There was a rubble yard in the back—it was a mess," Ms. Voith told *Architecture* magazine. "One of the design goals was to create a gracious entry sequence from the garage to the house. The walk is punctuated by required turns to emphasize views. The rill, pergola and paving all were designed to provide interest, because the distance is rather long. Entering through the new garden door, the immediate view is of the main stair in a newly created 'rear' entrance hall that connects directly to the front hall. The door's position in the house, its large scale and extent of glazing all speak to the desired sense of understated grandeur."

Ms. Voith said that many of the projects on display at the Athenaeum were still ongoing. These included the athletic facility for St. Andrew's School, the Penn Charter School theater project (still under construction) and the VMA's work on the Mercer Museum in Doylestown.

The economy, however, has proven to be a challenge, since during bad economic times architects' heads are the first ones to roll. "We are extremely nervous. We are not exempt. There was a project we were doing for Yale University; we had just finished the construction documents, but then Yale put the project in the drawer. So we're definitely seeing the effects of it and figuring out how to work with our clients in this economy," Ms. Voith told me.

The exhibition at the Athenaeum indicates that VMA will continue to be a major architectural player for a long time to come. "For 20 years, the Philadelphia firm of Voith & Mactavish Architects has been producing context-respecting, quietly innovative architecture," Eve Kahn wrote in her introduction to the VMA exhibition catalogue. "The firm operates with breadth and depth, grace and flair….The architects have managed these feats without developing any signature style, without imposing on clients any Voith & Mactavish 'look.'"

Let's turn our attention to a work published by esteemed Philadelphia artist Noel G. Miles, whose paintings of City Hall can be found in *The Splendors of Philadelphia's City Hall: An Artist's View*, published in 2002, with an introduction by Greta Greenberger and a foreword by then mayor John F. Street. While Noel Miles's name may not be a household name like Andy Warhol or David Hockney, when Prince Charles visited Philadelphia several

Philadelphia watercolor artist Noel Miles in his studio. *Courtesy Noel Miles.*

years ago, the city presented him with a gift of one of Noel's paintings, which today hangs in the Clarence House in London. Miles's painting is, as far as I know, the only painting of Philadelphia owned by the British royals.

While the buildings and historic structures pictured in this book are not *new*, through the eyes of Noel Miles they assume a new meaning. The artist's *relationship* to each building is a key element to this very different kind of "Philadelphia Story."

Whether it's recapturing the spirit of Girard Avenue when it was populated by mainly merchants (especially men's stores) or recalling the rustic pleasures of Franklin Street in Northern Liberties and North Philadelphia (in the 1950s) when it was filled with handsome brownstones and known as "Doctors Row," Miles's story is really about the little-known history of the city as experienced by an African American artist who grew up outside conventional artistic environs. Miles's work taps into something special: the way a building touches lives.

When we work in a building for years, sleep in it at night, worship in it once a week or take classes in it for years, afterward something of us—a part of consciousness—remains in the stucco, cinderblock or carved mahogany. A memory or impression is left. Return to a beloved building from childhood and you will still feel something in the walls reaching out to you.

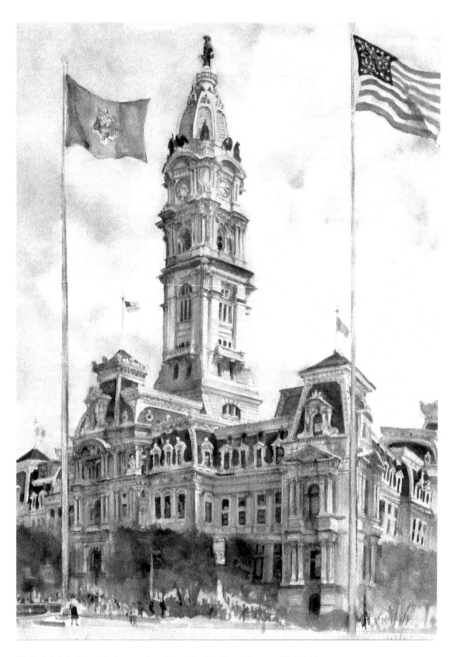

Philadelphia City Hall as painted by Noel Miles. *Courtesy Noel Miles.*

Richard Allen Projects

For a boy who grew up in Philadelphia's Richard Allen Projects (it was Eleanor Roosevelt herself who cut the ribbon when the building opened), where Bill Cosby was a neighbor, trips into Center City were frequent. Noel Miles's father, born in 1901, was an immigrant from Cuba ("He was from the same town as Desi Arnaz," Miles likes to say) who worked for Linton's and the Horn brothers. Although his mother was Methodist, it was his father's Catholicism that exposed him to the art of the western liturgical tradition. Candles and incense seemed an ideal link to all things classical.

Strong women helped mold his character, especially his great-aunt Ida, who worked at the New Century Club at Twelfth and Walnut Streets, the oldest chartered women's club in America. Aunt Ida's position at the club, Miles said, was much like the chief maid at Eton Place in PBS's Masterpiece Theatre series *Upstairs Downstairs*. Aunt and nephew were so close that when PSFS had its very first black teller, Aunt Ida embraced him and said, "Oh honey, they hired their very first black teller!"

Years later, Aunt Ida would be photographed by a *New York Times* photographer as she stood beside the last president of the New Century Guild on occasion of the guild's anniversary.

The Richard Allen Projects was an unlikely breeding ground for an artist who would come to be appreciated for his fearless attitude to watercolor. "I always felt that from the age of thirteen I liked to draw," Miles told me in his apartment on Spring Garden Street. "I was always getting my siblings to pose for me, and I did quite a number of paintings and drawings that were very good."

One of his first mentors was his white eighth-grade English teacher, Ethel Hibbert, a member of the Fourth Street Friends Meeting. Miss Hibbert had a penchant for guiding minority kids both in and outside the classroom. She not only taught him to appreciate art but also what had come to be regarded as the "black national anthem," James Weldon Johnson's "My Country 'Tis of Thee."

Miss Hibbert would take him to the Academy of Music to see Marian Anderson perform. The concert inspired him to do a portrait of Anderson, an occasion that was met with citywide publicity when young Miles had Anderson sign the work. The year was 1947, the date of his first public notice. The Anderson portrait marked his growth as a young artist, a step up from copying Brenda Starr comic strips. It also set Miles's sights on the Academy of Music.

While the Academy certainly impressed Miles as being representative of Philadelphia's rich architectural heritage, the Julian F. Abele–designed Philadelphia Free Library resonated with him as well. Like the first black bank teller at PSFS, having a black architect design one of the most iconic structures in the city was also a first—or an "Aunt Ida" moment.

While still a young Fleischer Junior High School and Dobbins High graduate, Miles met another life mentor, Samuel H. Brown, a well-known WPA artist who had been honored by Eleanor Roosevelt. (Brown's work, in fact, had been included in a large WPA retrospective at the Philadelphia Museum of Art.) He was already developing a sense of architecture, and he knew that Horace Trumbauer was one of his favorite architects. Years later, when he worked in the advertising department at the *Evening Bulletin* (a few years later, he secured a stint at the *Daily News* before winding up as art director at WPVI-TV's *Action News Team* on City Line), he had not stopped painting buildings that appealed to him.

A favorite subject, the Widener Building, still retains much of the charm it had in the early twentieth century.

Both P.A.B. Widener, the builder of the Widener Building on South Penn Square near City Hall, and Horace Trumbauer, the architect, were self-made men. Widener, the wealthiest man in Philadelphia at the time of his death in 1915, started out as a butcher's assistant. He made a fortune selling meat for the Union army during the Civil War. Trumbauer was educated in Philadelphia public schools but dropped out at age sixteen to work as an apprentice at the architectural firm of G.W. and W.D. Hewitt.

In its day, the eighteen-story Widener Building was the most state-of-the-art office tower in the city. The interior is devoid of woodwork, and the floors are either marble or cement. The exterior is composed of Indiana limestone and bronze. Designed in the classical Beaux Arts-style, the structure's tri-level plastered façades, steel ornamentation and steel-framed windows complement the buildings around City Hall.

Trumbauer's European-style shopping arcade, originally consisting of two floors of shops, is the most fascinating. This open passage allows the city to literally flow through the building's lobby from South Penn Square to Chestnut Street. The arcade was closed in 1963, but Francis Cauffman Foley Hoffmann Architects began restorative work in 1992.

Back to the Beginning

Over the years, the exterior of the building had turned black because of the way the buses go around City Hall. During the restorative work, care had to be taken when adding doorways and leveling the lobby floors with the elevators since there was a three-foot gradual ground slope from South Penn Square to Chestnut Street.

Original drawings indicate that the Widener had a kind of lower mezzanine restaurant. This 1920s restaurant had a grand stairway that went down from the lobby. The remains of the restaurant include ceiling ornamentation and some very large restrooms.

But the biggest assault the building had to endure over the years were the drop ceilings that people installed in the '60s and '70s.

Noel Miles asked, "Can a beautiful building be like an unwanted stepchild? Can it begin 'life' in Gilded Age luxury but end up being traded by a series of buyers after a five-year vacancy in which the only 'users' of the building were vagrants, rats and pigeons?"

Much later in his career, as a graduate of the Philadelphia College of Art, a member of the Philadelphia Watercolor Club and the American Watercolor Society and a winner of the latter's Dawson Prize, Miles's work began to attract attention. The artist's watercolor exhibition at Cliveden in 1992 displayed his interpretations of a number of Fairmount Park sites along the Schuylkill, as well as the Strawberry Mansion Bridge and Memorial Hall.

"Miles' watercolor style possesses all the characteristics that make this medium such a challenge. They are spontaneous and translucent yet vibrant and splashy with color washes and defined with sufficient brush detail to give the rendering aspect credibility," the *Chestnut Hill Local* reported. There was also the occasional portrait commission, although most of Miles's work is done in watercolors. "The presentation of one of his paintings to the Prince of Wales was a painting of the Academy of Fine Arts building. A painter himself, the British royal remarked to Miles that he was 'not in your league.' Miles's style finds its source in a more fearless school or attitude to watercolor."

Father Divine

Father Divine was a benevolent Harlem preacher and civil rights and social welfare activist who purchased the Divine Lorraine Hotel in 1948. His International Peace Mission had its headquarters in the building and found

employment for many African Americans in Philadelphia. "History hasn't quite decided what to make of Father Divine, a preacher who rose from obscurity by advocating a strict moral code—and by convincing thousands of people that he was God," wrote the *Kansas City Star*.

After Father Divine's death in 1965, the Peace Mission owned and operated the hotel until 1999, the year that brought the finest preserved late nineteenth-century apartment house in the city into another albeit less positive era. Since Father Divine's death, the Peace Mission Movement had been under the direction of Father Divine's second wife, Mother Divine (Edna Rose Ritchings), a white Canadian woman he met in 1946. Mother Divine died on March 4, 2017.

The Peace Mission Movement began as a force for peace and goodwill between the races, as an incentive to make people "industrious, independent, tax-paying citizens instead of consumers of tax dollars on the welfare rolls," as Mother Divine noted in her small book, *The Peace Mission Movement*.

Father Divine's greatest contributions are in the area of civil rights. As early as 1951, he advocated for reparations for the descendants of slaves and for integrated neighborhoods. Decades before the Civil Rights Act, the NAACP, Stokely Carmichael, Angela Davis or the Black Panthers, Father Divine preached peaceful nonviolent social change. His work on behalf of civil rights is a mostly understated fact.

UNPREDICTABLE FUTURE

For half a decade, the Divine Lorraine Hotel on North Broad Street was vacant and unattended, visited only by pigeons, rats and an occasional vagrant in search of shelter despite its having been awarded the official Pennsylvania State Historical Marker in 1994. Some spoke of demolishing the landmark at the time, while others, like a New York real estate entrepreneur who purchased the building in 2000, wanted to refurbish it.

Prospects seemed good for the structure, especially in 2002 when the building was added to the National Register of Historic Places. Real estate's unpredictable roulette wheel, however, brought about another abrupt jolt: the building's resale and the unveiling of plans to build condominiums and retail space.

With the new sale in the bag, the building's future seemed certain, and the American Institute of Architects Landmark Building Award in 2005 seemed to confirm that fact. When yet another developer bought

the Lorraine for $10 million with plans to add five fifteen-story condo towers behind the hotel, the future seemed ensured. In 2015, a developer announced plans to convert the building into rental units with commercial outlets at ground level.

Churches constitute a significant part of Noel Miles's oeuvre. As a boy, Miles used to attend Our Lady of the Blessed Sacrament, a Catholic church on Fairmount Avenue near Broad. Years later, he was surprised to learn that both Our Lady of the Blessed Sacrament and the parish of St. Peter Claver were black parishes intentionally segregated by the Archdiocese of Philadelphia. This was a time when indiscriminate mixing of the races was unacceptable and ill-advised.

It was while attending a Solemn High Mass with his Cuban immigrant father that Miles learned to appreciate French Gothic church architecture and older liturgical forms. His painting of North Philadelphia's Church of the Advocate illustrates what Miles calls "his increased fascination with churches."

The legendary Church of the Advocate, designed by architect George M. Burns (1838–1922), stands as a monumental example of ecclesiological design in the United States. Its French Gothic forms include stained glass, flying buttresses and ornamental gargoyles.

The interior vistas of the church are immense and almost symphonic. "Painting, sculpture and architecture that ought to compete and disagree somehow harmonize into something larger," wrote critic Peter Rockwell. "In the Church of the Advocate, paintings that by their color, form and meaning are an art of protest function together with carvings by master carvers who never thought of themselves as artists."

The nave, with a thirty-foot-high stone statue of the angel Gabriel, is especially dramatic. Gabriel used to perch outside the church, but time and the elements forced the statue's removal to a more secure position inside the church near the medallion-studded rose window. The rose window is shrouded behind a vast net that was put up decades ago to collect falling plaster from the capitals near the ceiling.

The effect is at once ethereal and surreal. The church, which is listed in the National Register of Historic Places and was designated as a landmark by the Philadelphia Historical Commission in 1980, began to deteriorate in the 1960s

Originally built as a Presbyterian church in honor of George W. South, a wealthy Philadelphia merchant, it was thought too ornate for Presbyterian worship services and was offered to the Episcopal Diocese.

The Church of the Advocate has always been on the forefront of social and political issues. It hosted the Third Annual National Conference on Black Power in 1968; in 1970, it was the site of the Black Panther Convention attended by five thousand people. In 1974, the Episcopal Church's first ordination of women occurred in front of the sacred, monogrammed five-panel-high altar.

In the 1970s, artists were commissioned by the late Reverend Paul Washington to create a series of large paintings representing the black experience to be positioned around the nave of the church. The end result of Father Washington's vision was that most of the white, middle-class parishioners left the church.

No book on Philadelphia would be complete without a look at William Strickland's Merchants' Exchange Building in the Old City district. Long before architect Strickland designed the Corinthian columns and front portico of the Philadelphia Merchants' Exchange, Dock Street was the city's center of commerce. Schooner owners and waterfront industry leaders gathered in the old London Coffee Shop near the corner of Front and High Streets (now Market) to buy and sell. Later, they'd meet in places like City Tavern. Eventually, these informal meeting places proved insufficient. What was needed was a Temple of Commerce, and who better to design it than Strickland, significant for being among the first architects of the young nation to design buildings that did not follow predictable colonial patterns.

In 1833, Strickland toasted the 140 artisans and workingmen who collaborated on the building, complimenting their "good conduct and orderly deportment," which he saw as being as "remarkable as their skill and excellence of workmanship."

Viewed by some scholars today as the greatest building in Philadelphia, Strickland's Greek Revival design extolled the ideals of democracy. The lantern, or cupola, atop the structure was copied from the Choragic Monument of Lysicrates. The building had mosaic floors, a domed ceiling and frescoes painted by Nicola Monachesi, famous for his frescoes in Catholic churches. The building's long, svelte windows, in combination with an interior stairway lorded over by two large lions imported from Italy, caused one city newspaper in 1831 to declare Philadelphia the "Athens of America."

The early Merchants' Exchange had a coffeehouse and a post office, as well as an office for Strickland. The National Park Service, which acquired the building in 1952, said that Edgar Allan Poe would walk here almost

every day to mail his manuscripts. Unfortunately, many of the manuscripts Poe mailed from this site were rejected.

As the city's commercial hub moved west of Broad Street, the Exchange became less important. The once glorious Temple of Commerce was gutted in 1901. Eventually, even the great lions were moved to the Museum of Art.

In 1952, the National Park Service purchased the building because, like the early schooner owners who wanted to consolidate, it wanted a large central headquarters for its various departments. "In 1958, the Park Service retrieved the lions after it began an elaborate restoration of the building based on historical documents," according to Charles Tonetti, chief historical architect for the site. "The Park Service restored the east end with the curved portion of the building and moved the lions back. The large stone scrolls were re-carved based upon investigation of old photos, and reinstalled."

Tonetti added that in 1901, during the gutting of the building, the structure was fitted with a steel frame. Before the steel was installed, there were barrel-vault frames on the first floor and a timber frame on the second floor. A portion of the building, a section of the employee lunchroom, still retains the original barrel frame. The massive exchange floor on the first floor was reconfigured by the Park Service. Although much of the interior integrity of the building is lost, the grandeur of Strickland's window portico is still very much seen.

The Park Service has a rich archive and library filled with the unpublished writings of the Founding Fathers, as well as photographs and etchings detailing the building's history. Inside the lanterns, one can see skeletal walls of old brick set back from the long lighthouse-style rectangular windows. This 3-D effect—the columned structure reinforced by "hidden" infrastructure steel—provided views of Dock Street and the river beyond, just the view the schooner owners of old would have wanted to contemplate on a clear day.

The Skyscraper that Was Never Built

Almost a decade ago, there was optimism surrounding the fact that Philadelphia would soon be home to one of the nation's tallest skyscrapers. Where city mansions once stood, the 1,500-foot-high American Commerce Center was slated to be taller than the Empire State Building (1,250 feet) and the World Trade Center towers (1,362 and 1,368 feet high). The project promised to change Philadelphia's reputation from a "connecting" city to

New York and Washington to a world-class destination. Then the economy took a nosedive and the project was put on hold. The project would have included a twenty-six-story hotel and six stories of street-accessible retail along Arch Street. A sixty-three-story office tower was designed to be topped with a striking three-hundred-foot spire.

The building was lauded as iconic and breathtaking, and many said that it would put Philadelphia on the world stage. Architects Gene Kohn and Bill Louie of Kohn Pedersen Fox Architects, creators of Philadelphia's Mellon Bank Center with its iconic pyramid top, have designed world-class skyscrapers in Shanghai and Hong Kong. The Philadelphia project included public green spaces on several levels of the building and promised to bring more than two thousand construction jobs to the city over the three-year proposed construction period.

For developer Garrett Miller—vice-president of Hill International Inc. (Philadelphia division), a 1999 University of Pennsylvania Wharton graduate and 2000 Sydney, Australia rowing Olympian—the American Commerce Center would have created a new dynamic environment for Philadelphia. "Cities are dynamic environments," Mr. Miller said. "They either improve or they get worse. Philadelphia needs to put itself in a position to change for the better. Although we have a great historical past that we should respect, it's important for us to realize this and embrace our future. The thing to remember is, cities don't stay the same. When you choose to live in an urban environment, you choose a dynamic area that is always evolving."

Mr. Miller was referencing a small but vocal opposition to ACC, a contingent of mostly older residents of the Kennedy House in Center City. ("If you're under sixty, you're likely to love ACC, but you may not like it if you are over sixty," Mr. Miller told me.) At a previous City Planning Commission meeting, opponents of ACC wanted the project scrapped or at least the height of the tower scaled back to traditional and "safe" Philadelphia height limits. Opponents of the project apparently feared that the iconic gleaming tower, which would have been one of the tallest buildings in the nation, would block views of the city from their Kennedy House windows or cast unsightly shadows. Opponents also insisted that the building's height was out of scale with the neighborhood. The proposed skyscraper, however, is not in the Fairmount neighborhood but rather smack in the middle of the city's financial district.

For Christopher Paliani, a resident of the Logan Square neighborhood at Nineteenth and Arch Streets, the notion that the new building would be in somebody's neighborhood was anything but valid. Mr. Paliani created

a website in support of ACC and said that many Logan Square neighbors thought that the project would be a huge benefit to the neighborhood. "This area is really the central business district, but the opponents are making it seem like it is being stuck in the middle of Fairmount. This is one of the best places they could put this building. This is the kind of building that people would move to Philadelphia from New York for. This is not a neighborhood issue. It's a regional issue, and having one small group having veto power over something is not something that benefits the entire region," Mr. Paliani said.

The idea of squashing a proposed skyscraper project because it would potentially block occupant views in another high-rise ignores the fact that all buildings in the city block somebody else's view. Sooner or later, buildings go up and somebody's view gets blocked. "There was the same kind of opposition when they wanted to build Liberty I and II. Detractors said those buildings were too big or too small, and now that they are there they are a spectacular addition to the city," Mr. Paliani added.

Opponents of ACC voiced concerns over the shadows that would be cast by such a tall building, but Mr. Paliani said that the shadow effect would not affect the Kennedy House, only his building at Nineteenth and Arch Streets. "The majority of residents where I live support the project. There are even people who live in two-story houses around here who are excited about this building," Mr. Paliani said.

Retail re-merchandiser Andi Pesacob, who designed the first six floors of high-end retail space for ACC, said that that when the architects presented six possible renditions of the proposed building, both she and Mr. Miller pointed to the one in question and said, "That's the one!" "It's a beautiful building and an incredible design. It's a piece of art," Ms. Pesacob said.

Ms. Pesacob's retail design, which included a glass floor on street level so that one can look down into another part of the store below, was an idea she got from a club in Las Vegas. "The architects took my design, went over it with L&I, then flushed it out with technical details," Ms. Pesacob said. "Each retailer has its own entrance on street level, and then you go up to their store on their own escalation."

An impressive design characteristic of the ACC was the pedestrian-friendly street-level design. The artful "ground scale" design was a feature that made the rising tower above look even more fantastic. No matter what school of architecture you subscribe to, the building was no vertical glass canyon that "slammed" the face of the sidewalk like a footprint left by Frankenstein's monster.

A City Planning Commission meeting is a grandstander's paradise. At the last ACC City Planning Commission meeting, opponents voiced their opinion that Philadelphia doesn't need the American Commerce Center because "Philadelphia isn't that kind of city." But what does "that kind of city" mean? City Planners heard arguments like this in 1986 when the debate raged about Center City buildings exceeding the Billy Penn's hat height limit. Those debates were loud, passionate and sometimes vicious.

The odd intrusion of Senator Vince Fumo into the controversy only added to the confusion. Mr. Fumo, a politician and not an architect, vowed to fight the construction of the American Commerce Center and went on record as calling the building a "monstrosity." Fumo, who was once considered the most powerful politician in Pennsylvania—he served thirty years in the capitol—was convicted of 137 counts of conspiracy and fraud in March 2009.

For Ms. Pesacob, finding national and international retailers for the ACC building was a high priority. "It's not just about putting in high-end retail but retail that has a very unique twist." Plans were for a gourmet food store, two or three restaurants, a boutique cinema, a theater and a high-end gym.

Philadelphia needed a world-class building that would ordinarily be built in New York, Chicago or Los Angeles. The time was ripe for thinking outside the box. (Box-lock thinking affected the design of the Cira Center. It was designed to be much taller than it is, but unfounded fears about another 9/11 attack caused the building to be scaled down. The scaled-down look did not escape the eye of some critics, who have criticized Cira as being "too squat, as if it had its head shaved off.") As Mr. Miller observed, Philadelphia should celebrate its history, but this doesn't mean it has to be stuck in it.

In a unanimous decision, the City Planning Commission eventually voted to rezone the area around Nineteenth and Arch Street for the proposed American Commerce Center. In a three-and-a-half-hour session, the commission heard testimony from Kohn Pendersen Fox Architects and investor and Hill International attorney Peter Kelsen. Architect Gene Kohn told the commission that the project comes at the right financial moment for Philadelphia. "This project will provide much-needed jobs, drive new companies to Philadelphia and develop a new energy and optimism for the city," he said.

Kohn reminded the commission that "all great cities make bold moves" and told members that the building of the Benjamin Franklin Parkway was resisted by people who didn't want to demolish houses and buildings for the Parkway's construction.

"Can you imagine how things would be had the Parkway not been built?" Kohn asked. "We would have lost a great asset to the city leading to the museum." Mr. Kohn also mentioned that when City Hall was built, it was the tallest building in the world. "City Hall was a catalyst of growth. If you look at what Philadelphia was like when City Hall was started, it was all very low rise. After City Hall came the Bellevue Stratford, built in 1904, and it was a major height building. After that, other taller buildings happened."

Gray Smith, an architect retained by the Kennedy House Residents Association, told the commission members that the proposed skyscraper was too big, would affect traffic and have adverse effects on the surrounding neighborhood. "The building would cast solar reflections and glare in relation to other residential buildings," Mr. Smith said. Mr. Smith also stated that the present zoning code that prohibits skyscrapers in the area of Nineteenth and Arch or the Parkway should not be altered to accommodate the project.

"The American Commerce building exceeds the 125-foot height requirement ten times," Mr. Smith said. While Mr. Smith said that he admired the architecture of the building and thought the building had a spectacular design, he said it should be moved to a more appropriate site, such as North Philadelphia.

More than 250 people packed the Friends auditorium, many carrying pro-skyscraper signs. Hill International presented a four-minute digitally animated video on the building that most in the auditorium applauded. The vast majority of speakers testifying before the commission supported the project.

The commission's unanimous decision meant that the area could be rezoned to accommodate a skyscraper the size of the American Commerce Center. The normal designation for the area, a C-3, would now move up to a C-5 or a C-6. The commission's approval paved the way for the project to get the full approval of the city council before going back to the planning commission for further analysis, such as an examination of vehicle and pedestrian traffic patterns.

The commission's decision was met with smiles and muted jubilation. "Everybody understands that anytime you build in the inner-city urban environment, you are going to affect those who are immediate neighbors— you are going to change their life. We believe it will be for the better. We believe that in the end, after it's built, they will benefit greatly from the enhanced amenities, environment and lighting. It will make a major

Edgar Allan Poe House interior.
Courtesy Joe Nettis.

statement for companies outside the city that Philadelphia is a major city and it is arriving and it is growing," Mr. Kohn said.

The legacy of Edgar Allan Poe has become big business in Philadelphia. Proof of this was evident during the Inaugural Poe Arts Festival at the Edgar Allan Poe National Historic Site and the German Society in October 2017. For a mere ten dollars, participants got to sample beer and food, watch performances and listen to talks about Poe.

Most readers will recognize Poe, along with Mary Shelley (*Frankenstein*) and Bram Stoker (*Dracula*, which was written in Philadelphia), as one of the progenitors of horror fiction. Poe lived in Philadelphia for about six years and spent the last eighteen months of his time here with his wife, Virginia; his mother-in-law, Muddy; and his cat, Catterina, in the (now) historic home at Seventh and Spring Garden. While in the city, Poe worked for a number of magazines, although his journalistic run was sometimes rough because he liked to drink in the afternoon. This habit caused him to be fired from one publication, although he was given a second chance when a man named George Graham made him editor of *Graham's Magazine*.

IN THE LAMPLIGHT OF B-MOVIE GOTHIC HORROR

When Poe aficionado Herb Moskovitz asked me to read adapted sections from Poe's story "The Murders in the Rue Morgue" to Poe House visitors during the inaugural festival, I was more than willing to oblige. On the night of the readings, Herb and I were stationed in Poe's old kitchen, a fairly small room that barely held the groups ushered in by a guide to hear us read. In the dark room, we took turns reading the adapted story, the only light a small flashlight clipped onto the corner of our scripts. The interest (and appreciation) expressed by the various groups that crammed into that small space was impressive and contagious, and it made me wonder just what

it was about Poe that attracted such a diverse array of people. While it's possible that some in the groups that came to hear us read were well-read literary types, I felt that most were actually general readers with an interest in Halloween horror as it related to a scary story by Poe they may have remembered from childhood, even though there's nothing especially scary about Poe's fiction.

The gore in Poe's horror fiction—the rolling heads, the stab wounds, the walled-up victims unable to breathe—is too outlandishly Gothic to arouse genuine fright among most readers. Standing in a dark kitchen, it became obvious to me that none of the visitors was really frightened, but most were more interested in hearing how Poe's Gothic sentences rolled off a reader's lips on Halloween. The idea, after all, was to create an atmosphere where Poe seemed to be in every particle of dust floating in the house, even if the really frightening experiences would have to wait until everyone at the festival went home and caught up on the latest world and local news, where the real horror resides.

The numbers of people who crowded the Poe House that night got me wondering if Poe's writing somehow speaks to our age more than it did to previous generations. Is the increased violence in the world, from ISIS to the killings in streets of Chicago, the catalyst that helps drive some to bask, with minimal discomfort, in the lamplight of B-movie Gothic horror? Or is something else going on? Only a one-act play written by Poe's friend George Lippard captured the sense of true horror when it ended on the festival stage with one man slitting another man's throat. Here, I thought, is an authentic contemporary link.

There's no doubt that Poe, and the manufacture of his legacy, has become big business, but would Poe appreciate this fact were he able to come back to life? Several years ago, there was a Poe "war of the corpses" when Philadelphia Poe scholar Ed Pettit challenged the curator of Baltimore's Poe House, Jeff Jerome, by suggesting in a *City Paper* article that Poe's body should be moved from Baltimore, where it is buried, to Philadelphia, where Poe wrote many of his noteworthy stories. The implication here, of course, is that Poe's Philadelphia experience was richer and more substantial than the experiences he gathered in Baltimore. Poe actually considered himself to be a Virginian, so in theory Richmond, Virginia, might also have requested Poe's corpse to be transferred there for reburial. One could chime in for months about the relative merits of various resting places as they relate to Poe, but in the end, arguments like this end up sounding like theologian Thomas Aquinas quibbling about how many angels can dance on the head

of a pin. As a former Baltimorean, I can tell you that Baltimore does have a foreboding feel to it that Philadelphia does not have. For this reason, it is a more fitting city than Philadelphia for Poe's earthly remains.

Poe's skyrocketing popularity has a kind of boardwalk quality to it, reminiscent of mass-produced knicknacks and mugs sold in T-shirt novelty shops. When a writer becomes so popular that his/her image winds up on jars of Nescafé and breakfast jam, the tendency for some is to not bother with the writer at all. Picture ten thousand people reading *Harry Potter* in a football stadium and you might understand why some readers would opt never to go to that stadium. You might describe oversaturation like this as the "drinking the Kool-Aid" literary equivalent of the celebrity-loving sheep who follow every bit of news about the Kardashians.

Heavily Gothic literature with lots of blood spilling is often equated with teenage angst. Writing only about dark things is a little like dressing up 24/7 in dark Goth clothing, which used to be the fashion among teenagers. As in fashion, so in literature, it helps to accessorize and diversify.

Yet the mystique of Poe is powerful enough to seduce even the most resistant reader. This is why while in Poe's kitchen I found myself running my fingers along the walls, as if forcing a spiritual communion between myself and the writer. Standing in the dark, knowing that this was once the room where Poe lounged, chatted or argued with his wife or mother-in-law, scolded the cat, suffered multiple hangovers or dreamed up new story ideas while running his fingers along the wall was for me a Halloween bonus. After all, the kitchen in any house is where the most dramatic family events occur, and this was almost certainly true for the Poe family.

At some point during my time in Poe's kitchen, I thought of the Walt Whitman house in Camden, New Jersey, another national literary shrine, although far simpler in structure and allure than the Poe House but in many ways far more authentic. The Whitman House has not been remodeled but, in fact, contains the same humble furniture that Whitman used. While Poe's sojourn in Philly was relatively short, Whitman's stay in Camden was so long that it's probable that a DNA expert could comb the place and discover, even at this late date, "pieces" of old Walt in the walls and floors. In fact, the unglamorous Whitman House comes close to replicating the standard small Fishtown row home.

It's an understatement to say that Poe's work is not universally appreciated. There are some critics, for instance, who say that it is vastly overrated. A poetry website, Poetry Snark, lists the ten most overrated poets of all time. Included in the list are Charles Bukowski, Ted Hughes, Alfred Lord

Tennyson and Edgar Allan Poe. The famed English poet T.S. Eliot once wrote of Poe that he "dabbled in verse and in kinds of prose, without settling down to make a thoroughly good job of any one genre."

But all of this is ultimately in the eye of the beholder. To appreciate Poe doesn't mean having to get stuck forever in Poe at the risk of ignoring other writers of greater or lesser importance, even if his mystique, however self-indulgent in its dark Gothic imagery, is far more seductive than the lives of most scribes.

FASCINATING WOODMONT

Mother Divine and Jim Jones

RITTENHOUSE SQUARE AND THE
HENRY P. MCIIHENNY MANSION

For many years, the empty mansion at 1914 Rittenhouse Square stood as a memorial to Philadelphia socialite and millionaire Henry McIlhenny, who died in May 1986 of heart failure.

Who was this pillar of Philadelphia society who gloried in giving dinner parties for beautiful people while traveling the world in search of art treasures? McIlhenny's professional life included a stint as a member of the curatorial stag of the Philadelphia Museum of Art; he was also on the board of the Philadelphia Orchestra. His father, Henry P., was responsible for earning the family fortune. He invented the gas meter, and with his wealth, he became an art collector of notable worth.

Writer James Lord, in his book *A Gift for Admiration*, maintained that although the family was nouveaux-riche, "their richesse was so considerable, their manners impeccable, and their mansion in outlying Germantown so vast that polite allowances were made [for McIlhenny's homosexuality]."

After the death of Henry Sr., Henry Jr., fresh out of Harvard, decided to become an art collector himself. This meant world travel and countless introductions to dukes, poets, artists, actors and heads of state. He collected works by Van Gogh, David, Cézanne, Renoir, Degas, Rouault, Picasso, Vuillard, Dalí, Seurat, and Toulouse-Lautrec while also encouraging his

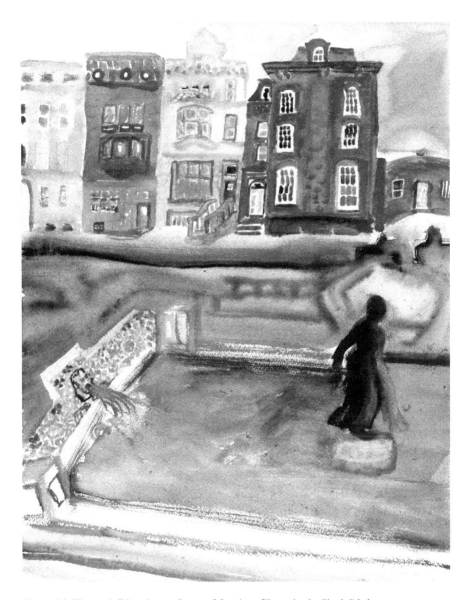

Henry McIlhenny's Rittenhouse Square Mansion. *Illustration by Chuck Schultz.*

mother to buy more art until, at last, he had so many paintings he needed a house to put them in.

Although he already owned the thirty-two-thousand-acre Castle Glenveagh in Ireland, Henry wanted a place in Center City, Philadelphia. Number 1914 Rittenhouse Square soon became a study in impeccable

manners, with Mr. Henry Fussey as the butler in tails and Mrs. Heritage acting as Henry's personal secretary. Mrs. Heritage spent all her time sending out party invitations and answering Henry's personal and business correspondence.

Besides these vexing tasks, there were always thorny questions about which artist or painting to invest in next or where next to take the McIlhenny yacht. Then came the question of the ballroom Henry wanted to build exclusively for use by Princess Grace of Monaco during one of her American tours. This feature was added to 1914 Rittenhouse and became the largest ballroom in any private home in America, but unfortunately Her Highness never visited.

Lord wrote that Henry was never lonely and never gave the impression of being morose:

> *It has been said that happiness is elusive for the possessors of great fortune, especially for those who have inherited them. Not for Henry. He had hundreds of friends scattered across the world and these included not only princes and dukes but also numerous poets, musicians, actors, and dancers, even movie stars. They enjoyed his company and he very openly enjoyed theirs. An exceptionally genial host, he was one of the most entertaining men one could hope to know....It seemed impossible to imagine that Henry had ever said to any human being, "I love you."*

Lord wrote about Henry's meeting of Aleco, one of a number of vigorous Greek youths who swam out to his yacht during a cruise in the Greek islands:

> *He came from a modest bourgeois background. Had received an acceptable education, but did not look forward with equanimity to marrying a presentable girl of his class and settling down to an uneventful family life in Athens....It may not therefore have been altogether a thoughtless whim that had led him to swim out for a closer look at Henry's yacht. Aleco proved in every sense to be a pleasurable and entertaining companion. He had an instinctive sense of how to make himself agreeable. It was specified from the beginning, however, that Aleco would not be expected to live in Philadelphia. Henry would never have accepted an arrangement which publicly proclaimed that he had provided himself with a kept boy. Aleco would be installed in an apartment in New York, and visit Philadelphia on weekends. This arrangement suited both parties very nicely. Henry could continue as an upright pillar, so to speak, of Philadelphia society, while Aleco explored the opportunities of Manhattan.*

Lord noted that Henry was concerned with art but also every cultural aspect of his era. "For many years he was on the boards of the Philadelphia Orchestra, one of the country's finest, and of the Metropolitan Opera. He went frequently to New York to the theater, rarely missing a production of merit. His contributions to charity were considerable and regular in support of medical and scientific research, educational institutions, the preservation of various species of wild animals threatened with extinction, and other meritorious causes."

After his sixtieth birthday, 1914 Rittenhouse was becoming cramped. The house, despite is grandeur, only had four guest rooms, and the dining room could only accommodate thirty people. Lord wrote:

> *Having bought and demolished the ugly, two-story house overlooking his garden, Henry in 1972 acquired the house on the other side of 1914, this one a tall, five-story stone mansion which would provide not only more guest rooms, a new office for his secretary, and living quarters for the butler, but also a space for an addition that Henry had long dreamed of: a ballroom. Here he would be able at last to give the grandest parties of his grand career as a giver of parties. The ballroom occupied the entire ground floor of the renovated mansion. As a space conceived entirely for the sake of entertainment…it was palatial, with much marble of various colors, crystal chandeliers, plenty of gilt bronze, and Doric columns. It was, to be blunt, rather ostentatious, but that, after all, was what was wanted in the only ballroom to be built in America after World War II.*

Before the addition of the ballroom, Henry acquired a small two-story house that overlooked the garden. To fund the purchase, he had to sell a late Renoir, *The Judgment of Paris*, with its depiction of weighty ladies frolicking in a roseate garden. After he had the small house demolished, he created an impressive domed entrance hall that doubled the size of the main drawing room. The main drawing room was where he hung the largest painting in his collection, a portrait of Pope Pius VII and Cardinal Caprara by David, which he denoted to the Philadelphia Museum of Art in 1971.

Following Henry's death on May 12, 1986, after a serious heart operation, the Philadelphia Museum of Art received some 414 objects of art that were, as Lord attested, among "the outstanding masterpieces of Western art." Two weeks prior to Henry's death, his sister, Bonnie Wintersteen of Chestnut Hill, died, leaving her Chestnut Hill mansion to fall into ruins.

In 1925, a poet named William Coxe Wright penned a work about Rittenhouse Square's famous bronze goat statue:

> *There's a Little Bronze Goat in Rittenhouse Square/And he's different from goats that I've seen elsewhere./His little head's down and he's steppin' right in/To roughhouse, for little goats always have been/Read to butt and to scamper and brawl/Just like little boys one and all./From the fountain of youth his soul must have sprung./For he typifies all that is playful and young.*

In 1825, the name Rittenhouse Square came into being. Previously the square was known as Southwest Square. It was one of five open squares devised in 1682 by Thomas Holme, surveyor-general of Pennsylvania. The land, which originally belonged to William Penn, was especially noted for its density of trees and wildlife. In 1706, newspapers in the city reported that wolves near the perimeter of the square were a danger to sheep, so the more cautious colonialists kept to the area around the Delaware River. Southwest Square, known also as Governor's Woods, became a magnet for hunters wishing to shoot pigeons and other wildlife after a 1730 ordinance was enacted fining hunters five shillings for shooting doves, partridges and pigeons in the streets of the city. As a result, Southwest Square became a hunter's paradise. In 1816, a fence of rough white boards with latched gates was erected around the square; the fence lasted until 1853. Marion Willis Martin Rivinus, in her extraordinary monograph *The Story of Rittenhouse Square, 1681–1951*, wrote that the fence was replaced with an iron one and that "a bell was rung at closing time":

> *Sometimes pedestrians entering from Eighteenth and Walnut Street would not hear it, and upon traversing the Square be confronted with the alternative of climbing the fence or spending the night in the open. Which raises quite a diverting mental picture of some of our distinguished lawyers, green bag in hand and long catching coat-tails, scrambling over the barrier, probably muttering in not too technical terms what they thought of the caretaker. In the days before the promiscuous brief case, all Philadelphia lawyers carried green cloth bags, with a drawing string at the top, as a proud badge of their profession. It might be a subject for a debating society, which went over the fence first, the lawyer or the bag?*

During the 1900s, Rittenhouse Square came into its own as one of the better residential neighborhoods of Philadelphia. Rivinus described the

annual Easter parades held there as being the envy of Fifth Avenue, New York, what with the ladies "in their best bib and tucker and the gentlemen in top hats and frock coats, complete with grey suede gloves, spats and canes, and of course gay boutonnieres."

Rivinus's history tells us that in 1909, two prominent Philadelphians, a Mrs. J. Willis Martin and Dr. J. William White (physician to noted Philadelphia-based author Agnes Repplier), were vacationing in Lake Como, Italy, when their conversation turned to the beauty of European cities versus "the tawdriness of Rittenhouse Square." While Rittenhouse Square may have been less than tawdry, it certainly did not compare to the Parc Monceau in Paris, which became their ideal of what the square should aspire to. This was a time when concrete seemed to dominate everything in the square, it being an era when "many trees had died and others were roughly topped or lopped off."

For her part, Mrs. Martin headed to Paris and photographed the Parc Monceau. With the able assistance of French architect Jacques Greber, she was able to photograph the area in a way that would make it easy to compare camera angle shots of Rittenhouse Square and then plan for the redesign of Rittenhouse according to the French model. The years 1912 and 1913 were devoted to drawing up a charter for a new organization, the Rittenhouse Square Improvement Association.

Under the direction of architect Paul P. Cret, a reflecting pool was added to the square, and grass and trees were planted to break up the monotony of concrete that lined the square all along Eighteenth and Walnut Streets. The entrances to the square, Rivinus wrote, were decorated with flower urns and pedestals. The planting of hundreds of plants and shrubs throughout the square caused Mrs. E.K. Price to comment, "When the planting was begun it was found a little shocking for the old gas pipes and rusty water pipes long since discarded and broken, had then each the consistency and color of Gorgonzola cheese, and the odor of a char factory."

Among other changes, there was the rearrangement of walks and gravel paths, the installation of new walks and the moving of the Barye Lion. The reconfiguration of the square took years. Rivinus noted, "As a starter, $30,000 was collected, manure and lime and much needed paint were applied.…An interesting note is that the bill for spreading fertilizer and lime came to the appalling sum of $11.00."

No city square is complete without rules, and so it was decided that "roller skating by boys up to the age of ten and girls up to the age of fourteen" was to be allowed.

In 1927, the Fairmount Park Commission assumed the responsibility of the administration of Philadelphia's four city squares. Trouble with vandalism came shortly thereafter.

Note: Many complaints about the spitting in the square and the danger to children from the use of angle irons and wire cord railings around the grass plots were received. It never seems to have occurred to the ordinary citizen that he might help by not spitting or by keeping his children off the grass. But in a cooperative spirit, the caretaker was again taken to task and the grass guards removed, with the obvious consequent detriment to the grass and shrubs. In 1916, this had to be rectified by long poles of gas piping with wire stretched between them.

CENTER CITY OVERVIEW

The chainsaw-like buzz inside Philadelphia's future premier steakhouse, Union Trust, is deafening. Workers recoil wires as unseen machines make sandblasting noises. The thin spray of dust in the air, while an irritant to sensitive eyes, is a positive precursor to what lies ahead: the aroma of wagyu and Kobe beef, not to mention filet mignon or an assortment of other steaks that will soon fill this beautiful building.

In a city already comfortably populated with steakhouses, Union Trust (719 Chestnut Street) was the brainchild of Walnut Street's Capital Grille developer, Joe Grasso, former chef Ed Doherty and former executive chef of the Palm and Del Frisco's, Terry White.

The building itself is a spectacular choice for a restaurant, designed in 1888 by Philadelphia architect Willis Hale, a Victorian gentleman whose idea of great architecture was to "out-eclectic" Frank Furness.

Once considered one of the finest architects in Philadelphia, Hale's star fell when the public no longer had any respect for architectural designs that showed a marked "lack of restraint." (Hale's obituary in *American Architecture* magazine mentioned that Hale's work showed a remarkable "lack of restraint.") Hale originally designed the Union Trust Integrity Bank as one of three townhouse/mansion-style bank structures on the 700 block of Chestnut Street. Trained by architect Samuel Sloan and Philadelphia City Hall architect John MacArthur, Hale's flamboyant style became so unpopular at his death that his name was virtually blacklisted by the movers and shakers of Philadelphia Society, the very people he once cultivated. No "famous" architect in the city of Philadelphia ever had it harder than Hale,

who died penniless in 1907, his entire body of work dismissed as "crude," "violent" and "revolting."

But with the Union Trust building now in its third incarnation—DAS Architects did the steakhouse remodeling job, while Benjamin Franklin Bridge architect Paul Cret renovated the building in 1923—a world-class steakhouse may be able to "reach back into history" and enhance Hale's reputation. "It was considered one of the ugliest buildings in the city because it was out of style, it was gaudy and Gothic," Ed Doherty told me as workers raced to finish before the big opening. "There used to be a third bank attached to the building, but that was demolished to make a parking lot."

Mr. Doherty mentioned that in the 1940s and '50s, the Jack Kilmer jewelry family took over Union Trust after their building burned down on Jeweler's Row. Some of the jewels to be found in the "new" Union Trust are the tubular nickel-plated chandeliers that hang from the cathedral-like ceiling. There's also the colorful redone florets that border the sixty-foot-high ceiling, which give the DAS makeover a kind of Ayer building splendor. The imposing arches on the walls have been infused with acoustical panels for the best in sound control. The pure leather cubical seating (draped in clear plastic during my visit) is arranged on different floor levels like theater seating. The "height ascendancy" of the different floors is subtle to the point of invisibility, even when viewed from the balcony, where there are private and corporate dining rooms, some 425 seats in all.

"This restaurant is unique, and something brand new and the most exciting thing I've ever done," Mr. Doherty said before introducing me to Mr. Grasso. "We did a complete renovation," Mr. Grasso added, pointing to various spots in the ceiling. "The cornices have all been repaired. The cappings were done with lead-coated copper. All the glass was replaced." He indicated to the new glass within the labyrinths of the frontal arched window that looms as large as Notre Dame's rose window. "Over the years, the weather created weather etching on the old glass. It looked like you needed to wash it, but you really couldn't get the grime off."

Original plans included the retention of the old, wire-door (human being–operated) elevator, but that was not to be. To architect Hale's credit, Mr. Grasso also pointed out the building's first-floor windows. "Most banks at that time were built without windows on the first floor that you can see into. When the building was a jewelry store, the whole front was covered with a marble tile. It was horrible 1970s décor."

THE REAL PHILADELPHIA STORY

Woodmont is not only a world set apart; it is also a world with a history. Located in Montgomery County, this seventy-two-acre estate is the home base of the Peace Mission Movement, started by Father Divine in 1919 in Sayville, New York.

The mansion itself is a multi-room French Gothic masterpiece, designed by Quaker architect William Price for Philadelphia industrialist Alan J. Wood Jr. in 1892. After the demise of the Gilded Age and the selling off of many of Philadelphia's old mansions, it was sold to Father Divine for a relatively humble $75,000. Woodmont then became the headquarters for the Peace Mission Movement.

The Peace Mission Movement began as a force for peace and goodwill between the races, as an incentive to make—as Mother Divine noted in her small book, *The Peace Mission Movement*—people "industrious, independent, tax-paying citizens instead of consumers of tax dollars on the welfare rolls." In the area of theology, many of Father Divine's followers believe that he was/is God. In the past, this fact has annoyed many members of the press and resulted in bad publicity for the movement.

Father Divine's marriage to the second Mother Divine was a celibate affair, as members, both married and unmarried, are prohibited from having sex or using alcohol and tobacco.

An invitation to attend the monthly Sunday banquet at Woodmont, which the Peace Mission Movement considers a Holy Communion service, was extended to me and artist Noel Miles. Miles had gone to Woodmont before, with brush and canvas, to capture the marvelous interiors for our project when Mother Divine extended the invitation.

When the day of the pilgrimage arrived, we boarded the R-7 for Bryn Mawr and then hailed a cab to Gladwyne, where Woodmont is located. Our cabbie, a rather youngish urban type who seemed more suited for a city taxi than navigating the lost vistas of Montgomery County, had no idea where Woodmont was, but like a true con man, he tried to hide this fact by driving fast.

When it became apparent that he was winging it, Miles made him get his bearings. By happanstance or miracle, we happened to notice the Woodmont address etched simply and unobtrusively on a stone wall. The taxi then took the long rustic driveway through a corridor of trees. Along the road to the mansion, I noticed a few clumsily etched hand-carved road signs, the kind you'd see in a Boy Scout camp circa 1960.

Mother Divine's Woodmont Mansion in Gladwyne, Pennsylvania, declared a National Historic Landmark in 1998. *Courtesy the author.*

A wide clearing in the brush brought the mansion into view. At this point, the cabbie could barely suppress an "Ahhhhh!" Was this some unnamed palace on the Thames transferred via UFO to fairly predictable Montgomery County, where the only queen had been Hope Montgomery Scott? I spotted an elderly white man sitting on a chair—or was it a tree stump?—near what looked to be a shed. A watchman of some sort, very

Artist Noel Miles and Mother Divine at Woodmont. *Courtesy the author.*

polite. Did he sleep in the shed? I was full of questions. The cabbie let us off in the middle of the massive semicircular drive.

A small black woman in a beret and white gloves with a "V" embossed on her blouse waved to us as we approached the mansion. She was perched several heads above us, sentry-like, on the portico landing— shades of Buckingham Palace formality. Her smile was beatific but steely, her thin body conjuring images of self-denial. Introductions were made and up the steps we went, the cab idling as if the cabbie wanted a longer glimpse.

"Call if you want a pick up," he shouted from the cab. We were not banking on a pickup but a ride home, or at least a ride to the station from one of the dinner guests.

Inside the grand reception room, we saw museum-quality gilt-framed paintings, lush carpets and oak woodwork. Miss Faith, the sentry of the steps, explained the history of the house. We noticed a mammoth framed portrait of Mother and Father Divine hanging over the reception area like an iconostasis in a cathedral. "My one aim is to live a virtuous life under the Personal jurisdiction of FATHER DIVINE," Mother Divine wrote in 1952. "My Marriage to FATHER has brought the fulfillment of this desire and I can most assuredly say that in these past four or more happy years that I have been married, FATHER's Virginity has been more firmly established in my consideration, for I have not seen anything about Him that reflects that of a man."

"May I tape our conversation?" I asked Miss Faith.

"Oh no, you may not," Miss Faith said, looking at me in disbelief. This was a perfectly natural question for a journalist, but Miss Faith's reaction somehow made me feel thoroughly ashamed of myself. Was I now a besmirched houseguest who had to be watched? I would later discover that in years past, journalists delighted in taking advantage of Mother Divine's generosity and then went on to butcher her in print. It's the way journalism is these days, where stories about suburban teachers having sex with seventeen-year-olds is considered breaking news.

Without any sort of announcement, namely the ringing of chimes or a small handbell, my eyes were drawn to the top of the magnificent central staircase. A woman in a long white beaded dress was being escorted down the central staircase by an elderly woman in a beret. It was one of those Hollywood cinematic moments—half royal family, half an exciting new story that has yet to be told.

"Who are these people?" I heard Mother Divine whisper to the aide. When she was reminded who we were, Mother approached Miles first, extending a hand. When Mother turned to me, I took her hand and said that it was an honor to meet her. After all, this was the brave woman who, in 1972, issued Reverend Jim Jones and his followers his marching orders. Mother Divine ordered Jones to leave the Woodmont estate after he attempted to take over the Peace Mission Movement, claiming that he was the reincarnation of Father Divine. Some two hundred of Jones's followers had arrived from California, "pretending," as Mother stated, "a sincere desire to fellowship with members of the Movement."

Mother asked them to leave when "his distaste for the government of the United States and the establishment, and the prosperity of the followers in general began to be expressed in casual, then more deliberate remarks he made to Mother Divine and others." Several years later would come the insanity of the Peoples Temple in Guyana.

Jeff Guinn, author of the book *The Road to Jonestown, Jim Jones and the Peoples Temple*, wrote about the time that Jones came to Woodmont:

> *Temple buses took almost three days to make the trip. Stops were made only for gas and bathroom breaks. For a change, there was lost of room on the individual vehicles, empty seats to hold all the Peace Mission members who'd want to return with them to California. When they arrived in Philadelphia, Temple members were housed in Peace Mission apartments, which they found to be clean and comfortable. They liked their hosts, who seemed genuinely pleased to meet them. The Temple members asked for everyone's name and the best addresses at which to contact them—this was standard Temple procedure. Jones himself stayed at Woodmont, and all the guests were taken on a tour of the property, which included a lengthy stop at a bronze-doored chamber enclosing the body of Father Divine. Afterward there was an elaborate banquet, with much fancier place settings and food than the Temple members were used to back in California.*

Guinn described a second dinner at Woodmont when Jones announced to everyone that Father Divine had "conferred his mantle on me." This comment led to his expulsion from Woodmont. A dozen or so Peace Mission members joined Jones and the Peoples Temple brigade on the trip back to California.

The drive back to Mendocino County was tense. "When they arrived, Jones gathered the followers who'd made the trip and explained that what had happened at Woodmont was not his fault. Mother Divine had been enthusiastic about merging their ministries under Jones's leadership, so much so that after maneuvering so they were alone, she tore open her blouse." Jones then proceeded to tell a lurid lie about the woman who had treated him with such respect.

In my quest to find out more about the Mission, I asked Miss Faith where the chapel was, "the place where you have services." My question was met with puzzlement. "The banquet is the holy communion service," Miss Faith said. I would understand the mechanics of this very soon, once the banquet got underway.

The lush, white banquet table sat about sixty people. A swan on a "lake" of glass was the centerpiece, in addition to fresh flowers. Women outnumbered men about ten to one. Mother sat at the head of the table; beside her was a setting for Father Divine. An attendant stood behind me and Miles ready to assist us during the meal.

Dinner began when Mother rang a large handbell. A female cook in a white uniform produced the platters from a small kitchen directly behind Mother. Numerous platters of salad items—including a wide assortment of vegetables, condiments and sauces—set the pace for more complicated platters offering meats and fish, rice, potatoes, breads, more vegetables and meats until at last diners could devote their entire attention to the business at hand rather than the elaborate ritual of passing platters.

When platters are passed from one diner to another, they must never touch the table. Diners must also not hold two platters at the same time, so the entire synchronization of the plates had the movements of a dance. While this was going on, diners listened to an old audio tape of a Father Divine sermon. The mostly elderly crowd—men in suits and women in Peace Mission uniforms (berets and jackets embossed with a "V")—combined eating with the singing of hymns. A few elderly white women, European by birth, clapped their hands in sing-song fashion in between mouthfuls.

The plate passing started up again when dessert was served: huge cakes, pies, jello molds and ice cream were passed in the same fashion—all

homemade, all luscious and yet not a single person at the table looked to be overweight.

With synchronization worthy of the Rockettes, additional platters kept being delivered to both sides of the table. Diners were expected to take only what they could eat. I ate all of what I put on my plate except for a little bit of salmon skin. The food was marvelous, the vegetables being among the best I've ever tasted.

After dinner, Miles and I were asked if we wanted to say a few words to the assembly. I mentioned that the dining experience reminded me of the time I spent in Catholic monasteries, when you would eat in silence while listening to a monk read from scripture or the lives of the saints. The Catholic connection, as it turned out, was not that far-fetched. A woman from St. Paul's Parish in South Philadelphia told me to look out for a lineup of Catholic saint statues around the perimeter of the Peace Mission dining room. I counted ten or more Catholic saints positioned some ten feet above the heads of the diners.

For me, the hymns and hand clapping that occurred during the banquet raised a red flag. "Here's where biting journalist types like Christopher Hitchens have a really wicked time ripping into Mother and all things divine," I thought. But Woodmont, in rapidly deteriorating world, is actually more of a treasure than not. It's quiet, isolated and beautiful, a mansion with many rooms and good food—an empire with its own benevolent queen, a masterful lady with a piercing glance.

After dinner, Miles and I were told that Mother wanted to see us alone, in Father Divine's office. The office, as it turned out, is a dead ringer for the Oval Office in the White House. Miles and I stood with Mother by Father's desk, an aide not far away. Directly in front of the window was Father Divine's shrine and tomb. For a few moments, things were very quiet. Then sunlight hit Mother Divine's face.

We both agreed, on the train ride home, that here was the real "Philadelphia Story."

The Lippincott Mansion Rittenhouse Square

While both the documentary and play *Grey Gardens* have generated a lot of fascination, one need look no further than 2023–25 Locust Street to see Philadelphia's own renovated and restored version. The recently restored

mansion has shed new light on the building's glorious past as the Philadelphia home of Christina Lippincott, the suffragette daughter of publisher J.P. Lippincott, known at the turn of the twentieth century as an eccentric of extreme proportions. But we'll get to that story in a moment.

The mansion itself is an imposing structure, elegantly and magnificently overstated in its latest incarnation as the Lippincott House Bed & Breakfast. Opened to the public just last year, the mansion has enlivened this block of Locust Street after years of dark, gray obscurity. "It was a dark, quiet place," recalled Mary Beth Hallman, whose English husband, Jack Eldridge, purchased the mansion in 1997. "It had no life to it, and we thought this was just plain silly. We thought, let's open the doors and share it with the people."

And share it with the people they did. The moment neighbors on Locust Street saw lights go on in the mansion and movers carrying in all types of furniture inside, they flocked to the front door to find out what was going on after years of unsung obscurity.

Although the Lippincott House is no longer a B&B, when it was in full swing it was a marvel, with three floors of guest rooms, stained-glass windows, Victorian fireplaces, hand-painted murals and Brazilian rosewood paneling. The nine thousand square feet of lavish spaciousness included a grand piano with candelabra and a dining room table large enough for a White House press corps meeting. There was also a media room with theater-style seating and an upstairs game room with an antique, mother-of-pearl inlaid pool table.

When I took my tour with Mary Beth, I not only saw the various rooms for rent—from the opulent Adams Room with its en suite bathroom, bidet, whirlpool bath, fireplace and seating area—but I was able to appreciate how "small" can also be beautiful. Especially notable were the handsome Franklin Room and the equally as impressive Morris Room, with its original claw-foot bathtub and Victorian rain shower.

The mansion dog, little J.R., followed us every step of the way. Brought up in Australia and trained as a fox hunting fellow, this little guy was somehow orphaned out and threatened with "extinction" until Mary Beth, who worked in Australia for a while, adopted him and brought him back to Philadelphia, where her sister encouraged her to return and live after a twenty-year hiatus.

Mary Beth said that she left the city in the 1980s for Florida when Philadelphia didn't seem to have a future. Eventual changes in the city made it a different place than it was then, she said.

Before 1997, the mansion had been a law firm. Prior to that, from 1921 to 1961, it was a doctor's office. A reception area, still intact, was built on

Stained-glass window, Lippincott Mansion. *Courtesy the author.*

the first floor; patients were seen by the doctor on the second floor. "During the renovation, I was out front tending the flowers when a lady came by and told me she'd been born here in 1950," Mary Beth said. "My husband, Jack, always says that a house isn't a house until someone is born there and someone dies there."

The mural in the Lippincott dining room, while not as spectacular as *Dream Garden* in the Curtis Building, is stunning in its own right. It was part of the wedding present Joshua Ballinger Lippincott gave his daughter, Christina, when he gave her the house on occasion of her marriage. "The mural has something to do with the wedding. It's a timeline showing the Tuscany countryside and Christina on a horse in 1897. After we had the mural cleaned, there were amazing changes in the colors," Mary Beth said.

J.P. Lippincott & Company began as a bookseller in 1792, but in 1836, it became a Society of Friends religious publishing house specializing in Bibles and devotional books. The advancing years saw the company evolve into a trade publisher so that by 1900, it had headquarters at 227–31 South Sixth Street on Washington Square.

In 1978, the company was purchased by Harper & Row Publishers (now HarperCollins). When patriarch Joshua Lippincott died in 1886, his son, Craig, took over the company presidency but committed suicide in his home at 218 West Rittenhouse Square (the present site of the Barclay Hotel) on April 7, 1911.

The sudden, mysterious death of someone who seemed to have it all found its way to the front page of the *New York Times*. "Publisher Found Dead by His Valet with a Bullet Wound in His Head," the *Times* headline ran. "Reason for Act Unknown—Thought to Have Gone Suddenly Insane." The valet found a revolver beside Craig Lippincott's body, but despite this, the family insisted that some terrible accident had occurred and that the death was accidental. Nobody likes to talk about suicide.

In 1911, Christina was living at 2023–25 Locust Street and becoming more interested in the women's suffrage movement. That interest would lead her to divorce her husband as she devoted more time to what was then perceived as a "scandalous activism." Not much is known about Christina's life. Did she, for instance, befriend famous Philadelphia suffragettes like Dora Lewis (aka Mrs. Lawrence Lewis), who was also from a prominent Philadelphia family?

Dora Lewis was one of the leaders of a famous women's hunger strike after being jailed by authorities sometime between 1913 and 1915 for her activism. In jail, she was kicked by guards until she was knocked unconscious when she hit her head on her iron bed frame. During the suffrage movement, the Lippincott mansion became known as the Philadelphia house where "no good woman was ever seen entering those doors."

Christina Lippincott sold the mansion in 1921. "She was a different woman from what I understand," says Mary Beth. "The woman who was Christina's caretaker when she was in a nursing home contacted us and said, 'Christina always kept the name Lippincott. She always talked about this house when she got really senile in the mid-1970s, until she died in her late nineties. At the home, she kept thinking that she was still on Locust Street where the servants were.'"

There have been visits by Lippincott family members to the house when it was a B&B. "Family members have stayed here," Mary Beth added. "Older family members speak of her as the eccentric, crazy aunt, so when she died, a lot of Christina's stuff went into the rubbish."

Look around the mansion and you'll see remnants of Christina's house. In the Adams Room, for instance (where Christina slept), you'll see the original chandelier with dragon imagery. The dragon-motif chandelier in the dining

Rittenhouse Square's Lippincott Mansion. *Courtesy the author.*

room is also original, as is the stained glass (including a panel in the dining room where the face of a clergy member seems to have been "scratched out"). The large dining room table was the doctor's contribution, but lawyers used it for their schemes, plots and briefs for years.

Mary Beth and Jack took me up to the roof deck, where there used to be a bell tower, and which adjoins the old servants' quarters and staircase. "We envision this as a place where people can come up for cocktails. For those who can't take the stairs, we have an elevator. It will be really beautiful," Mary said.

And it was, indeed.

THE MANSION CHANDELIER MAN

Walking to Warren Muller's chandelier art studio from the opposite end of the Girard Avenue area of Northern Liberties is a bit like stepping into a an old celluloid redux of *The Matrix.*

The open sky, while slightly reminiscent of Colorado, meets a very bland sort of industrial highway. There are no sidewalks here, although a dead railroad track snakes in and out of various abandoned lots. The feeling of desolation is oddly comforting—the phrase "industrially romantic" comes to mind—and the tall fence meant to block access to a scrapyard only halfway succeeds—passersby over the years have dug out peepholes for glimpses into a hidden terrain of debris mountains composed of waste material from consumer society.

Muller's studio, Bahdeebahdu, is highlighted by a Dadaist outdoor sculpture that looks like an image from a dream. The studio's immense basilica-like doors open into an equally immense space that, at first, feels too empty. Inside the studio, more than likely, you'll be met by the resident feng shui guardians, Elbe and Bella, two Chihuahuas that will run toward you but stop just before reaching your feet. Like an animated Hallmark greeting, the dogs will get you to follow them to Muller, who may be anywhere inside the labyrinthine cave working on his latest chandelier.

Muller's chandeliers are made from scrap metal, trashed buggy wheels, old vinegar bottles, toy trains, found objects, family heirlooms, dolls, toy ships, imperfect crystals or plastic fish that look like the stuffed specimens in a fisherman's dens. If the range here seems impossibly wide, that's because it is. If you want ample proof of this, take a trip to Bahdeebahdu yourself, where you'll see any number of working projects in suspended animation.

A signature Muller chandelier can cost upward of $25,000. When a client asks Muller if he can make a chandelier from a box of old family heirlooms—which may include anything from an old set of antique hobby horse heads to an assortment of Victorian-era tops—Muller is careful to say that he'll do what he can, although there are no guarantees that he will "use their stuff."

Muller chandeliers are in private homes, mansions, offices and restaurants the world over. A few summers ago, he completed a chandelier for the Chandelier Museum in the south of France, a near three-year project that necessitated

Warren Muller, the creator of mansion chandeliers, in his studio, Bahdeebahdu, at 1522 North American Street. *Courtesy the author.*

spending time in France with his assistant, Rebecca. The fact that the French have heard of his work and treated him like a celebrity—giving him a house to live in while he worked on the project, as well as access to scrapyards, thousands of imperfect crystals from the museum and a special dinner in his honor—stands in stark contrast to his relative, muted celebrity in Philadelphia, a city where many artists, from Henry Tanner to Thomas Eakins, have felt less than appreciated.

"I decided to do the French chandelier in a traditional shape, sort of a cone, wide at the top, narrow at the bottom, in order to relate to what they do naturally," Muller told me over lunch in a Northern Liberties Piazza eatery. "When they looked at it when I was finished, they said, 'Oh yeah, that's a chandelier.' But it's very chaotic what I did. The piece contains beautiful Cupids, beautiful bronze, arms; it's very complex, very French. The imperfect crystals they offered me were perfect. I had a bottomless pit of French crystals, so we embellished the whole thing." Muller said that he named the chandelier after the owner's mother, who told him afterward that she was excited about seeing her past revived and brought into a whole new realm.

For a Boulder, Colorado couple, he was asked to do his take on a traditional chandelier, but when he showed them the piece, he was told that the chandelier "wasn't girlie enough." At the time, Muller scratched his head and asked himself, "What's girlie?" Perhaps in a perverse way it was the legacy of Boulder's JonBenet Ramsey that inspired him to apply a quick fix—the addition of "some draped glitzy things"—that eventually won the approval of the couple. "Oh yeah, that's much better," they told him.

The art world has caught on to the Muller mystique. Hilary Jay, of the Design Center at Philadelphia University, noted that Muller's work reaches beyond aesthetic appreciation "to become culturally reflective and intellectually inspiring. He keeps good company today contemporary artists and designers such as lighting designer Ingo Maurer, the Dutch collective droog, Marcel Wanders, Philippe Starck, all who create works that conjure a dream and a wink."

"In a way that architect Frank Gehry has reshaped our expectations of buildings, Muller has exploded notions of the look and function of lighting.... Suddenly lamps are fun. And space is transformed," wrote former Museum of Modern Art director of education Philip Yenawine.

At Bahdeebahdu, I spotted a number of pieces waiting for the right buyer. Muller, who produces about twenty chandeliers per year, works during downtime cycles when sales are low, although whatever he makes is

eventually sold. "I'm always prepared for downtime," he said. "Downtime is the time when I make things without a request. A lot of the pieces in my studio are pieces I made just because no one was asking me. I have so much stuff that I collect. And I am always adding things. Eventually, someone needs it for whatever reason."

His *Marcel du Lamp*, a chandelier based on themes by Duchamp, hung in the studio for months before being spotted by one of the guests at a wedding (the Bahdeebahdu space can be rented out for private functions). Muller, in fact, had given up trying to sell the piece and had already decided that he was going to keep it when the wedding guest put in his bid. Shortly after this, another buyer came forward, but it was too late. Muller, who has learned to work with this sort of ebb and flow, said, "In my old age I've learned to be patient—things take the time they take. Just because you can imagine them now, you also have to give things the life that they need to evolve."

The *Hung like a Horse Chandelier* demonstrates just that. Anything but discreet, it is half Robert Mapplethorpe, half Pee Wee Herman's Playhouse. *Cute* is a word a group of modern Catholic nuns used to describe it. "The nuns became my friends. There's a homeless shelter in the neighborhood that we've taken on as a project. We've done a few events here to raise money for the shelter that the nuns started," Muller told me, while I tried imagining the good sisters, some in habits and some in chic stretch pant suits, inspecting the horse's thick neon-lit projectile.

Bahdeebahdu's fundraising events for the shelter became so popular that they were moved to the Pennsylvania Academy of the Fine Arts, where at one party there was a concurrent show of "provocative nudes." Muller said that his initial reaction was to worry how the nuns would process this, but thanks perhaps to a path having already been cleared by the art world's Sister Wendy, he added that "the nuns were just fine."

Born in the Bronx to eastern European Jewish parents, Muller recalled his childhood as a sort of Federico Fellini–driven "museum in the streets," full of color, noise and activity. "My parents died in 1976, just six months apart. They had a dry cleaning business, so we always had a storefront. I have an estranged sister a few years older than me. I tried to interest her in me, but that didn't work. So you go and make your own family," he said.

From the Bronx, he went to the Hartford Art School and then traveled to the island of Paros in Greece, where he enrolled in the Aegean School of Fine Arts. On the island, he met a photographer from Philadelphia who invited him to come to the city and enroll in the Philadelphia College of Art. After this, he got involved in documentary filmmaking and the world

of dance, leaving Philadelphia often to travel and live in San Francisco, New York and Berlin. Still, he always managed to find his way back to the Quaker City, as if under the spell of a dragging vortex. "I've been working here so long, you know, but the city ignores you—in spite of this I go about my business."

Not to worry. As long as you're known in Paris, who cares about Philadelphia's Terry Gross, Marty Moss-Coan and *Radio Times* or winning a Best of Philly award?

In 2006, the *New York Times* featured Muller and his interior designer partner, RJ Thornburg, in a piece about the couple's Pocono Mountain retreat, a three-bedroom, 1,800-square-foot house on three acres of hills, fields and woods. Muller told the *Times*, "In the country, we take a lot of walks. There's space to breathe, and plenty of room for imagining our dreams and goals." The couple currently divides their time between the studio and the traditional farmhouse setting. In the studio, there is a fully equipped kitchen and enough space for living accommodations, although the average customer would never suspect that the studio is also doubles as a home away from home.

Muller and Thornburg met thirteen years ago through interior designer Floss Barber. Barber was in Muller's studio and suggested he come along to a luncheon interview. "You might be interested in meeting him," she said. Muller took the bait and said he wound up having appetizers, a drink and dinner. "I stayed and stayed and stayed. I felt this rapport with him."

Thornburg, as it turns out, got the job with Barber and worked with her for about a year before opening his own shop across the street from Muller's old studio in Old City. The two later decided to go into business together and opened a studio on Cherry Street, where they sold chandeliers and furniture by designers.

Wink, a 135-page art book on Muller's work put together by the artist's friends, is a lavish work of art in the style of Taschen Books. "I invited people to write essays about me," Muller said. The result is an all-inclusive look at every aspect of the artist's life. *Wink* includes photo kaleidoscopes of Muller's work and personal shots of him and Thornburg at home in the Poconos (including a party shot of both men in drag). Childhood photos of Muller—his big ears and proud pompadour reminiscent of Howdy Doody—show up in the middle section.

A Small Mansion Atop a Center City High-Rise

You wouldn't know it from the sidewalk, but on the rooftop of Center City's Touraine at Fifteenth and Spruce Streets, there's a world-class adobe house designed by Adolf deRoy-Mark, an architect noted for his Southwest/Santa Fe–style designs. The one-story house, aptly furnished with natural wood, brick, tile, flagstone and river rock, is an example of adobe architecture at its most sophisticated.

I interviewed the owner of the house, Craig M. Drake, at his adobe house a few years before his death on March 15, 2015. My impressions were as follows.

The owner of the house, Craig Drake, is not only a direct descendant of Sir Francis Drake, but he's also every bit as unique as his flat-roof villa. As one of the world's premier jewelry suppliers, Mr. Drake, a Penn Charter and Wharton school graduate, said that his childhood included getting to know Grace Kelly, whom he said would often come to his parents' house to visit his sister (Miss Philadelphia 1927, by the way). A life of hard work—he'd clock one hundred hours per week sometimes—crystallized into good fortune when he met Lois McNeil of McNeil Labs. Ms. McNeil, who fell in love with his jewelry, informed her society friends that Mr. Drake was the one to buy from.

From a life of hard knocks, Mr. Drake's life then slowly materialized into a life hobnobbing with the powerful and wealthy, including a close friendship with presidential candidate John McCain. (Mr. Drake told me that while in solitary confinement in Vietnam, McCain kept his sanity by daily mental reviews of historical facts, his study of French and a three Beefeater Martini and lobster dinner he had with Mr. Drake in Philadelphia's Bookbinder's restaurant.)

If you're lucky enough to be invited to view Mr. Drake's sky-high adobe home, make sure you don't refer to it as a penthouse. "It's the only house built on a roof in the city. It has a basement. They dug a foundation because the roof was that thick. The penthouses are two floors below," Mr. Drake told me.

Built in 1981 as a sort of crown jewel atop the 1920s Touraine, the outdoor deck, or portal, is handsomely framed by wood corbels covered in ivy. The many lush plants and tall Southwest-style grasses arranged along the deck and curved corners transport you to New Mexico and Arizona. They were originally dwarf plants, but Mr. Drake said that everything is growing by leaps and bounds because of the recent heavy rains. "It's wildly great, isn't it?" he asked, pointing to the world of greenery outside the floor-to-ceiling

windows. "We are the only people living in our garden, which is hard to explain if you haven't seen the place."

The "we" in this picture is Mr. Drake's Brazilian-born wife, Tania, whose picture is everywhere in the house alongside countless museum-quality artifacts like Andrew Jackson's White House water cooler, Stonewall Jackson's beer mug, General George Patton's pistol and holder, Sir Francis Drake's horn box, a Civil War–era gunpowder holder, a three-hundred-year-old cream separator, a Florentine table and a strongbox from a stagecoach. Multiple clocks and a two-hundred-year-old French watering can, as heavy as a small cinderblock ("imagine a four-foot-nine French girl trying to water flowers with this thing," Mr. Drake offered before explaining that the can was "bent in the Concorde coming back to the USA"), barely complete the artistic inventory. One would need a few days to really appreciate the priceless gems Mr. Drake has accumulated over the years, such as the signed chest once owned by Benjamin Franklin. "Franklin packed his books and papers into the chest when he went to France to get money for the Revolution," Mr. Drake added.

Mr. Drake's house is entered through a plain "apartment style" door that gives no indication of what lies ahead. But go up two flights of small stairs and you'll find yourself in a world of adobe light and color. The vista, as seen through the tall windows, may leave you speechless for a second, but once you become used to it, you'll become so comfortable you won't want to leave. Walk around the place and you'll see the genius of Adolf deRoy-Mark: the small, whimsical portholes and the intricate carved-out spaces in rooms and hallways where objects of art are attractively placed will have you looking for more surprises. This home, as its own work of art, will not disappoint.

Settle in beside the kiva, or central fireplace, and your eyes will be drawn to a curved shelf–like area that Mr. Drake and Tania have filled with more exquisite objects. The dining room, which also gives the impression of being in the middle of a garden, will put you in the mood for an elegant formal dinner.

The bathroom's sectional design includes portholes and windows of different shapes. The sunken mosaic whirlpool tub recalls the bathhouses of Imperial Rome.

But just when you think you've seen everything, another porthole or curved small space (nichos) beckons. Of special note are the tiny portholes at the end of a long white tunnel extending high into the ceiling like funnels or chimneys.

When the now deceased Adolf deRoy-Mark redesigned the Papago Plaza in Arizona, he told a Phoenix newspaper, "The owners are from California; they're sort of visionaries. I didn't have to fight them in order to be able to do something interesting."

While Mr. Drake's house is nothing like the controversial shopping center with its fake ladders, second story and four-story, five-sided glass blocks, it does touch on the visionary. From Mr. Drake's landscaped deck, for instance, one has a great view of the chimney, a touch somewhat reminiscent of Papago Plaza's stucco towers that recall the architecture of Anasazi pueblos. Isn't it great, indeed!

In 2015, *Philadelphia Magazine* writer Liz Spikol wrote about Craig Drake's life in a memorial piece published shortly after Drake's death on March 15, 2015:

> *He smoked expensive cigars in expensive bars with his chum Julius Erving. He regaled Mick Jagger with jokes on the Concorde; he got invited to the birthday beach bash of the son of Libyan dictator Moammar Khadafy in St. Barts, where singer Enrique Iglesias admired Drake's young, sexy wife. There were dinners at "21," late nights at Studio 54, jaunts to Mykonos and Monte Carlo. Chicago socialite Candace Jordan, a former Playboy Playmate, encountered Drake while in St. Tropez with tennis ace Jimmy Connors and his wife. "The first time we met him, he had all of these fantastical stories about celebrities and all of these high-profile people. And my husband and I just looked at each other and raised an eyebrow," she recalls. "And sure enough, the next time we were there, he's with all of these people he's just talked about."*

Sadly, Spikol's piece concluded with a not-so-glamorous summing up:

> *Was it the pursuit of false idols that got Drake into so much trouble in later years? The recession did hit independent jewelers hard. Whatever the root cause, Drake's business closed amid controversy in 2010, and later that year the property manager of his Center City penthouse—which had been included on the "Lifestyles of the Union League Rich and Famous" tour in 2008—sued him for $15,000. There was a fall from grace, as there so often is.*

Chapter 5

COLLARING THE "SAGE OF GLEN LOCH"

Alone by the fireside, a man sadly looks
At a picture that hangs on the wall
He has never forgotten the sad sweet face
Of the beautiful belle of the ball
He's reading her letter
My picture I send, I have loved you
But only in vain
Oh try to forget that we ever have met
Then he thinks with a heart full of pain

She lives in a mansion of aching hearts
She's one of a restless throng
The diamonds that glitter around her throat
They speak both of sorrow and song
The smile on her face is only a mask
And many the tear that starts
For sadder it seems when of mother she dreams
In the mansion of aching hearts

—*"The Mansion of Aching Hearts," Harry MacDonough, 1902*

LOCH AERIE MANSION

When the poet James Whitcomb Riley visited William E. Lockwood in Glen Loch, Pennsylvania, sometime in 1895 or 1899 during his tours of eastern U.S. cities, he arrived at the Glen Loch station of the Pennsylvania Railroad. That station was nestled nicely in the 836-acre estate of Lockwood, founder of Glen Loch and the millionaire manufacturer of the popular paper collar for men. Riley, at that time, undoubtedly noticed that Lockwood's Italianate Victorian Gothic marble and blue limestone mansion—built from quarries that have long been covered over by Route 202 and designed by architect Addison Hutton with its eaves, torrents, arches, tower and cranberry stained-glass windows—resembled his own Indiana home.

Why the poet chose to visit Lockwood is unclear—unless, of course, the wealthy businessman had an avid desire to host America's most popular poet during one of his national poetry tours. It was Riley who quipped, "Omit the school room from my history entirely, and the record of my career would not be severely affected." Riley also said that because he was taught to read at home and the love for books came at an early age.

Riley was called the "People's Poet." Critics of the time said that his humor was unsophisticated yet had an elfish, pleasant quality. Some critics lamented the fact that there was never any "sting" in anything he wrote. Riley took great pleasure in his perceived wholesomeness and once wrote that he had "never written a line that could not be read by anyone."

It is not known whether Lockwood had any mystical inclinations, but in a book about Riley's youth, author Marcus Dickey maintained that when the poet's mother died when he was eleven or twelve, Riley was alone in a field when the poet reported, "Till as a vision I saw my mother smiling back upon me from the blue fields of love—when lo! She was young again. Suddenly I had the assurance that I would meet her somewhere in another world!"

Whatever the reason, Riley was now in the most spectacular house in Chester County, Pennsylvania. In those days, the area was filled with grain dealers, dairy farmers, so-called maiden schoolteachers and marble quarries. Glen Loch (Scottish for "lake of the glen") was Lockwood's personal kingdom, an area rich in Revolutionary War lore. The fields and forests there have long yielded Continental army muskets and cannonballs unearthed by children and farmers until at least the 1960s. It was in these fields and forests that General Washington and his men established camps on their way to Valley Forge.

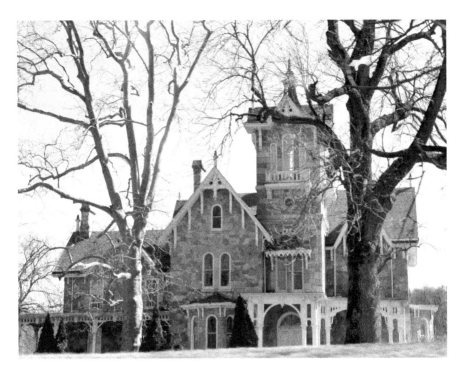

Loch Aerie Mansion, designed by architect Addison Hutton in 1864–65, in Frazer, Pennsylvania. *Courtesy Carla Zambelli Mudry.*

The original 836-acre estate once housed three separate farms, tenant houses and four railroad stations. Glen Loch, in fact, constituted an entire town and had its own post office. The mansion itself cost $250,000 to build. The property also contained a number of springs, which attracted the wandering (and lustful) eye of the Pennsylvania Railroad (PRR).

The PRR had already engaged Lockwood's fury when it built and named the Glen Loch train station without getting Lockwood's permission to use the name, causing Lockwood to change the name of the estate to Loch Aerie. The PRR would also break its promise to Lockwood that it would maintain the pipes that carried water from the estate's springs for the railroad's upkeep of its steam locomotives. In addition to breaking this contractual agreement, the PRR used all of the water from the estate, leaving the Lockwood family high and dry. Lockwood had no choice but to fight the PRR, but this would be a battle that he would lose. The fight cost him his fortune.

Lockwood was once called the "Sage of Glen Loch "in East Whiteland Township and was described in the press as "an aggressive industrialist,

Grand staircase, Loch Aerie Mansion. *Courtesy Carla Zambelli Mudry.*

inventor, and public minded citizen who could be expected to run a one-man offensive against the Pennsylvania Railroad." He was born on October 7, 1832, in Andalusia, Ohio. His first wife died two years after the family moved to the new mansion. They had one child, Elizabeth (later Mrs. Samuel H. Jones). Lockwood then met Ella Eby of Philadelphia. She became his second wife. They had three children: Ella (the family called her Daisy Dunbar; she later became Mrs. Richard J. Reilly Lockwood); Edith; and a son, William E. Lockwood Jr., who died in 1949. William Jr. was in the brokerage business at 1333 Chestnut Street at the time of his father's death. William E. Lockwood's obituary in 1911 stated that "he was stricken with pneumonia and his advanced age precluded hope of recovery."

The Loch Aerie mansion was just a quarter mile from where I grew up in Frazer, Pennsylvania. My boyhood home was originally built as part of a simple housing development consisting of six split-level houses, thanks to the post–World War II housing boom generated in part by the GI bill. Some extended family members often referred to our Frazer house as being "in the sticks" because it was surrounded by fields, streams, hills and great swaths of hilly forests.

The three-bedroom split-level home was set square in the middle of land that once belonged to a nearby farmer who had cows grazing in our backyard. My mother, busy working in the kitchen, would often utter a shocked "oh!" when a cow or two would break through the barbed wire fence and walk up to the kitchen window.

Driving along Lancaster Pike near Planebrook Road and Route 29, you could glimpse much of Loch Aerie behind clumps of trees. Trees also covered a good portion of the mansion's front porch. Only a section of the mansion's tower (which contained a nine-hundred-gallon water tank) could be spotted among the treetops.

As children, we had always heard that old Loch Aerie was inhabited by two old sisters, Miss Edith and Miss Daisy, who rarely came outside but occasionally made appearances when curiosity seekers explored the

The Swing

How do you like to go up in a swing,
 Up in the air so blue?
Oh, I do think it the pleasantest thing
 Ever a child can do!

Up in the air and over the wall,
 Till I can see so wide,
Rivers and trees and cattle and all
 Over the countryside—

Till I look down on the garden green,
 Down on the roof so brown—
Up in the air I go flying again,
 Up in the air and down!

Loch Aerie as depicted in a 1957 edition of *A Child's Garden of Verses* (Little Golden Book, illustrated by Eloise Wilkin) by Robert Louis Stevenson. *Courtesy Carla Zambelli Mudry.*

estate's massive backyard. The backyard contained a man-made pond and a weather-beaten statue of Neptune that seemed to recall ruins from ancient Greece.

You could not just walk on the grounds of Loch Aerie because one or two of the old sisters who lived there inevitably would spot you and say

Left: William E. Lockwood Sr. *Courtesy Chester County Historical Society.*

Right: Daisy Lockwood in childhood. *Courtesy Carla Zambelli Mudry.*

Opposite: Ella Eby Lockwood. *Courtesy Carla Zambelli Mudry.*

something. Miss Edith and Miss Daisy seemed to have eyes in the backs of their heads. The ornate mansion—with its Swiss Gothic architecture, alpine roofs and chalet dormers—approximated the gingerbread houses we had seen in children's books. For us, it was a house of intrigue and mystery.

We especially liked to visit the house in summer, albeit in a sneaky way because we didn't want to be spotted by the sisters. The few times when we weren't benignly "apprehended" we would linger by the fishpond near the overgrown gardens and lose ourselves as we looked into the sun-bleached eyes of Neptune. We were also careful to periodically scan the mansion's windows for shadows or silhouettes indicating that the sisters were in spying mode. When this happened, one of the massive shutters might open and a sister's voice would call out, "Who goes there?"

We ached to get inside Loch Aerie, but as the sisters were old and very private, we knew this would never happen. We did not know then that the estate was once one of the largest in Pennsylvania and that in 1877 it had its own telephone system and security system. Every door in the house was wired with a burglar alarm. The nineteenth century also had its own version of a homeless problem, as vagabonds or tramps would sometimes try to

hide on the property or try to get inside Loch Aerie through one of its many windows. At one point in the mansion's history, a dozen tramps were rounded up on the grounds of the estate.

Loch Aerie had so many tramps on its property because it was located on a railroad hub. After the Civil War, many veterans were out of work or displaced, so travel meant trying to find a new way of life. They were referred to as "tramp armies," and the public didn't like them. The gainfully employed at that time had no understanding of the problems associated with unemployment, so they considered the tramps savage and even evil.

As the nineteenth century drew to a close, many of these tramps had been on the road for two decades. Their constant travels in the end became an established way of life. After 1870, women took to the road as well, many of them disguising themselves in overalls or army breeches, as public space then was gendered as male.

Loch Aerie had five bedrooms, round stained-glass windows, a large cranberry stained-glass window on the second floor, a spiral staircase and that large water tank that was half hidden in the trees. It also, at one point, had its own landscape designer, Charles Miller. Throughout the years, both before and after its demise, it had been featured in many magazines and newspapers.

In 1923, the *West Chester Local News* reported a devastating three-hour fire of "accidental origin" in the old mansion:

A large amount of furniture and many works of art and breakable articles were saved by the firemen and stacked beside the road under guard for removal later to a place of safety. Among the things saved was the entire collection of firearms of Mr. Lockwood, one of the finest in this country, which had taken years to collect. It was on the third floor, but the firemen succeeded in reaching it with the roof blazing over their heads and carried it to safety. Many articles were removed also by way of second-floor windows and taken down ladders.

The fire was accidental but exactly how it started is not known. At the time Mr. and Mrs. Lockwood, a maid and a colored boy, Clyde Proctor, 17, were in the house. The boy was sent to the rear yard near the wall

The Lockwood Envelope Machine at the 1876 Philadelphia Centennial Exposition. *Chester County Historical Society.*

of the frame kitchen, to start the engine. He carried a lighted lantern and just what occurred is not known, the boy not being able to explain fully, but it is supposed the fumes from the engine caught from the flame of the lantern, causing an explosion which reached the tank and when it blew up the kitchen and upper portion of the house were saturated with the blazing fluid.

Members of the family heard the sound of the explosion in the yard and immediately a huge sheet of flame enveloped the wooden sides of the kitchen and reached the roof of the main building, firing the eaves also.

The fire had started about 7 p.m., and it was three hours later before all the apparatus was withdrawn, leaving small extinguishers in case of a fresh outbreak during the night.

During the fire, Mrs. Lockwood, her maid and Miss Edith Lockwood, sister of William, did much fine work in removing treasures from the rooms of the building, and, dashing into the structure time after time until finally restrained by the firemen, when they formed a guard over things taken out by the roadside until relieved later by men guards for the night. Hundreds of automobiles from West Chester, Downingtown, Malvern and many other

places crowded the roads, but at all times they kept a driveway open on both the Lincoln Highway and Pottstown Road, although a jam on both roads was prevented by township officers and others.

In 1886, Mr. Lockwood's cloth-lined paper collars were manufactured by the Lockwood Manufacturing Company at 255 South Third Street in Philadelphia. Advertisements of the period attest to their being superior "to any Collar in the market." As the only paper collar of the time lined with cloth, the collars also had a layer of paper on each side and were shaped to "fit the neck and allow a space for the cravet." Their resemblance to linen was highly prized, while the claim was made that they "are very strong, and do not tear at the button holes, and are the only collars made that can be turned and worn on both sides without the button holes giving way and the paper tearing." Lockwood collars were stamped with the Lockwood trademark. Potential buyers were warned: "Do not be deceived by the boxes or false representations, but see for yourself. If the collar itself is not stamped upon the inside as above [illustration], it is not genuine."

The detachable men's paper collar was invented by a woman. The inventor was not a scientist or a woman of distinction but what they used to call "a

William E. Lockwood Jr. as a small boy.
Chester County Historical Society.

mere housewife." The inventor's name was Hannah Montague from Troy, New York. She invented the detachable collar because she was tired of having to deal with her husband's "ring around the collar." Mrs. Montague's invention caught fire. Detachable collars were all the rage in 1862. By 1870, the detachable collar industry had advanced to include the laminating of linen onto thick cardboard stock. Finally, an early form of plastic called celluloid was interlined with the linen to create a very stiff collar that could be cleaned with soap and water.

One of the treasures in the Lockwood mansion was the painting *Washington after the Battle of Trenton*, by Christian Schussele, probably commissioned by Lockwood himself for Loch Aerie.

Left: William E. Lockwood Jr. *Chester County Historical Society.*

Right: William E. Lockwood Jr. became a broker at 1333 Chestnut Street and died in 1949. *Chester County Historical Society.*

Schussele, who was born in France, immigrated in 1848 to the United States, where he very soon became one of the chief painters in Philadelphia. Schussele's painting was later given to the Valley Forge Memorial Chapel.

In business with his brother, E. Dunbar Lockwood, the W.E. and E. Dunbar Lockwood Company in Philadelphia manufactured envelopes, folding boxes, tags and paper collars. The Lockwood brothers also had offices at 93 Reade Street in New York City. While other manufacturers in the country made paper collars, William Lockwood made the claim that he had purchased a patent on the product. A news story in 1967 on Lockwood's paper collar product stated:

> *He challenged approximately eight other companies that made a similar product with violating his patent. Claiming their own patents or denying Lockwood's, these companies cordially invited him to file suit against them to settle the matter in court. No record of the outcome was found in the Lockwood scrapbooks of newspaper clippings, but it is evident that the family head continued to make his fortune selling paper collars at 10 cents a dozen.*

Lockwood lectured throughout the country on locomotives and was a proponent of the Shaw locomotive, an engine that did not wear out track rails prematurely. The following description of the Shaw locomotive in 1891 has something of the tempo and rhythm of modern poetry.

A single slide valve, duplex acting steam counter-balanced, double cylindered locomotive. No "nosing around," "no wee-wahing," "no galloping," "no hammer blows," "no rotating and hammering metal counter-balance," all "pulls" and "pushes" in a downward direction, and none lifting or gyrating. All backward and forward jerks removed. All motion in the direction of the line of translation. Perfect elastic steam balance in all directions and at all speeds.

Lockwood later became managing director of the Shaw Locomotive Company and delivered lectures like "The Adaptation of the Locomotive to Safe High—Speed Travel." Newspaper accounts of his lectures at this time described Lockwood as "a master, and as a demonstrator and instructor he is very easy to understand."

Nevertheless, he had his detractors. One 1891 newspaper account, possibly from the *West Chester News*, read:

Edith Lockwood with the family dogs at Loch Aerie. *Chester County Historical Society.*

For many years William E. Lockwood of Glen-Loch, has been attending the Republican conventions at West Chester and making himself ridiculous by introducing fanatical resolutions. So great has been his fame in this respect that of late he has been called "Resolution" Lockwood. We have asserted time and time again that William E. Lockwood had no right to participate in the proceedings of a Republican convention, nor the right to vote at a Republican primary election. But he is allowed to do both. Mr. Lockwood is not a Republican, and he well knows it. The Republicans of Chester County know it....On Tuesday this man Lockwood attended the Republican county meeting in West Chester, and took with him a bundle of his stereotyped resolutions. His resolutions were snowed under because they were antagonistic to the interests of the Republican party.

In an 1881 profile of prominent Philadelphians in the *West Chester Local News*, E. Dunbar Lockwood was described as being forty-two years old and a "fellow whose skin fits him well....He is a large man, but not overly so. He is fine looking and the bald place on the apex of his knowledge box doesn't mar his personal appearance in the least. If anything, it rather increases his look of intelligence and serves to blend his top perspective with ethereal distance in a very harmonious manner." E. Dunbar was called a reformer, tackling "ring rule politics whenever he can get a good hold of it."

The report stated that "with ex-President Hayes, he is held in high esteem—as he was throughout that official's administration, and between them a close correspondence has been kept up during several years. Indeed we are creditably informed that President Hayes consulted with him in regard to all Pennsylvania appointments, and regarded his counsel and views as being first-class."

The profile then goes on to describe E. Dunbar's "jerky sort of manner associated with all his movements as well as in his conversation, and this, every one who has ever met him will remember as being one of his physical characteristics." Newspaper men liked and respected E. Dunbar, apparently agreeing with the writer of the article that "he is one of the best men this side of the twentieth century to interview, and while he cannot be styled a leaky individual, still he opens out with a freedom that is refreshing and pleasant and is sure to send away his interviewer with his note book well filled with first-class matter."

A FISTFIGHT IN THE UNION LEAGUE

Very few public lives are lived without a bit of scandal, and for E. Dunbar, that scandal included a Philadelphia Union League altercation during which E. Dunbar clashed with Mr. James McManus over a reform document that E. Dunbar attempted to circulate inside the League. The *West Chester Local News* reported that "after a few words on the subject, he, McManus, struck Mr. Lockwood a blow with his fist. Mr. Lockwood's deportment on that occasion had the effect to further elevate him in the good opinion of his friends, and the blow left no unsightly scar, and the unpleasantness was not carried from the League Rooms. All of Mr. Lockwood's works point to a purification and elevation of the standard of politics, and toward this his untiring labors are constantly being directed."

In an odd turnabout, the article goes on to castigate William E. Lockwood. "Like his brother William, he is quite enthusiastic in whatever he engages to do a work, but he accomplishes more than his brother and partner. He fights corruption in politics and winds some success, while William charges his one-horse brigade on the Pennsylvania Railroad Company and comes to grief every time."

E. Dunbar Lockwood died in December 1892 at Philadelphia's Aldine Hotel. The cause of death was attributed to "an attack of the grip, from which he was suffering more than a month ago." His obituary went on to explain that Mr. Lockwood had resided at the Aldine Hotel, 1910–22 Chestnut Street, since 1884, "when at the death of his mother, Mrs. E. Webb Lockwood, the homestead at No. 1859 Chestnut Street was broken up. That house had been the family residence for a quarter of a century, the Lockwoods having moved into it in 1859 from their former home at No. 104 South Ninth Street."

In yet another *West Chester Local News* profile, William E. Lockwood was described as one who made "an excellent collar" and who starts his day by "doffing his business robes in his palatial residence at Glen Loch, which is so nicely folded in the embraces of charming Chester Valley."

The profile continues: "We have often seen this gentleman on the train and we have as often wondered that the P.R.R. Company did not get a special coach for him—one that would go to pieces on its own hook and thereby knock his form into 'pi,' as a printer would say." As for William's extreme verbosity, it is suggested to readers that if they wish "pass a pleasant day," all they had to do was purchase "about a dollar's worth of transportation and go out and see him some Sabbath when he is at leisure."

Loch Aerie, rear view, with fountain, circa 1920s. *Chester County Historical Society.*

The article continued:

Take an early train, and after having warmed your feet and oiled your throttle valve, mention something relative to the financial condition of the aforesaid railroad company [P&RR]. *Few words will do the business—and you'll have no more use for your tongue until you pass from under his hospitable roof. Take our word, he'll entertain you every moment with no adjournment at dinner time. Statistics, figures, etc., will be the burden of his*

182

remarks, and you'll be obliged to read every annual report of that company for the last dozen years with copious newspaper and other comments upon the same, made by your enthusiastic host....If you live to get away and have not lost the wag of your tongue, just casually express some thought in regard to the Glen Loch and Phoenixville Railroad, and ask him what he thinks of West Chester people. This will serve to hurry you away, and if you are a little late for the next train it will be of advantage in the way of aiding you in catching it. Try it.

The *Columbia Herald* in Lancaster County reported in 1886 that William E. Lockwood had become a judge:

It may seem a little strange to those who know the genial Mr. Lockwood why The Herald calls him Judge. It is not on account of his distinguished appearance, that would naturally suggest "General"; nor on account of his dollars, although they have touched the million line; nor is it because he is an accepted authority on "hammer blow" but it is for the reason that he was regularly and unanimously elected to the "Country Judiciary" of Chester County. In plain solid Lancaster we are not much given to showy titles and the Country Judiciary are known as Justices of the Peace, but in Chester they assume the high title of "Judge."

In 1894, Harrisburg's *Daily Telegraph* published a poem about Lockwood by Shandy Maguire:

Friend Lockwood, while the night is young,
I have a ditty yet unsung.
Just give me your attentive ear,
Until its music you will hear.
I've often scrimmaged through my head.
In search of rhymes are going to bed,
To dress up subjects rude and rough,
Which I considered pretty tough;
But, dear old friend, just now I find
A nut to crack of hardest rind;
To frankly tell you what I think,
In language smeared with printer's ink.
About that "Quest" you harp on so,
Your everlasting hammer flow.

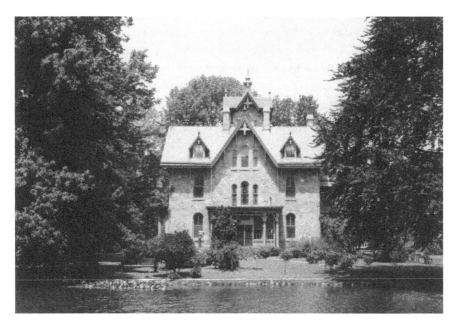

Loch Aerie, rear view, circa 1920s. After the Civil War, the area was overrun with vagabonds and tramps, often ex-soldiers, who sometimes attempted to enter the house illegally. *Chester County Historical Society.*

Miss Edith, who was employed for many years in the greenhouse at the Church Farm School, died in May 1967. Her sister, Mrs. Ella E. Reilly, died in September of the same year. Both were members of St. Paul's Episcopal Church on Lancaster Pike in Glen Loch. As a teenage newspaper journalist on assignment, I went to the mansion to interview Mrs. Reilly for a *Main Line* publication. Mrs. Reilly told me stories about her father and the paper collar, the Pennsylvania Railroad and about the poet James Whitcomb Riley. Suddenly, all the years of mystery and reserve surrounding Loch Aerie and its occupant sisters vanished in a confessional waterfall.

In the book *Vision and Ability: A History of CFS, the School at Church Farm* by Mary Neighbour, Miss Edith Lockwood is mentioned in connection with the school's floriculture program. Church Farm School was founded as a boarding school for boys without fathers in 1918 by Reverend Charles Shreiner, an Episcopal priest with the nickname "the Colonel" because of his love of discipline. "As early as 1924, Edith Lockwood was on campus to teach this subject and to manage the school's greenhouse and flower beds, which included a large peony field from which 60,000 to 70,000 flowers

The remnants of the once great Loch Aerie fountain, 2017. *Courtesy Carla Zambelli Mudry.*

were cut and sold annually. Church Farm flowers could be found throughout Chester County, as well as on the altar at St. Paul's Church."

Neighbour quoted one 1940 CFS alumnus who recalled having worked with Lockwood:

> There were three of us who regularly worked in the greenhouse with Edith Lockwood, who lived down the road and seems to have been with the school since its earliest days. There were times, too, when she would help Mrs. Taggart in the kitchen whip up a batch of scrapple or sausage. I liked Miss Lockwood very much, but I hated the weeding….As a reward for our work, she took us to the Philadelphia Flower Show each year, which was a thrill. Miss Lockwood was a bright, cheerful person; highly entertaining and a good worker. She gave us a lot of very practical, simple guidelines to follow in the business of running a greenhouse.

Jim Tate, a 1952 graduate of the Church Farm School in Exton, recalled working with Miss Edith Lockwood in the school's greenhouse:

There was always an older boy and a younger boy who worked with Miss Edith in the greenhouse. I was 11 years old and although my primary responsibility at the school was working in the dairy, I would work in the greenhouse about once every 3 months. Miss Edith was quiet and very resolute about her work in the greenhouse. There wasn't much conversation going on. Usually when a younger boy started with her in the greenhouse if he liked working there and she sensed it and she liked the boy, he would eventually replace the older boy when he graduated. Often times the kid that worked in the greenhouse worked there for 5 or 6 years.

After death of the sisters, the house lay abandoned for a time, opening the door to another kind of "tramp"—motorcycle gangs like the Warlocks and the Pagans who set up camp and used the mansion as their headquarters. In a feature article on the mansion in 1973, Marge Worth of the *Daily Local News* reported that one morning after Mrs. Reilly sold the house to Dan Tabas, who at the time also owned the Downingtown Motor Inn, "gunfire sounded at the old Lockwood mansion on Rt. 30 in East Whiteland Township and a member of the Warlock motorcycle gang was injured from shots believed to have been fired by members of the Pagans, a rival gang."

The motorcycle gangs used the mansion as a repository for their various thefts. "Undignified too was the unloading of items from the old house by police who raided the mansion to recover what has been estimated as $100,000 worth of items believed to have been stolen in 35 burglaries throughout Chester County."

Worth reported that the most recent occupants of the mansion "were the injured Warlock and his girlfriend, and a wolf which the Warlock kept unfettered in his bedroom." In the 1970s, there was also a fire in the mansion's east wing.

In 1961, six years before the deaths of the sisters in 1967, seventy-one acres of the estate were sold, leaving twenty-three acres. The contents of the mansion were sold at an auction in 1967 shortly after Mrs. Reilly's death.

Loch Aerie has been compared to Bryn Mawr's La Ronda estate and to Granogue, Irénée du Pont's estate in Delaware. The magic of this old place is transcendental and compelling, although Neptune has long since vanished.

Elizabeth Biddle Yarnall, author of *Addison Hutton, Quaker Architect, 1834–1916*, wrote of a visit to Loch Aerie in 1958 with her husband:

In 1958 my husband and I telephoned for an appointment and received so enthusiastic an invitation that the big house, with its pattered stone walls and bracketed details, seemed warmly hospitable as we approached it. The stone of which the house is built, a dark gray limestone with touches of pink and blue and somewhat resembling marble, was quarried on the surrounding Lockwood farm, originally over 600 acres in extent. So smoothly cut and fitted are the stones that it is easy to credit the family tradition that their patterns were painstakingly established on the ground before they were transferred, section by section, to the loads that young boys carried up ladders to the stone masons working above.

On entering the spacious hall, which served as a reception room, we were struck by the high ceilings with their elaborate plaster cornices. Facing the front door a massive stairway with the handsome walnut balustrades and wide railing rose to a high landing, where it divided and turned back upon itself in two short flight of steps, one to the right and one to the left, leading to the second floor. The crystal chandelier that originally hung from an arch across the hall had been replaced by an electric fixture with a Tiffany shade, but the eagle of the plaster from which the original was hung still looked down from the cross beam.

After our visit to the cavernous kitchen with its dependent pantries and the somber dining room with its paneled walls and massive Victorian furniture, the sisters led us to a billiard room chiefly remarkable for a large oblong window directly above the fireplace. When we noticed the displacement of the flue and commented on the difficulty of securing a good draft under these conditions, we were assured that the arrangement had always been highly satisfactory. In fact, both sisters recalled that as small children their special delight had been to sit beside the open fire while their father read aloud and to see above the mantel, instead of the stone of the chimney, the full moon shining through the wintry trees. Later, we were shown the ample bedrooms still equipped with their black walnut wash stands enclosing brightly ornamented porcelain bowls. Indeed, so many of the regional furnishings of "Loch Aerie" remained in use that as we emerged again into the bright sunshine it almost seemed as if for a few moments we had stepped into the Victorian world of Addison Hutton.

In April 2016, Loch Aerie was auctioned off at $710,000; however, that deal folded. In October of the same year, another bid was accepted from Steven and Dana Poirier of Downingtown, who have plans to transform the mansion into a popular wedding venue. Dana Poirier told Chester County's

Vista Today that she and her husband have long been looking "for a place with Chester County charm....My husband has a medical sales company, and he's been paying high rent for a while. Steven asked me to come look at the property. He said it reminded him of the Addams family. I was worried because I'm not crazy about that type of look. But when I drove up, I fell in love with it."

Poirier said that she couldn't believe how gorgeous it was. "We're excited to give her new life, and put some oxygen in her bloodstream. We're probably going to put an addition onto the back of the house, so we can host year-round events."

From a lofty eight-hundred-acre estate, Loch Aerie is now surrounded by an Outback Steakhouse, a Sheraton Hotel and a Home Depot.

As Samuel Johnson once said, 'The business of life is to go forwards."

Works Consulted

Bloom Harold. *The Poetry and Prose of William Blake*. New York: Doubleday & Company, 1965.

Borkson, Joseph L. *Philadelphia: An American Paris*. Philadelphia, PA: Camino Books, 2001.

Chaplin, Jeremiah. *The Life of Charles Sumner*. N.p.: D. Loth Rop & Company, 1874.

Cotter, John L. *The Buried Past: An Archaeological History of Philadelphia*. New Cultural Studies. Philadelphia, PA: University of Pennsylvania Press, 1992.

Divine, Father. *His Words of Spirit Life and Hope*. N.p.: New Day Publishing Company, 1961.

Divine, Mother. *The Peace Mission Movement*. El Centro, CA: Imperial Press, 1982.

Dixon, Mark. *The Hidden History of Chester County: Lost Tales from the Delaware and Brandywine Valleys*. Charleston, SC: The History Press, 2011.

Donald, David. *Charles Sumner and the Civil War*. New York: Alfred A. Knopf, 1960.

Epstein, Daniel Mark. "Lincoln and Whitman." *Parallel Lives in Civil War Washington*. New York: Ballantine Books, 2004.

Funnell, Bertha. *Walt Whitman on Long Island*. New York: Kennikat Press, 1971.

Futhey, Smith J., and Gilbert Cope. *History of Chester County, Pennsylvania, with Genealogical and Biographical Sketches*. N.p.: L.H. Everts, 1881. Digitized 2012.

Gifford, Edward S., Jr. *Father Against the Devil*. New York: Doubleday & Company, 1966.

Guinn, Jeff. *The Road to Jonestown, Jim Jones and Peoples Temple*. New York: Simon & Schuster.

Hildebrandt, Rachel, with the Old York Historical Society. *The Philadelphia Area Architecture of Horace Trumbauer*. Charleston, SC: Arcadia Publishing, 2009.

Jamison, Kay Redfield. *Robert Lowell: Setting the River on Fire*. New York: Alfred A. Knopf, 2017.

Kyriakodis, Harry. *Philadelphia's Lost Waterfront*. Charleston, SC: The History Press, 2011.

Lord, James. *A Gift for Admiration: Further Memoirs*. New York: Farrar, Straus & Giroux, 1998.

Loving, Jerome. *Walt Whitman: The Song of Himself*. Berkeley: University of California Press, 1999.

Lowrie, Sarah Dickson. *Strawberry Mansion: First Known as Somerton, the House of Many Masters*. N.p.: Harbor Press, 1941.

Marion, John Francis. *Bicentennial City: Walking Tours of Historic Philadelphia*. Philadelphia, PA: Camino Books, 1989.

———. *Within These Walls: A History of the Academy of Music in Philadelphia*. Philadelphia, PA: Philadelphia Restoration Office, Academy of Music, 1984.

Martin, Malachi. *The Jesuits*. New York: Simon & Schuster, 1987.

Milano, Kenneth W. *Remembering Kensington & Fishtown*. Charleston, SC: The History Press, 2008.

Morley, Christopher. *Travels in Philadelphia*. N.p.: David McKay Company, 1920.

Morrone, Francis. *An Architectural Guidebook to Philadelphia*. Layton, UT: Gibbs Smith, 1998.

Powell, Richard. *The Philadelphian*. New York: Charles Scribner's Sons, 1956.

Repplier, Agnes. *Points of Friction*. Boston: Houghton Mifflin Company, 1920.

Reynolds, David S. *Walt Whitman's America: A Cultural Biography*. New York: Alfred A. Knopf, 1995.

Rose, Michael S. *Tiers of Glory: The Organic Development of Catholic Church Architecture through the Ages*. Mesia Folio, 2004.

Shotwell, Walter Gaston. *Life of Charles Sumner*. N.p.: T.Y. Crowell, 1910. Digitized 2007.

Stroik, Duncan. *The Church Building as a Sacred Place: Beauty, Transcendence, and the Eternal*. Chicago: Liturgy Training Publications, 2012.

Swedenborg, Emanuel. *True Christianity*. West Chester, PA: Swedenborg Foundation, 2012.

Tucci-Shand, Douglas. *Boston Bohemia*. Amherst: University of Massachusetts Press, 1995.

Van Allen, Elizabeth J. *James Whitcomb Riley: A Life*. Bloomington: Indiana University Press, 1999.

Weigley, Russell F. *Philadelphia: A 300 Year History*. New York: W.W. Norton & Company, 1982.

Yarnall, Biddle Elizabeth. *Addison Hutton Quaker Architect, 1834–1916*. Philadelphia, PA: Philadelphia Art Alliance Press, 1974.

ABOUT THE AUTHOR

The author tours Loch Aerie. *Courtesy Carla Zambelli Mudry.*

*T*hom Nickels is a Philadelphia journalist and the author of twelve books, including *Literary Philadelphia: A History of Prose & Poetry in the City of Brotherly Love.* He was nominated for a Lambda Literary Award in 1990 and awarded the Philadelphia AIA Lewis Mumford Award for Architectural Journalism in 2005. He is a writer for *Philadelphia Magazine, City Journal* and PJ Media; the theater critic for *ICON Magazine*; and a regular HuffPost contributor. He has written for the *Philadelphia Inquirer,* the *Philadelphia Daily News, Metro Philadelphia, Travel Weekly,* the *New Oxford Review* and the *Broad Street Review.* His essay on Agnes Repplier was the featured essay in the Winter 2015 issue of the *American Catholic Studies Journal* (Villanova University). Nickels lectures on Philadelphia history and literature and on topics related to his national newspaper column.

CPSIA information can be obtained
at www.ICGtesting.com
Printed in the USA
LVHW081548310520
657066LV00009B/129